THE COMPLETE GUIDE TO
PHOTOGRAPHIC
COMPOSITION

TONY WOROBIEC

D&C
David and Charles

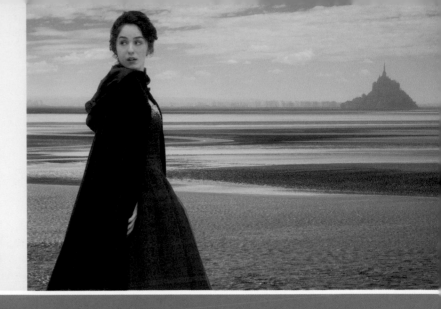

Contents

INTRODUCTION 06

Chapter 1: Taking a conventional view of composition

- **THE GOLDEN SECTION** 10
- **ORGANIZING INTERACTING SHAPES AND FORMS** 16
- **USING LINE TO STRUCTURE COMPOSITION** 28
- **LINKING THE FOREGROUND AND BACKGROUND** 38
- **PLAYING THE NUMBERS GAME** 45
- **THE VALUE OF COLOUR** 54
- **DIRECTING THE VIEWER'S EYE** 67
- **WORKING WITH PATTERNS** 70

Chapter 2: Achieving style through composition

- **IMPROVING IMAGE STRUCTURE** 76
- **LESS IS MORE** 89
- **PRACTICAL CAMERA TECHNIQUE** 109
- **DESIGN IN PHOTOGRAPHY** 113

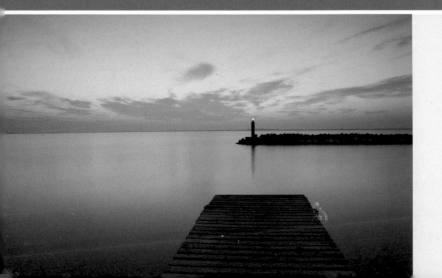

Dedication
For Barbara, Tina, Eva and Martin.

Chapter 3: Composing post camera

- **POST CAMERA TECHNIQUES** 120
- **A CREATIVE APPROACH** 123

Chapter 4: Taking a fresh look at composition

- **ALTERNATIVE APPROACHES** 134
- **COMPOSING FOR DISHARMONY** 143

CONCLUSION 155
ACKNOWLEDGMENTS 157
INDEX 158

Introduction.

'Composition' is a term used across a variety of art forms to describe the organization of elements to communicate thoughts and emotions. It might help to gain a deeper understanding of photographical composition by considering it within the context of other visual arts, as principles adopted by painters, architects and graphic designers can equally be applied to photography.

As a fledgling art form in the nineteenth century, photography specifically looked to the tradition of painting for guidance, a tradition where many of the so-called 'rules' were developed. Paradoxically, many contemporary photographers fail to look at what painters are doing today, which is a mistake as many lessons can be learned from their work. Furthermore, with the advent of Photoshop the overlap between graphic design and photography is remarkable; look at some of the current advanced Photoshop technique magazines and you will struggle to discern which is which. It is important to understand that photography should never operate in a vacuum and it helps to recognize that there are certain universal rules that apply to all areas of the visual arts.

Why do we compose our images? The conventional view of composition is that it is the action of juxtaposing various elements together in an aesthetically pleasing manner, but this rather assumes you are starting with a blank sheet of paper. Photography is slightly different insofar as the elements are already in position. As a photographer, our role is therefore to help the viewer understand what excited us when we took the photograph. This means that when you look through the viewfinder you need to select carefully to ensure that your visual statement is clearly communicated.

The main purpose for composing an image is to help the viewer empathize with what you witnessed at the time of shooting. For this reason, try to include only those elements that make a positive contribution to your intended visual statement. Clarity of intent is so very important.

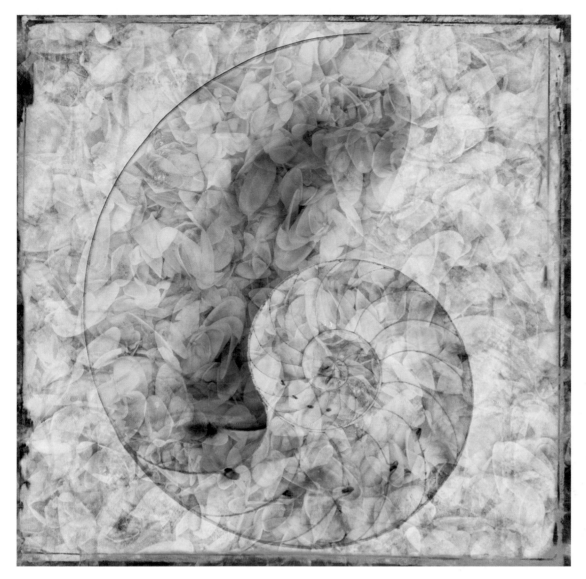

Once you have a sound understanding of composition, you will then have the confidence to experiment with new ways of developing your own personal style, confident that it will communicate effectively with others.

I find that visiting galleries or perhaps just looking at album covers proves a valuable source of inspiration; I constantly ask myself 'Why does this design work?' It also helps to look at photography that exists outside our normal comfort zone; for example, the advertising industry generates some of the most interesting images, as advertisers are so skilled at grabbing our attention while also evoking a mood.

It is sometimes suggested that there are implied sets of rules concerning composition; I think 'guidance' is a much better term and concept. It should also be noted that while certain principles work in some situations, they do not work in all. Possibly the best known principle is the rule of thirds, but to apply it to all or even most situations is to miss the point.

Composition is important and no matter how technically perfect, without it your image will lack clarity. 'Composition' means putting elements together, and while photographers do not enjoy the freedom to construct the image in the same way as a painter or a graphic designer, cohesion is still needed if images are to have meaning.

The aim is essentially to direct the viewer's eye to the parts of the image you consider important. You are also trying to communicate mood, and this can be achieved by orchestrating the visual elements. The more familiar you are with these, the easier it is to compose. By understanding the psychological effects of line, shape, form, tone, colour, texture, scale and proportion, you are able construct your images with purpose and clarity.

While I am urging you not to become obsessive about composition, it nevertheless remains the single most important photographic skill. Moreover, the more aware you become of how other photographers and artists structure their work, the more successful your own photography will become.

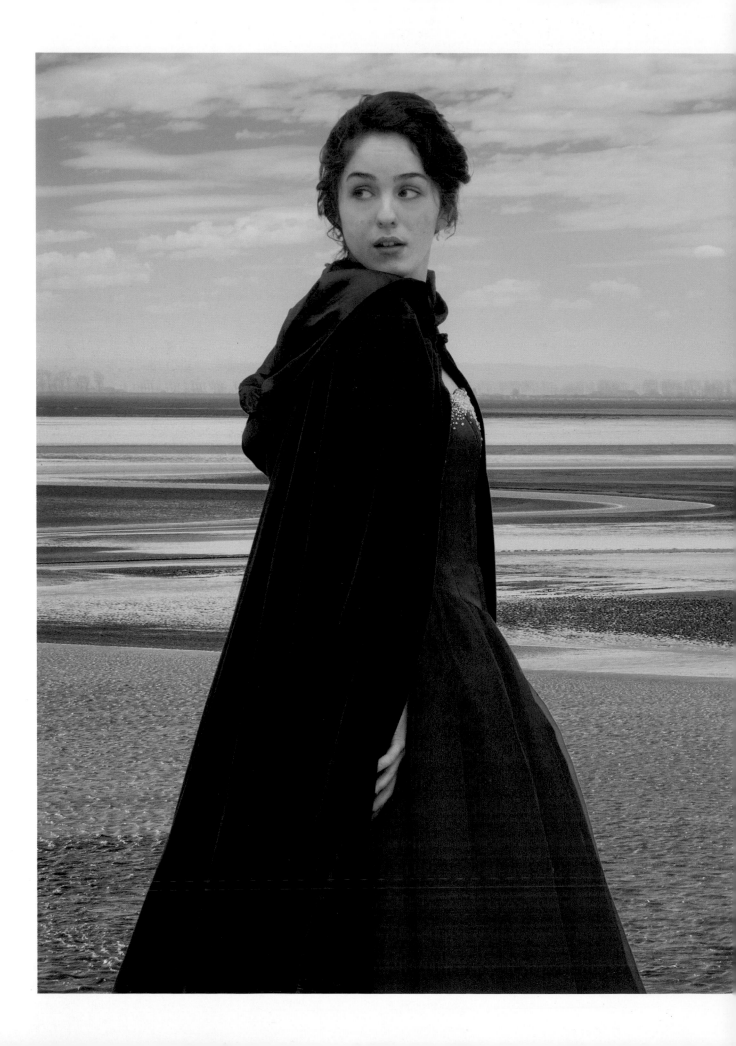

CHAPTER 1

Taking a conventional view of composition

In common with other aspects of the arts, photography has its own particular rules and conventions that have been developed over the centuries. No doubt reinforced by numerous magazine articles over the decades, most photographers have a good understanding of how to structure an image. While the principal purpose of this book is to expand that understanding, it does make sense to start with those aspects of composition that are commonly shared.

When I casually mentioned to a colleague that I was planning to write a book on composition, his immediate response was 'What more can you say about the rule of thirds?', the implication being that this was all you needed to know. In truth, this principle is slightly more complex than some might imagine. Many photographers are aware that the rule of thirds has been taken from a well established art principle named the Golden Section, although there are interesting variations of this. While many cameras now offer a Golden Section grid in the viewfinder, it also pays to be aware of the Golden Spiral and the Golden Triangle, which can be extremely useful variations of this important compositional principle.

The rule of thirds.

The rule of thirds stems from a much older painting tradition called the Golden Section, which is a simple principle, although its application can be complex and virtually impossible to apply to photography. It argues that in order to achieve the ideal proportion, one divides a line so that the proportion of the large section to the whole line is the same ratio as the small section to the large section. In essence, what that requires is placing a key component within the composition precisely 61.8 per cent along a specified co-ordinate. This can be achieved photographically if you are dealing with just one object, but as photographs often comprise numerous different features, organizing all of these within a framework is clearly impossible. This is where the rule of thirds kicks in. In this rule, the image is divided into thirds with two imaginary lines vertically and two lines horizontally to create three columns and three rows; in turn, this creates nine equal sections within the image. The key elements are then placed where these imaginary lines intersect.

Origins

The origins of the Golden Section and the rule of thirds derive from the observation of natural phenomena, an example of man trying to understand the laws of nature and appropriate them for design. Using these proportions the Ancient Egyptians were able to construct the pyramids, while the Ancient Greeks used them to create a sense of balance when building their temples. Of more significance to photography, the artists of the Renaissance used the Golden Section as a means of composition, Leonardo Da Vinci's *The Last Supper* possibly being the finest example of the Golden Section in use. A particularly interesting application of the Golden Section can often be seen in the design of Japanese sand gardens, making it truly a universal principle.

The reason why photography should want to adopt such guidelines was wholly understandable. As photography emerged as a valid art form in the nineteenth century, it naturally looked for guidance and painting offered the ideal role model. While the principles of the Golden Section date back to the Ancient Greeks, many worthy modern artists have developed illuminating examples of work based upon these principles. Possibly the most famous of these artists is Piet Mondrian whose beautifully crafted iconic abstracts are known the world over, although one needs to appreciate that the formal considerations he applied were numerous and virtually impossible to apply to photography.

Skill apart, it is not too difficult for a painter to depict a figure in the foreground, a building in the background, and a tree in the middle distance on a predetermined classically designed grid. As a photographer is unable to manipulate image components in this way, the answer it seems is to concentrate on just a single element, or to greatly simplify the image – yet this is not always an option.

So where does that leave us regarding the rule of thirds? While it is a useful strategy for constructing an image, it does have its limitations:

• It is drawn from a time honoured painting principle that is designed to achieve a sense of absolute balance, yet not all images will benefit from this. If you want to introduce pathos into your work, it is not the best compositional guideline to use.

• The rule of thirds can be very easily applied when there is one obvious focal point; if there are several, you will need to consider other compositional strategies.

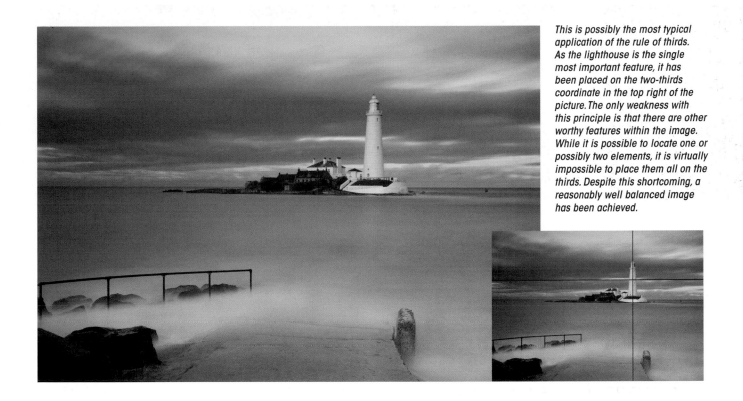

This is possibly the most typical application of the rule of thirds. As the lighthouse is the single most important feature, it has been placed on the two-thirds coordinate in the top right of the picture. The only weakness with this principle is that there are other worthy features within the image. While it is possible to locate one or possibly two elements, it is virtually impossible to place them all on the thirds. Despite this shortcoming, a reasonably well balanced image has been achieved.

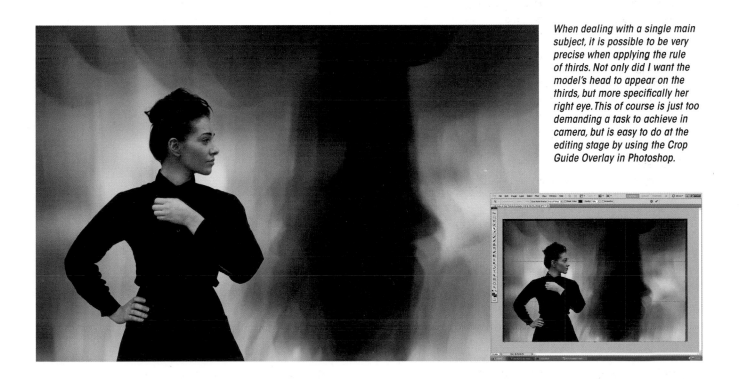

When dealing with a single main subject, it is possible to be very precise when applying the rule of thirds. Not only did I want the model's head to appear on the thirds, but more specifically her right eye. This of course is just too demanding a task to achieve in camera, but is easy to do at the editing stage by using the Crop Guide Overlay in Photoshop.

Colour and tone

It is often assumed that the rule of thirds is used only to position constituent elements, but it can be far more comprehensively applied. While many photographers give thought to proportion and visual weight, some are less aware that the balance of both tone and colour are equally important. While the principle purpose of the rule of thirds is to establish a grid for placing the key elements, it also divides the composition into proportioned zones.

This can apply to zones of colour: clearly, it may not be desirable to have two equal blocks of contrasting colour, yet if the colours are proportioned relative to the Golden Section and the rule of thirds, then a more balanced composition will be created (see colour block diagram). As an example, the area of red should only occupy ⅜ of the area occupied by blue, while the yellow should occupy ⅜ of the red. The same principle applies to areas of tone (see monochrome block diagram).

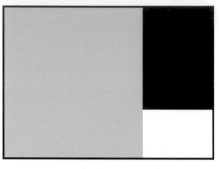

The rule of thirds can also be used to divide the image into proportioned zones. This can apply to colour or tones.

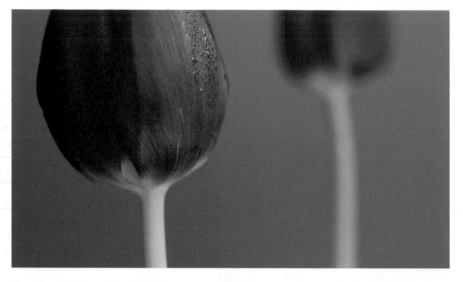

The rule of thirds should not only determine where the key elements are placed, but also govern the relative distribution of colour. Using the primary colours of blue, red and yellow, each is applied in decreasing amounts, so that the red areas occupy just a third of the blue, while the yellow occupies just a third of the red.

The rule of thirds can be very simply applied. While the horizon in this landscape does not conform to this rule, the main focus of attention (the copse of trees) does. In this way a pleasing, asymmetrical balance is achieved.

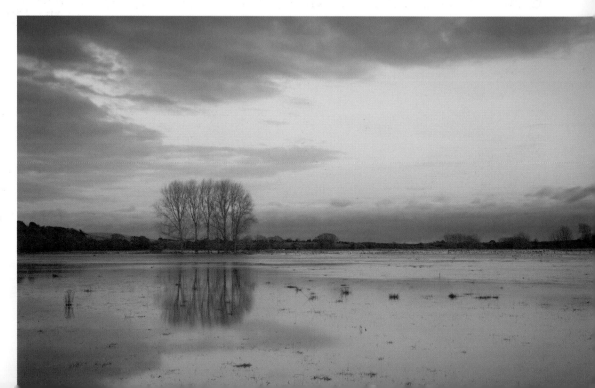

The Golden Spiral.

A rather interesting application of the Golden Section is a principle known as the Golden Ratio or the Golden Spiral. Diagrammatically this resembles a shell (see diagram) whose structure is expressed through a series of diminishing squares. If the two smallest squares have a width and height of 1, then the next biggest square measures 2; the subsequent boxes increase in size by 3, 5, 8 and 13. The spiral effect that these ratios create is both interesting and aesthetically pleasing. Moreover, by constructing your photograph so that the focal point coincides with the smallest square, your image will immediately appear both harmonious and balanced.

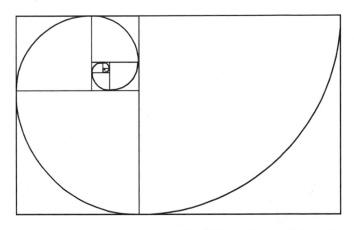

The Golden Ratio is most eloquently exemplified in the structure of spiralling shells and has proven to be a fundamental design principle underlying all aspects of the visual arts. If the two smallest squares have a width and height of 1, then the next biggest square measures 2; the subsequent boxes increase in size by 3, 5, 8 and 13. These are known as the Fibonacci numbers after the mathematician who discovered this unique set of ratios.

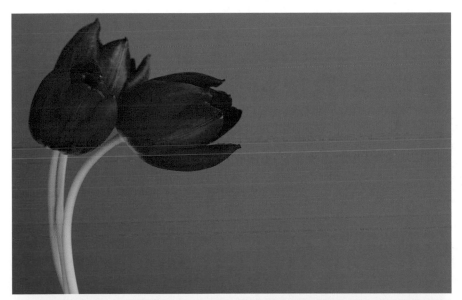

Producing an image that precisely conforms to the Golden Ratio would prove very challenging as it requires mathematical precision, but merely being aware of its structure should help you create a balanced and harmonious image. In this example the curvature of the stems on the left of the image draws the eye to the red flower heads.

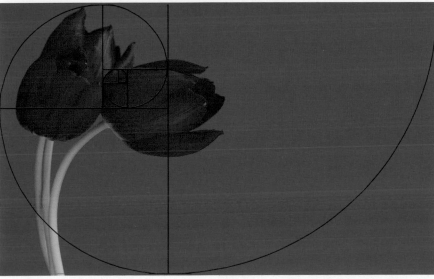

This unique set of ratios is known as the Fibonacci numbers after the mathematician who discovered it, and what makes Fibonacci's numbers so interesting is that they often appear in nature. A variety of natural forms appear to comply with this sequence, including pine cones, the seed distribution in the head of a sunflower, a pineapple, a cauliflower and of course shells. The spiral provides us with a wonderful template to work from with a complexity and beauty that is both challenging and remarkable.

From a photographic standpoint examining other less obvious spirals in nature would be a good starting point, but it is also quite noticeable how often the spiral has inspired numerous other visual artists, most notably architects. Not only are many modern constructions based upon the spiral, but also so much architectural detail. The spiral is a fundamental design that inspires both beauty and interest.

Points to consider:

• The Golden Spiral is another method for creating an image that is both harmonious and balanced.

• The spiral appears in countless examples in nature, it is a fundamental principle of design and is a source of inspiration for both artists and photographers alike.

• It is quite remarkable how often the spiral features in our doodles, suggesting that it is a deep-seated design schema shared by us all.

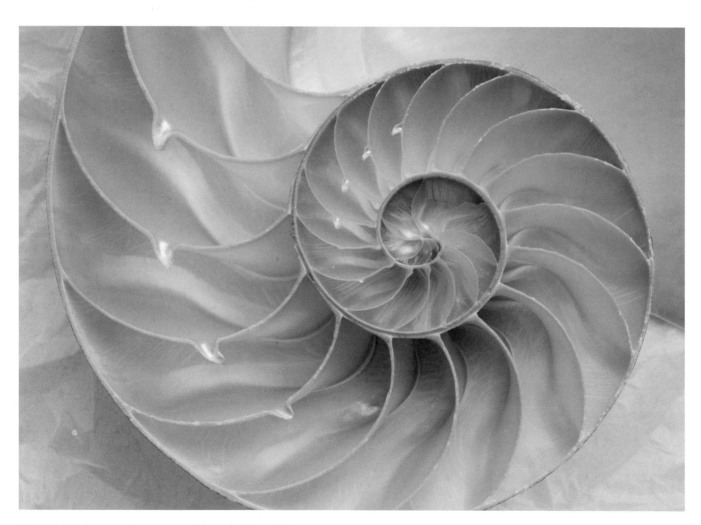

The Golden Ratio appears in many natural forms, but is possibly most clearly evident in the structure of a nautilus shell.

The Golden Triangle.

Finally, in the quest for a perfectly balanced photograph another application you may wish to consider is the Golden Triangle, which tends to work best with images featuring strong diagonal lines. Once again it does help if you are able to visualize the structure before taking your shot (see overlay). Imagine the frame divided by a diagonal line that creates two equal triangles and then create a further triangle from one of the remaining corners. In this way you are able to create three equi-angular triangles that might be different in size, but which reveal the same shape and angles. This format can be used to either subdivide the image into three distinct zones, or it can be used to emphasize an important focal point by situating it within the intersection of the three triangles. It is called the

Golden Triangle because it applies the same ratio as the Golden Section – in fact, if you were to apply the latter rather than the Golden Triangle the outcome would be virtually the same. It is just more easily applied to certain situations.

Points to consider:

• The Golden triangle is best applied when the image comprises strong diagonal lines.

• The principle is very similar to the Golden Section, except that an imagined grid comprising diagonal, rather than horizontal and vertical lines, is applied.

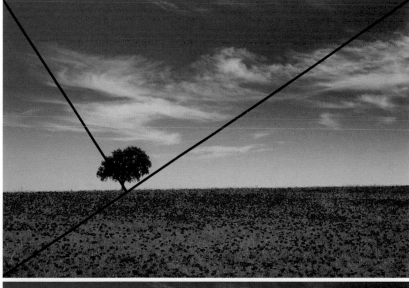

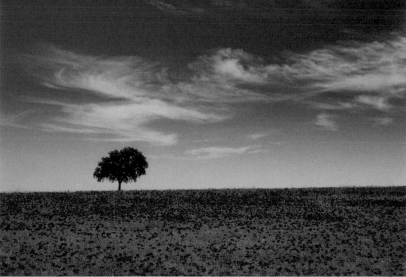

The Golden Triangle is an excellent alternative to the Golden Section. In this example, the lone tree is the obvious focal point. By placing it within the intersection of the three triangles, an immediate sense of balance is created.

This subject can be approached in two ways. First, a sense of clarity is introduced by identifying the shapes between key features within an image. Second and equally important, there is a tradition in art and design that seeks to diminish depth so that the image is presented as a sequence of shapes, an approach that has proven to be an inspiration to countless photographers.

Identifying shapes.

From a compositional standpoint the identification of shapes is important, as it helps us to construct our images. For example, if you are photographing three quite disparate individuals walking on a beach and if their relative positions form an obvious triangle, the opportunity for identifying a design is made much easier. There are numerous shapes you can explore, but for the sake of simplicity using the triangle, the rectangle or the circle offers the greatest clarity.

To make an object appear to be real it needs to appear three-dimensional, but is that what you always want? It is possibly helpful at this stage to distinguish shape from form. A shape is two-dimensional, while form suggests depth and volume; for example, while a triangle is a shape, a pyramid or a cone is a form. By considering the angles and with the careful use of light, three-dimensional objects can be made to appear two-dimensional: for example, the common house brick is demonstrably three-dimensional, but if seen from above it appears flat and patterned.

This introduces the viewer to a new way of seeing, although there is a precedent for this in art. At the end of the nineteenth century, influenced

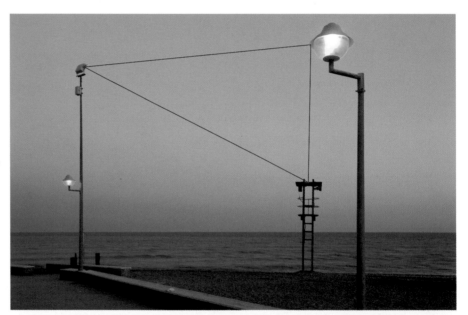

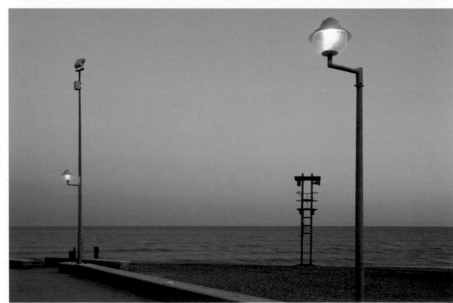

The three uprights in this simple composition have been organized so that the tops of each create a simple triangle. When organizing various disparate objects within a composition, it helps to have a simple shape in mind.

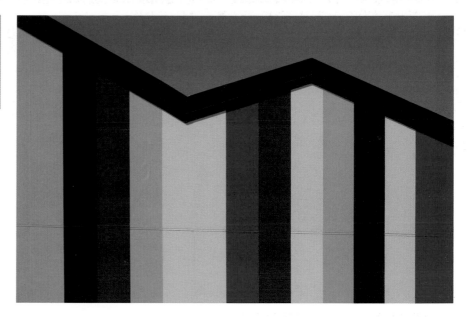

by prints they saw from the Far East, many of the post impressionist painters deliberately diminished the elements of form and perspective from their work; the results were both interesting and beautiful. By reducing your photographs to just shapes a similar process of simplification will occur that will introduce an enigmatic quality to your work. When reducing the image down to simple shapes, ensure that they positively interact; issues such as balance and contrast become especially important.

Look around and you will constantly identify simple shapes, particularly in the built environment. They often appear quite geometric, providing simple motifs.

By using flat light, one immediately becomes aware of the rich interplay of shapes; in this example, even the shadows appear as shapes.

Balance and counterbalance.

One of the reasons why the rule of thirds remains popular is that it is so easy to apply, particularly if you want to feature just a single focal point. However matters become a little more challenging when you want to introduce various elements to your composition, each with varying visual weights. In this case, you will need to balance and counterbalance them.

Establishing a sense of equilibrium is essential to good design; we achieve this by balancing the various opposing forces within the composition, which results in either a symmetrical or an asymmetrical composition. Symmetrical balance is when there appears to be equal weight on either side of an imagined central meridian or fulcrum. Of particular interest to us here is asymmetrical balance, which involves placing key elements of varying visual weight around a perceived fulcrum.

The easiest way to understand this is to imagine two children on either side of a seesaw. When each child is suspended in mid-air they are of course in perfect balance, although visually this might not appear interesting. There are numerous other permutations that will still suggest order:

when one child is on the ground and the other in the air balance is retained. Where this gets interesting is when you have two children on one side of the seesaw, but only one on the other. As you are all aware, equilibrium can only be achieved if the two children move inwards.

The position of the fulcrum will also have a bearing. While we normally imagine it being in the middle, it can just as easily be moved to either side, which can bring a fresh dynamic to the composition. If I am allowed just one further analogy, think of a set of scales: a small, substantially heavy object can be easily offset by a larger, lighter one. The same principle applies to composition, and as photographers it is essential that we appreciate the visual weight of each element within a picture.

While I have been keen to promote asymmetrical balance in both my analogies, it is also possible to produce exciting images that are symmetrically balanced; this tends to work best when you are dealing with complex compositions. The whole process of composition requires that you consider all the elements and carefully organize the image so that every feature is in equilibrium.

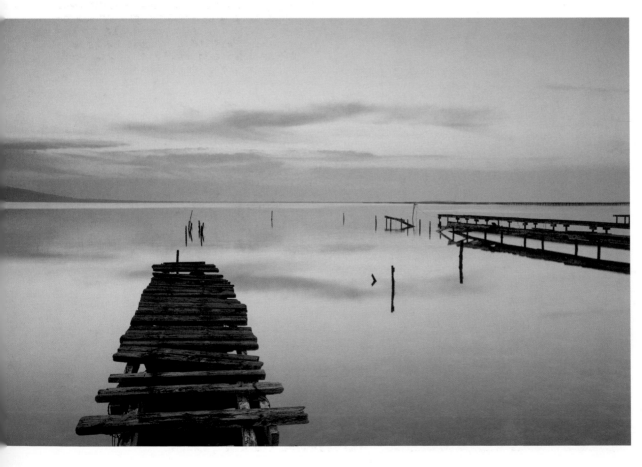

Balance and counterbalance is an important but often overlooked aspect of composition, as is of particular importance when dealing with a simple cluster of elements. In this example, while the pier on the left is counterbalanced by the one on the right, even the apparent randomness of the broken posts adds to the overall sense of design.

Measuring balance.

Composition is largely an intuitive process and never more so than when you are aiming to balance one element against another. Finding this balance is however much easier to do than you might imagine. As a simple example, when fixing a picture to a wall you instinctively decide where it should go in relation to other objects within the room; you move it until your inner eye tells you that you have found the perfect position. It is much the same process with compositional balance in photography.

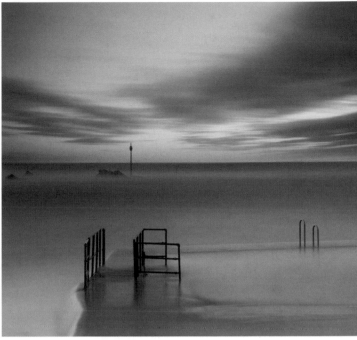

A long exposure of a lido photographed late in the evening: the natural inclination is to set one of these features on the thirds, but which one? Oddly, they all assume an importance within the composition. The largest and possibly the most dominant are the two guardrail structures in the bottom left; these are countered by the handrails in the bottom right and the lone post in the background. Without this post, the image would have lost its balance – think of the seesaw analogy. The other advantage of featuring all three elements is that the eye is encouraged to start in the bottom left of the picture, moving to the right and then up to the post at the top of the picture.

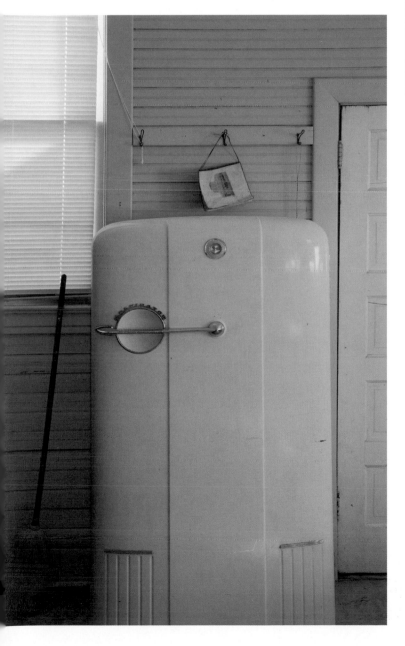

Objects tend to be randomly positioned, and the skill of the photographer is to see some semblance of order. In this example, the refrigerator serves as a fulcrum for the remaining objects, so that the broom in the bottom left is balanced by the dangling notepad, while the white door is countered by the blinds.

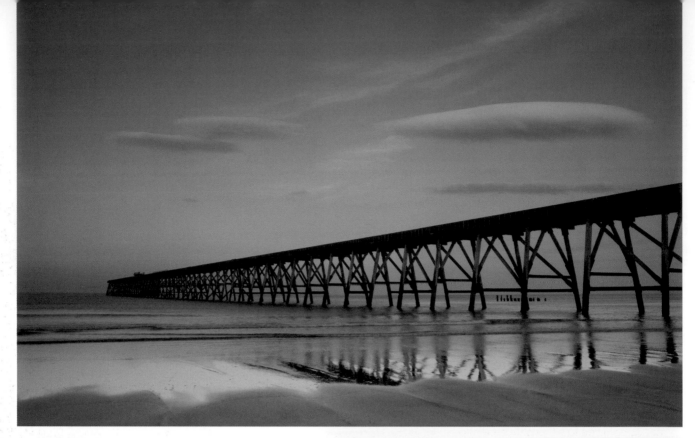

The pier is clearly the dominant subject, however the reflection in the foreground coupled with the clouds in the sky helps to restore balance and retain interest. Without all three elements, the sense of balance would have been lost.

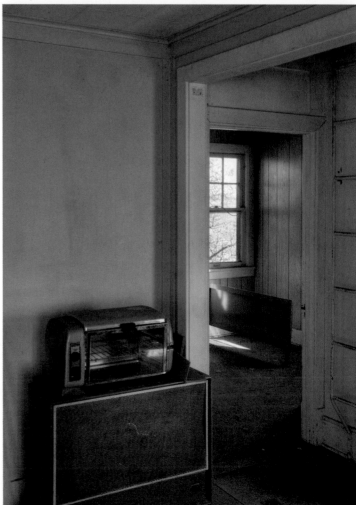

While investigating this abandoned property, my aim was to balance the toaster in the foreground with the open window. I was aware that this image comprises largely orange and blue colours, and while the cool hues of the toaster are surrounded by warm orange, the warmer tones of the window are encircled by cool blue. The interplay between these two complementary colours also contributes to a sense of unity and balance.

Dominant and subordinate.

Some images are successful because they conform to a rigidly balanced design, while others achieve a satisfactory asymmetrical balance that relies on the relative weight of the main features. An interesting further application of the balance/counterbalance principle is to introduce a dominant and a subordinate feature; when using this principle, the placement of the two elements will prove fundamental to the success of the composition.

If I may use the seesaw analogy again: the position of the fulcrum will also have a bearing. While we normally imagine it being in the middle, it can just as easily be to either side, so that a smaller weight can counter a heavier one. Establishing rules for this type of composition is difficult as there are so many variables. To be successful, analyse the key elements within the frame, assess their relative weight, and compose accordingly.

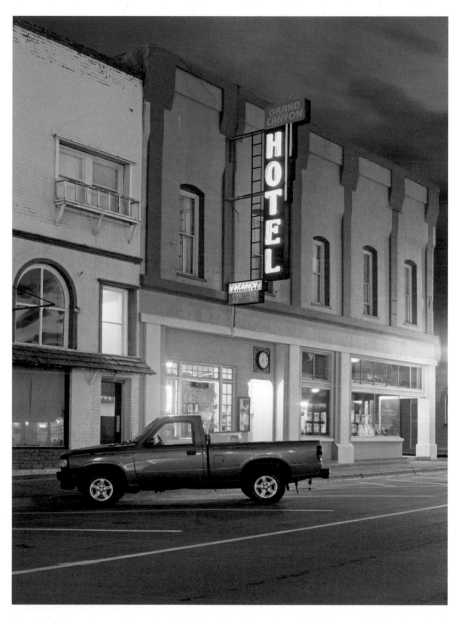

There are two very strong elements within this composition: the parked pick-up truck in the bottom of the picture and the illuminated 'Hotel' sign. While the pick-up is larger, it is effectively balanced by the sign as the latter represents the area of greatest contrast. The design is also strengthened because the sign appears at right angles to the vehicle.

Tip

Balancing the dominant and subordinate elements is best done intuitively.

The visual fulcrum.

While discussing balance (see Balance and counterbalance and Dominant and subordinate), I suggested that you structure the image components around an imagined fulcrum; occasionally, there will be a specific identifiable element that serves the purpose of a visual fulcrum. Often it is a seemingly insignificant feature, yet somehow the image would appear weaker without it. When constructing an image that requires you to balance out several disparate elements it certainly helps to identify a visual fulcrum, no matter how minor it may seem.

Tip

Try not to position the visual fulcrum too centrally.

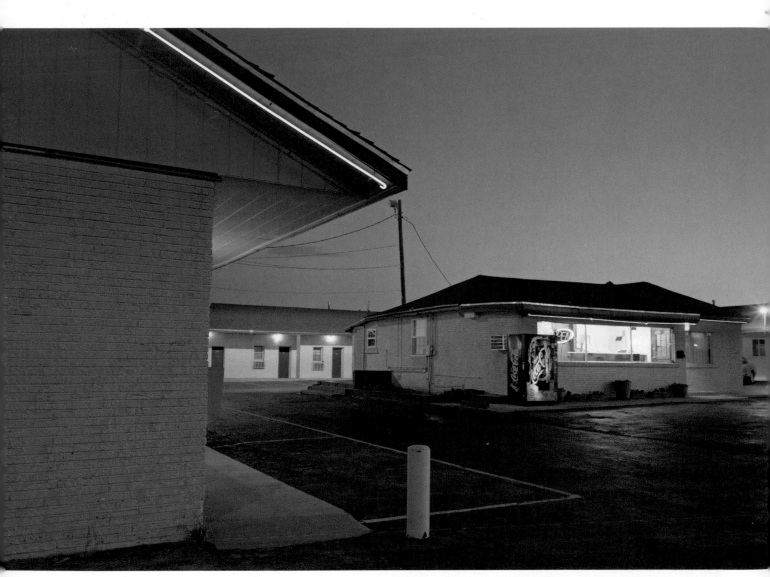

(Photographer: Eva Worobiec) Everything seems to revolve around the beige post in the foreground, which serves as a symmetrical visual fulcrum. To the left of it you have the garishly illuminated gable end, while on the right are a collection of smaller buildings; essentially the gable end is countered by the group of buildings to the right which the post serves to highlight. While the fulcrum is clearly evident, it is subtly counterbalanced by the Coca Cola machine; the white markings on the tarmac also help to give it more prominence.

Composing from one corner.

Many photographers overlook the possibility of composing their image from a single corner, but occasionally the results can be quite spectacular. Two things need to happen for this to work well: first, you need to focus on a single dominant feature and second, all the other elements within the image should serve to support it. Images constructed in this way are likely to appear unconventional and minimalist, but that should not deter you from having a go. When composing, get into the habit of scanning the edge of the frame and be prepared to consider any possibility.

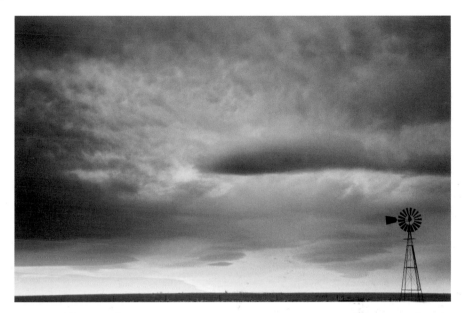

This is unquestionably a minimalist landscape, with the windmill in the bottom left corner as the only feature of note. While it appears small in the frame, it nevertheless assumes great importance. The essential additional ingredient here is the sky: with the cloud appearing to emanate from the bottom right corner, the significance of the windmill becomes more apparent.

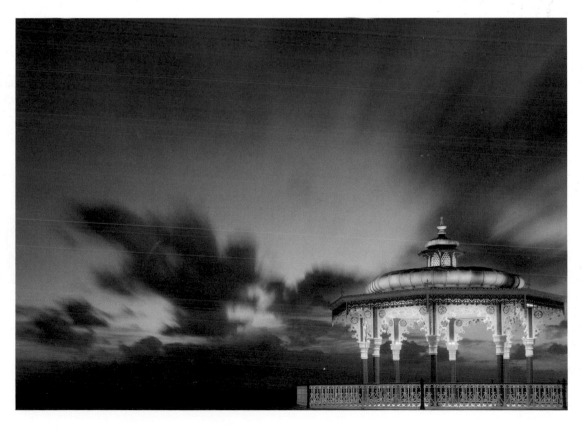

There are two obvious elements in this image – the illuminated grandstand and the evening sky. Placing the structure either in the centre of the image, or possibly on the thirds, would have obscured a truly dramatic sky. Yet because the contrast between the two elements is so apparent, I am able to position it in one of either of the two corners and still retain a sense of balance.

Composing from opposite corners.

Often when we identify an exciting feature, we aim to counterbalance it with something of equal weight. If the two elements are considerably set apart this might not be easy to do, but by placing them in opposite corners of the image a rather fascinating tension is introduced. This is particularly evident if each feature is placed in diametrically opposite corners; rather interestingly, the central part of the image becomes negative space. By organizing the composition in this way, you are encouraging the viewer to assess each element in turn.

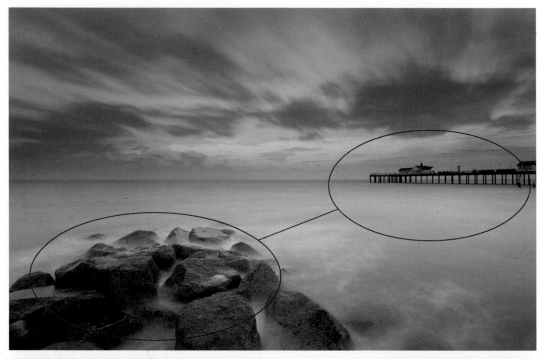

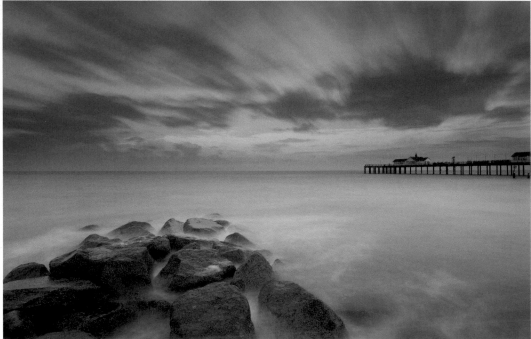

My attention was drawn to this elegant pier, but set against a large expanse of sea and sky it did appear rather inconsequential. By moving to the left I was able to use a group of rocks as a counterbalance, and by deliberately selecting a slow shutter speed the textural detail in the sea was diminished, serving to focus the viewer's attention onto the rocks and the pier.

Approaching the multifaceted design.

When faced with the conflicting visual shapes and forms that comprise a multifaceted design, it sometimes helps to use several compositional strategies within a single image. Just because you cannot immediately identify a design should not discourage you from taking the shot. Composition is in part intuitive so the more aware you are, the faster you will be able to respond to a demanding situation.

When dealing with a complex composition of components, you do need to ask yourself certain important questions:

• **What are you trying to say in the picture?** To find the answer to this question, it can often help to identify the features that relate to one another.

• **Which are the key elements that need to be highlighted?** When dealing with a single focal point this is relatively easy to establish, but proves a little more challenging when there appear to be several. How you organize these in relation to one another will be crucial to the success of the image.

• **How are the other elements within the composition supporting the key areas?** When composing a complex image, nothing should appear redundant. If you sense that parts of what you see through the viewfinder are superfluous, change your viewpoint.

• **Do the elements within the composition relate?** Often in difficult compositions, certain elements pair off. For example, when photographing a street scene you might identify a figure standing in an important part of the picture; waiting for another figure to appear in a corresponding part of the image will introduce that much needed sense of balance.

Tip

When photographing a complicated situation, if you sense that it looks right – even if you cannot immediately identify why – then most likely it is right.

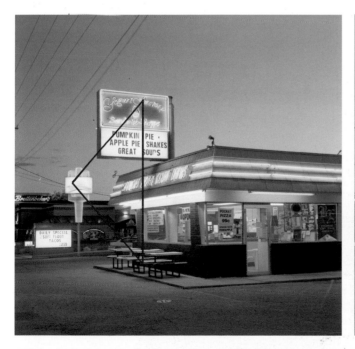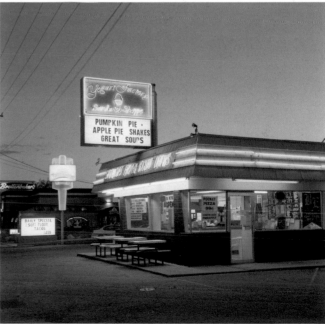

While on first glance this appears to be quite a simple picture, there is actually quite a lot going on. Although the large kiosk on the right is the dominant feature, this appears to be countered by the triangle created by the 'Yogurt Factory' sign, the green upright in the background and the benches in front of the kiosk. The telegraph wires are interesting as they serve both as an informal frame and also encourage the viewer to re-examine the picture.

Do not be discouraged from designing complicated images. While there is a role for simplicity, don't ignore the opportunity to produce something more visually challenging. For example, while you may well have identified a dominant and subordinate feature, there may be other interesting elements occurring from diametrically opposite corners. Providing you feel that all the included features make a positive contribution, your composition will be successful.

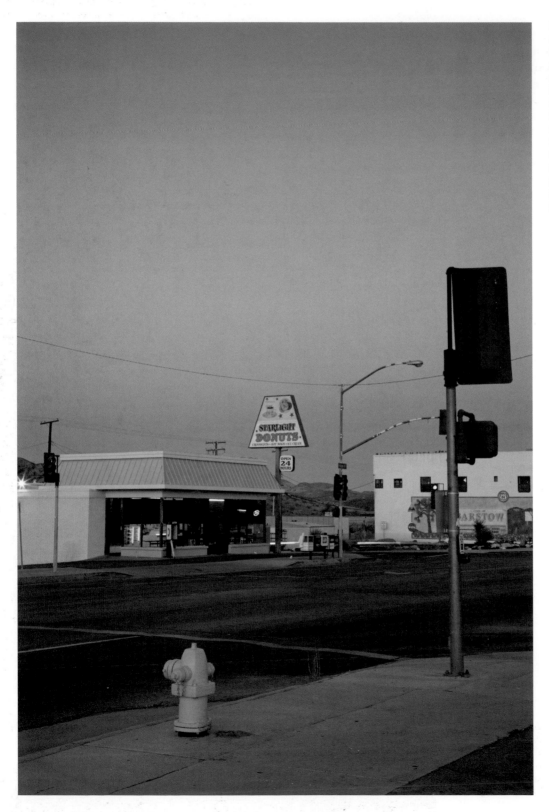

Text instantly draws the eye, so the 'Starlight Donuts' sign takes centre stage; it also serves as a fulcrum for a sequence of related features. The yellow kiosk adjacent to the sign is countered by the dark upright on the right of the picture, while the yellow hydrant in the foreground is paired off with the lamp post to the right of the sign. Interestingly, these four elements create an informal X.

Positive and negative shapes.

The relationship between the background and foreground is fundamental to composition, especially the shapes that are created between; this is particularly evident when photographing an uncomplicated motif set against a simple background. At this stage it helps to think of the subject being photographed as the positive shape, while the background it is set against is the negative shape. How these positive and negative shapes interrelate will ultimately determine the success of the composition.

Scientists in Germany conducted an interesting area of research at the beginning of the twentieth century into the notion of how we perceive. They formulated the Gestalt Theory, which argues that in order to achieve visual equilibrium you need to pay equal attention to the background of an image, as it is the interplay of positive and negative shapes that helps to create balance.

By giving thought to the shapes created by the background, a composition will appear more interesting. This approach often requires producing a tightly cropped image in which parts of the subject extend out to the edges. As a simple case in point, if you photograph a portrait with the entire figure in frame, then the image appears predictable and unexciting. Instead, if you crop part of the image so that the top of the head disappears, we view the figure afresh as the shape(s) in the background now play an active part.

When looking at this little pictogram, do you see a white goblet or the profile of two faces looking inwards? This amusing visual enigma graphically illustrates how we each respond to positive and negative shapes.

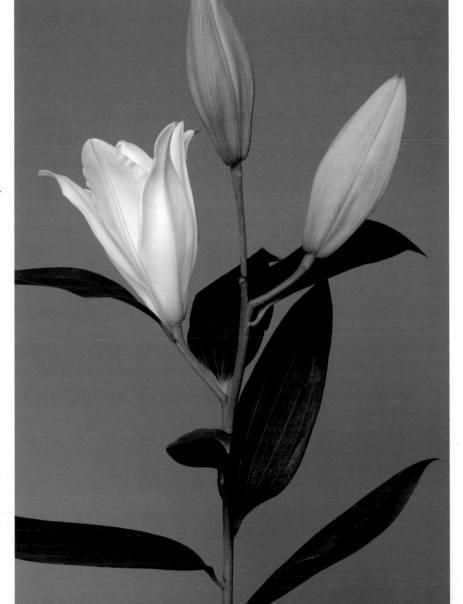

Tip

To effectively shoot a simple motif, look firstly at the negative shapes.

By composing this flower tightly so that parts of it extend out to the edge of the frame, the viewer becomes more aware of the shapes created by the green background. In order to create an interesting design, consider the interplay between the subject and the background.

Line is one of the most fundamental elements of design. As children it was probably the first one of which we were aware and as adults, we frequently employ simple line drawings when developing ideas. In photography, line plays an important role as a means of directing the eye to a specific part of the image, but as a discrete visual element it can also be used as the subject in its own right.

The line in composition.

Line can be extraordinarily expressive and it appears in many traditional art forms; in Europe we have long admired the beauty of Japanese prints for their lyrical use of line. As a visual element, line can vary considerably: we celebrate the lyrical, the curvilinear or the arabesque. Line can be soft or hard, straight or wavy, jagged or irregular; yet whatever its quality, it can add great interest to a picture.

When constructing simple compositions always remain aware of the background. While a lightly toned line will appear dramatic when set against a dark background and vice versa, subtle effects can be achieved when using a line and background of similar tonal values. The direction of the line is another important consideration: a sequence of parallel vertical lines suggests height and grandeur, while irregular vertical lines can often introduce a compelling and energetic rhythm. By way of contrast, a horizontal line has a calming effect – think of the horizon by the coast. Possibly the most forceful is the diagonal line, which introduces a sense of dynamism and energy: using it two-dimensionally can dramatically divide the image, while using it three-dimensionally will increase the sense of depth.

Line is so varied that it can become the subject in its own right. Whether you are shooting a landscape, constructing a still life or photographing an interior, there will be countless opportunities for developing a theme featuring lines.

Tip

Interesting line compositions can be found in many abstract motifs.

Line can often be used as a subject in its own right: a close-up of this derelict neon sign is a simple example. As only a very small part has been selected, the viewer is made aware of the strong white lines and the interesting abstract patterns they form, while the shadow introduces another much darker layer. If you are prepared to look you will identify numerous opportunities for producing exciting compositions of line.

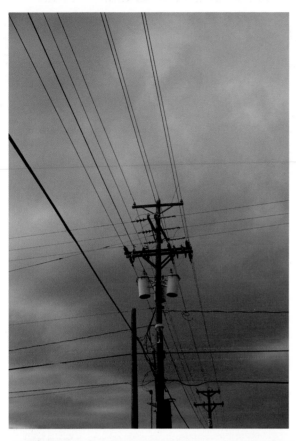

The opportunities for photographing line are all around us, although it is easy to overlook the familiar. In this example, a powerful sense of dynamism has been introduced through the diagonal orientation of many of the lines.

Lenses with a long focal length are ideal for capturing simple graphic images such as this, where oyster nets and their shadows have produced an interesting linear pattern. The lines in this example reveal a calligraphic quality not dissimilar to someone's signature.

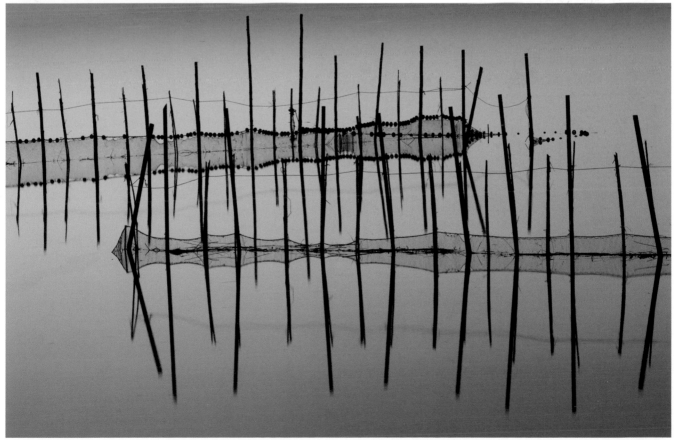

Using a lead-in line to create perspective.

Perspective creates the illusion that objects decrease in size the further they are from the camera, and using perspective is the single most effective way of creating depth in an image. Moreover, it becomes considerably more apparent when using a wide-angle lens; by way of contrast, lenses with long focal lengths tend to reduce the illusion of perspective.

It is almost impossible to exclude perspective when taking a photograph, although sometimes there are good aesthetic reasons for doing so. From a compositional standpoint, being able to control the effects of perspective clearly has its advantages. By manipulating perspective in order to heighten or suppress the illusion of depth you are able to control the sense of scale throughout the image.

As objects disappear into the distance, they appear to incrementally diminish in size; moreover, as lines or planes appear further in the distance, they appear to converge – these effects are known as linear perspective. When controlling linear perspective, issues that will prove important are the distance between you and the object you are photographing, and the focal length of the lens. By altering the focal length of the lens you are able to control the linear perspective in the image, which offers you some control over the apparent depth.

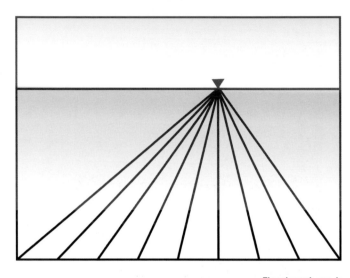

The viewer's eye is positively directed toward a single feature on the horizon because the lines in the foreground appear to converge on it.

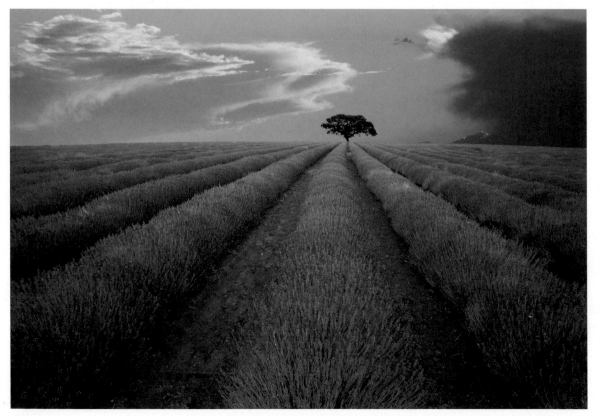

The patterns created by these lines of lavender have proven particularly useful for drawing the eye to the lone tree on the horizon. When taking this shot, it was a matter of walking along the rows of lavender until I reached a point where the effects of perspective were most apparent.

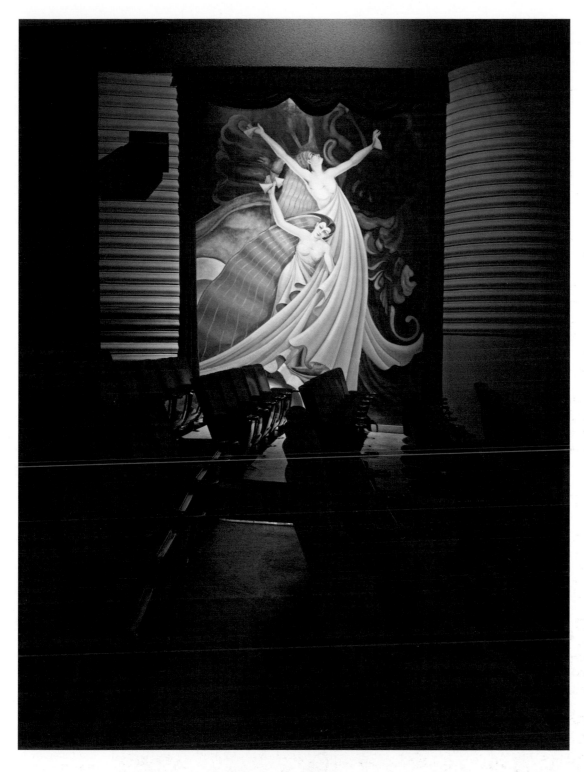

While photographing the interior of this impressive cinema, my eye was drawn to this beautifully illuminated mural. The gentle curve created by the rows of seats offers a subtle, yet effective lead-in line.

Developing this idea of linear perspective, many photographers use what is commonly known as the lead-in line to draw the viewer's attention to an important part of the image. The lead-in line can take several forms:

• The direct line. Use a feature such as a fence, a straight road or a line of telegraph poles to lead the eye directly to the area of interest. While this may not be particularly subtle it rarely fails to work, particularly when using a wide-angle lens.

• **The curving line.** From an aesthetic viewpoint, this is possibly one of the most appealing techniques. If you are able to construct your image so that the curving line starts from one of the bottom corners, you will be rewarded with a particularly strong composition.

• **The wandering line.** From a compositional standpoint, a more interesting strategy is to use a line that appears to meander towards the main focal point; the aim of this is to lead the eye through other equally interesting parts of the image. This is a technique that is often used when photographing landscapes where, for example, the viewer is encouraged to follow a line of flowers in a field, a ramshackle fence, or a stream.

• **The implied line.** Sometimes one identifies a line that appears to lead towards the main focal point, but then disappears, inviting the viewer to imagine the rest. Once again this can prove interesting as the implied line serves as a natural foil to the main feature.

• **The disappearing line.** Occasionally, the line will disappear out of frame, but it nevertheless serves the purpose of directing the viewer's eye towards the general area of interest. For this to work effectively what remains of the line needs to positively direct the eye, otherwise it could prove a distraction.

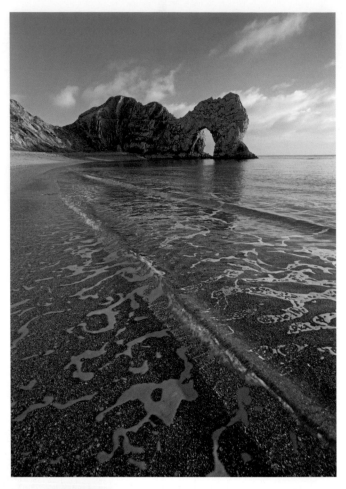

The obvious focal point is the natural arch, but to make best use of the foreground I used the lines created by the gently lapping waves to direct the eye. If you are able to construct your image so that the curving line begins from one of the bottom corners, the composition will appear particularly strong.

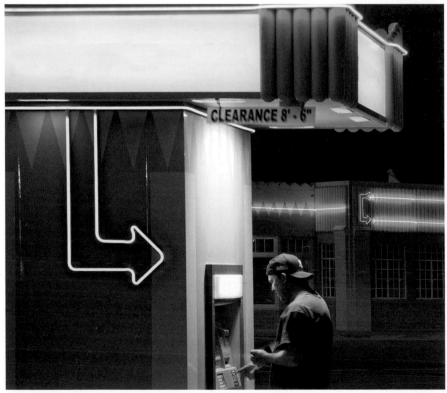

(Photographer: Eva Worobiec) Sometimes the lead-in line needs not to be blatant. In this example, the illuminated arrow on the left serves to highlight the figure standing at the cash machine.

The power of the diagonal line.

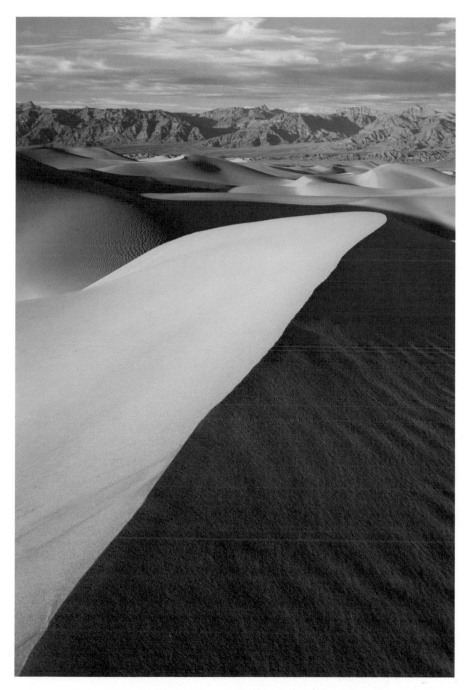

Emanating from the bottom left corner, the powerful diagonal directs the viewer's eye to the undulating dunes and the range of mountains in the far distance. In this way, the sense of depth is greatly increased. This effect is usually best achieved when using a wide-angle lens.

The diagonal line is possibly the most effective device to lead the eye into a picture, which is why it is a technique favoured by so many photographers, and looks most effective when appearing to extend from a single corner. As we in the West are accustomed to reading from left to right, we tend to be more comfortable when viewing a diagonal from the left corner to the right. If however you wish to introduce edginess into your image, you might consider reversing this.

When introducing a diagonal line to a composition, don't be half-hearted. Visual gestures such as this need to be demonstrable otherwise they could appear to be a mistake. On a similar tack, try to ensure that you do not use too many diagonal lines: unless they are all flowing in the same direction (for example, in a ploughed field), they could appear confusing to the viewer.

Tip

Try to ensure that you do not use too many diagonal lines unless they all flow in the same direction, otherwise they could appear to be confusing.

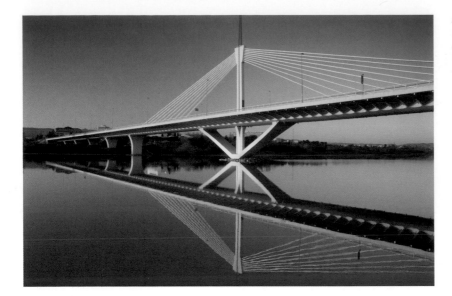

It is often assumed that a diagonal line needs to lead the eye directly to a specific focal point, but this is not always the case. In this example, the diagonal flow of the bridge and the reflection it creates becomes the subject in its own right.

There are four typical uses of the diagonal line in composition:

1 Objects are positioned along a diagonal line; in a landscape context this could be a line of trees, for example. The result can appear to be quite two-dimensional, pattern-like and lacking in depth, particularly if viewed from a high vantage point, and can have the effect of dividing the image into two interesting portions. This type of diagonal line is usually best achieved using a lens with a long focal length.

2 Possibly the most popular use of the diagonal line is to exaggerate the sense of perspective and increase depth; it is most effectively done using a wide-angle lens.

3 Particularly interesting designs can be created by using a diagonal line to intersect other lines. By ensuring that the area or areas of interest are located close to these intersections, a measure of clarity is introduced to the composition that results from this.

4 One can often identify interesting patterns created by a sequence of strong diagonal lines, which can become a subject in its own right. This could be a detail of architecture or a contrived still life, in which the flow of the design works diagonally to enhance the composition.

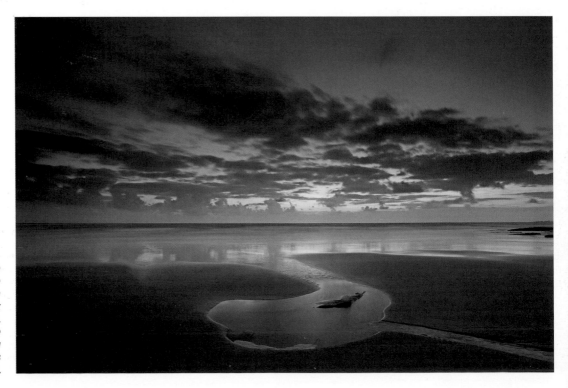

Even a short diagonal line can greatly improve the composition. My attention was drawn to the rock pool in the foreground, and the diagonal line created by the flowing stream on the right directs the eye to it.

The aesthetic of the meandering line.

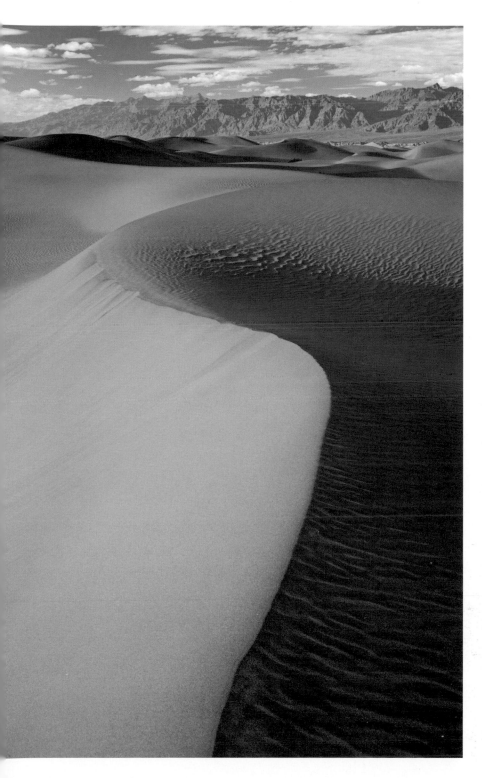

While lead-in and diagonal lines are relatively common features in photography, identifying a meandering or S-shaped line is more challenging. However, it is one of the most aesthetically pleasing compositional principles you can apply. The easiest way to imagine such a line is to think of a river flowing through the composition; if you are able to identify one, make sure that it positively leads the eye to the main focal point.

Creating an S shape is one of the best methods for creating a sense of depth, which is why it is so valued by photographers. Often photographers use a telephoto lens to exaggerate the effect of the meandering line, as it compresses the apparent distance between each curve. While the line might appear quite dominant in the foreground, this will attenuate back through the picture. Furthermore, starting the flow of the line from either of the two bottom corners will greatly add to the aesthetic appeal.

The S-shaped line can really add aesthetic appeal to an image. This shot was taken at the same time as the dune shot featured in The power of the diagonal line, except that unlike the diagonal line which leads the eye directly to the focal point, the meandering line encourages the viewer to scrutinize both the foreground and the middle distance as well. In this example, the positive S shape created by the edge of the dune invites you to savour the textural detail on either side of the flowing line, before appreciating the rhythmic qualities of the dunes and mountains in the distance. As the flowing line in the foreground appears dominant in the frame it becomes the main feature, while the dunes and mountains assume only secondary importance. The meandering dune in the foreground has been greatly exaggerated by using a wide-angle lens.

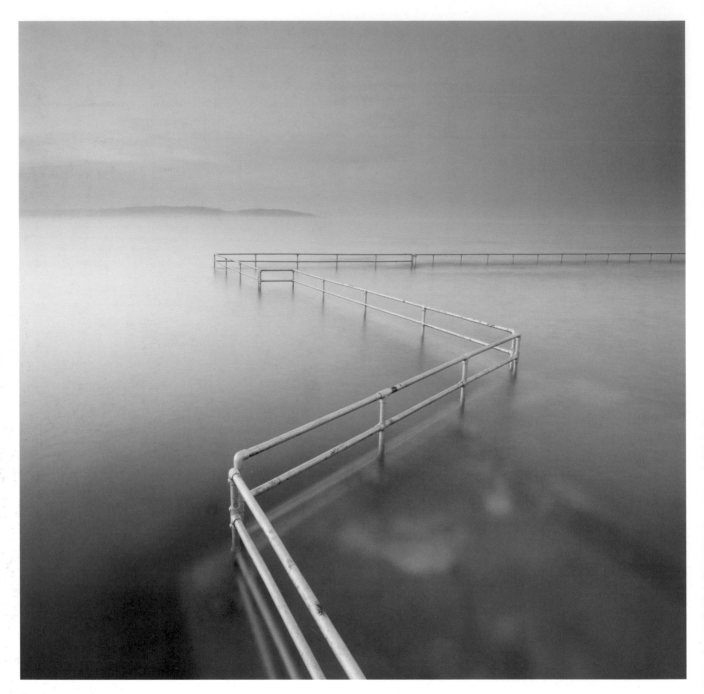

The zigzag line created by the white fence introduces a quiet tension to this image. Using a very long exposure, the sea and sky have been reduced to almost a single continuous tone; consequently the fence assumes far greater importance. While the line appears to direct the eye towards the headland on the horizon, it is the fence that is the main focal point; the headland is of only secondary importance. With the white fence disappearing to the right, it does help that the distant headland on the horizon appears to extend from the left of the scene.

While the general purpose of a lead-in line is to direct the eye to a specific focal point, a well-captured meandering line can offer sufficient interest in its own right. The curvilinear qualities introduce a sense of calm and tranquillity, so think carefully about the appropriateness of image you wish to use. Similar to the S-shaped line, a zigzag line can also add a strong sense of cohesion to the image, although the nature of this line is subtly different. Angular in nature, it introduces a certain tension, so once again careful thought needs to be given to the subject used.

A stream or river are the obvious choice of subjects for this effect, although a road undulating over the landscape, or possibly the seashore seen from a high vantage point, will also offer good opportunities. The meandering line introduces an indefinable grace while encouraging the viewer to explore the image in its entirety.

The visual full stop.

As previously suggested, because we in the West read from left to right we tend to do the same when looking at photographs, particularly if there is a strong horizon. As we look across an image, there can be a tendency for the eye to skate over it without resting on any particular feature. However, by introducing what we call a visual full stop, the viewer is encouraged to re-engage with the picture and discover those elements that particularly interested the photographer.

A visual full stop is simply a compositional stratagem to encourage the eye to re-examine key parts of the image: by including a dark but possibly innocuous feature at the end of the horizon, the viewer's attention is deflected back into the image; including a light feature at either end of the horizon will have the opposite effect, as it will tend to draw the eye. While I would normally suggest that the visual full stop should be placed to the extreme right of the horizon, there will be occasions when it should be placed to the left, if the apparent flow of the image is from right to left.

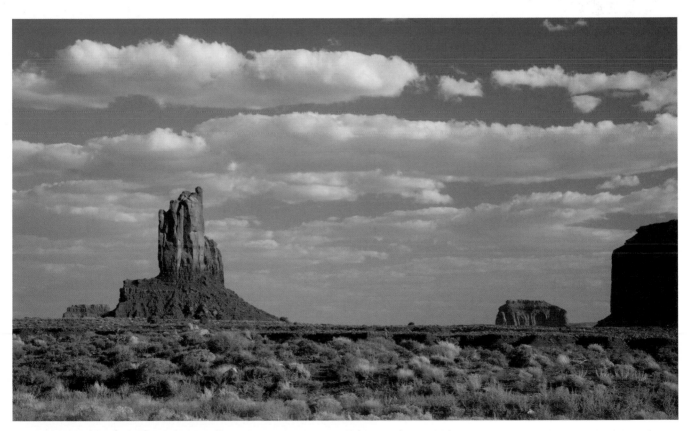

By introducing a strong and obvious horizontal, the viewer naturally reads the image from left to right. Including the dark butte on the extreme right encourages the eye to re-circulate and explore areas to the left of the image as well.

If you want to introduce depth to your image, then there should be an apparent foreground and background. How well these two areas relate will ultimately determine the overall success of the image.

The relationship between foreground and background.

Whether you are photographing landscape, still life or portraiture, the relationship between the foreground and background is important. Even when working in a genre that is not normally overly concerned with composition – photo journalism, for example – the relationship between the subject and its environment remains a central consideration. So when taking a photograph, you should seek to link the foreground and background in a way that is clear to the viewer.

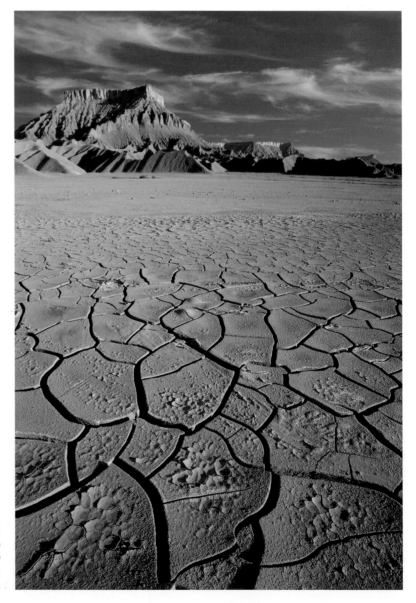

When aiming to link the foreground with the background, identify visual elements they may have in common. Here for example, the strong sense of pattern in the foreground is echoed in the butte in the middle distance. This kind of visual relationship can often be best exploited when using a wide-angle lens.

Achieve a link between the foreground and background by association. The beautiful motorcycle in the foreground suggests a flamboyant lifestyle, which is appropriately mirrored by the period diner in the background. As both are colourfully illuminated, the visual relationship is clearly apparent.

There are various ways to achieve this:

• Give careful thought to the background context in which we photograph a subject. For example, consider shooting a portrait: most people fit stereotypes through age, ethnicity, their job or the way that they dress; it is what makes us all interesting. So by placing your subject within a sympathetic context, an immediate link will be made. Incidentally, sometimes very interesting and possibly humorous images can be captured by placing the subject within an inappropriate context; either way, the link between the foreground and background is crucial to the success of the image.

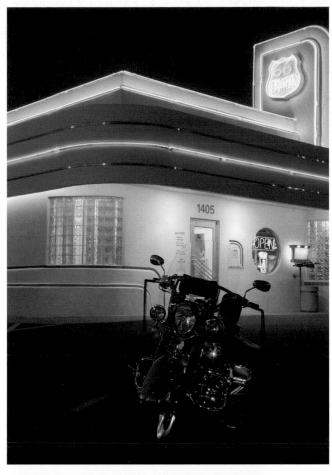

The urban feel of the model in the foreground clearly echoes the graffiti character in the background. One wonders if she was responsible for this artwork?

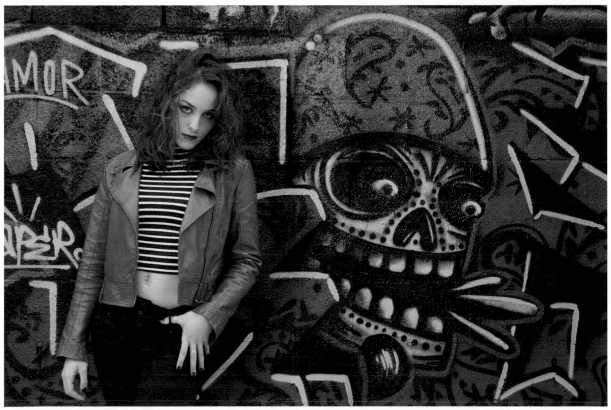

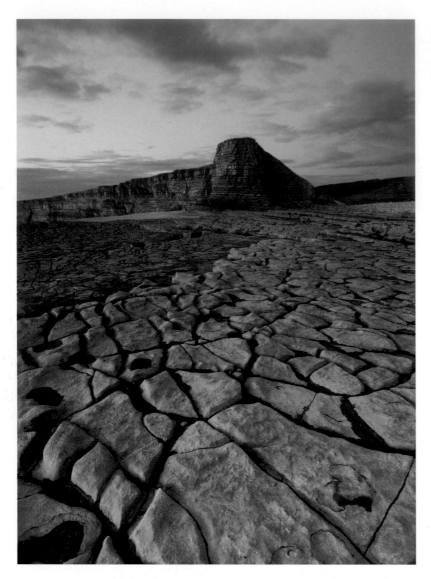

The link between the foreground and background can sometimes be quite subtle. In this example, both areas are strongly patterned, yet what links the rocks in the foreground with the illuminated headland in the background is the meandering line to the left of the picture, which serves as a gentle lead-in line.

• Use lead-in lines to link a feature in the foreground with the background; this technique is popular with landscape photographers. Aware that the main source of interest appears in the background, they first identify a small feature in the immediate foreground then find a lead-in line that links the two elements; this could be a road, a receding row of telegraph poles, or a natural feature within the landscape.

• Often the link between the foreground and background can be made by association. As a simple illustration, if I wanted to photograph a new high-tech car, it might be helpful to shoot it set against a contemporary steel and glass building rather than an historic ruin. By way of contrast, photographing a beautiful vintage car with a stately home in the background would clearly be more appropriate. After all, the advertising industry has long been successfully using such methods.

• The link between the foreground and background does not need to be quite so literal; sometimes a more subliminal relationship can be found. It could simply be that a strong shape in the foreground is countered by an equally interesting shape in the background. Look for other related visual elements that could be used to link areas together. In a landscape situation a strong pattern in the foreground might be complemented by similar patterns in the background; it is simply a matter of remaining aware.

• Whether you choose to retain maximum depth of field and ensure that both the background and foreground remain sharp, or instead decide to throw the background out of focus, will be a matter of your personal judgement. However there will be occasions when it will prove worthwhile exploring both options.

Using the foreground to mimic the background.

One effective method for introducing cohesion to a composition is to identify a feature in the foreground that mimics the background. Once you become aware of this as a compositional strategy, it is amazing how easy it becomes. The background tends to be the feature you cannot change, so once you have identified a possible scenario, search for something you can use in the foreground. For example, if you were photographing a mountain, find a nearby rock in the shape of a pyramid. Because people have animated characteristics, linking them to an interesting background is not difficult. Similarly when photographing the urban environment, you can often find posters or signage that appears to mimic the background – it is simply a matter of being aware.

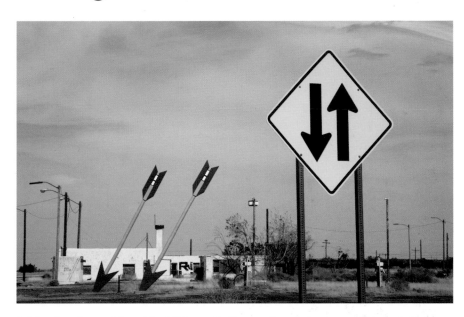

Driving along the much-famed Route 66, my attention was drawn to two large and somewhat incongruous arrows adjacent to an abandoned service station. It was only when I stepped back that I noticed a yellow road sign that also featured two arrows. By including both, the purpose of the image immediately becomes apparent.

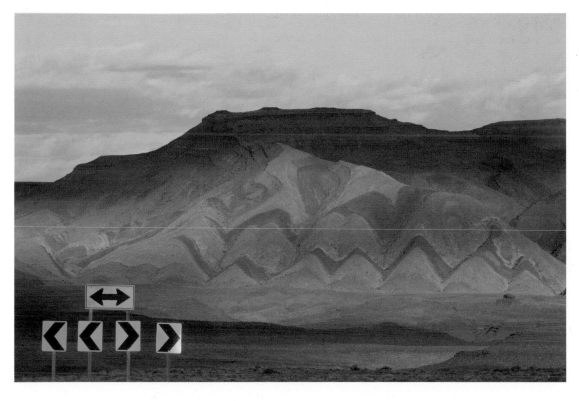

While this was not a particularly dramatic landscape I was nevertheless intrigued by the zigzag patterns in the rock strata. As I got closer, I spotted a road sign on the left that also featured a zigzag pattern. By including the sign, the viewer becomes aware of the more subtle patterns in the rock.

Creating a sense of scale.

One of the most obvious indicators of perspective is the sense of scale it creates: objects that are further away from the camera appear smaller. Put simply, if you photograph two objects of exactly the same size at different distances from the camera, the one in the background will appear smaller than the one in the foreground. You can use this principle to introduce a very definite sense of scale and depth into your work; at the same time you can use scale to distort depth, depending on what you are aiming to achieve.

Here are several methods you can use to add a sense of scale and depth to your work:

• The traditional method for creating a sense of scale is to place an object of which we know the size alongside the subject we wish to illustrate. As we know the size of the familiar object, we should be able to ascertain the scale of the subject we wish to feature; landscape photographers often include a lone figure in order to achieve this. On a more practical note, a jeweller wishing to shoot a small item includes a coin in the composition as a simple point of reference; as we know the size of the coin, establishing the size of the jewel is not difficult.

• Interesting things start to happen when photographing a row of objects of similar size. Consider a row of telegraph poles: the one nearest the camera will appear large, while the remaining poles will incrementally diminish in size. Even if you shot just two objects, the one furthest away will appear smaller, therefore a sense of scale and depth has been introduced.

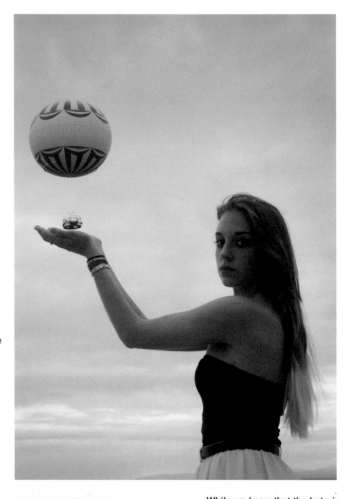

While we know that the hot-air balloon is large, distance has greatly reduced its scale. By understanding this, you are able to play interesting visual tricks; in this whimsical example the balloon appears like a small toy in the model's hands.

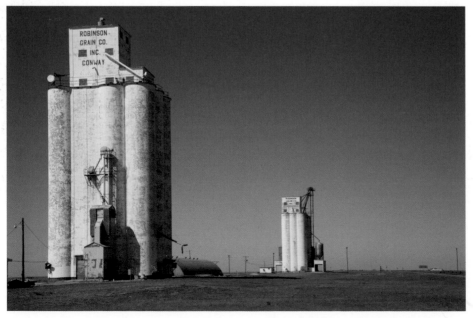

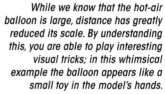

This is a traditional view of scale. The two grain silos are identical in size, however the one in the middle distance appears considerably smaller due to the effects of perspective. This effect is exaggerated when using a wide-angle lens.

• With a little care, it is possible to introduce a false sense of scale – this is where it becomes interesting. By placing a smaller object nearer to the camera while distancing the larger object, the smaller object will appear large, while the larger object will look small. By simplifying the background so there are no other indicators of scale, exciting and enigmatic pictures can be created. Photographically, possibly the greatest faux pas one can commit is the proverbial tree growing out of someone's head, although the curious might wonder 'Why not?' While this is often cited as an example of how not to take a photograph, if applied creatively, this principle can give rise to some interesting photography.

• Clever things can be done using wide-angle lenses. As you are well aware, these can exaggerate and sometimes distort perspective. So, if a person extends an arm towards the lens, the hand will appear disproportionately larger than the body.

Appreciate that scale can be manipulated, both to suggest depth, but also to create a false sense of scale. It is a matter of thinking how scale can be used creatively to enhance the statement you wish to make.

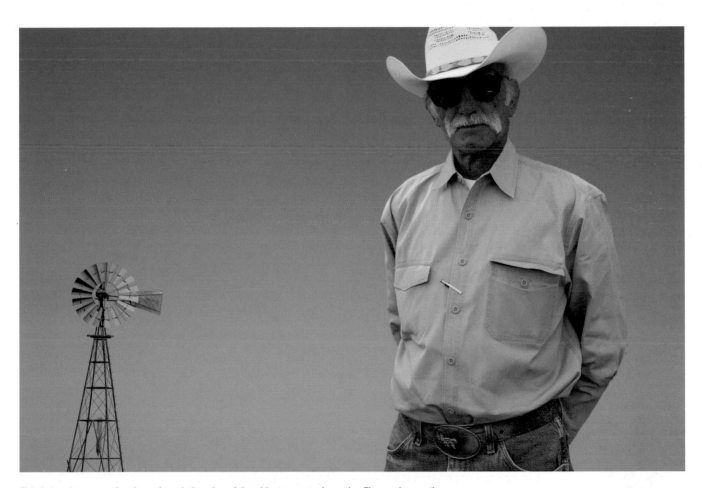

This is another example where the relative size of the objects proves deceptive. The cowboy on the right appears considerably larger than the windmill on the left, but in reality we know that the latter is much larger than the figure.

Relating content within the image.

What marks out an experienced photographer from a complete beginner is the ability to relate the foreground and background successfully. Someone using their camera for the first time will possibly identify a potentially exciting situation and while they capture all the required detail in their shot, they are not aware of the other elements they have also included that are superfluous to the image. In their rush to grab the shot, insufficient thought has been given to the content of the image.

One of the most demanding tasks when taking a photograph is deciding what to include, but more importantly what to leave out – the simpler you can keep a composition, the better. You may wish to photograph an historic building, so you need to decide whether you want to include a figure or not. The first question you need to ask yourself is what value will it serve? If it helps to add scale, or you feel you need a particular focal point, then do so; if you cannot see a specific purpose, then don't.

What you decide to include in your photograph and what you choose to leave out is one of the most fundamental skills when designing a photograph. You cannot assume that the viewer is necessarily on your wavelength, so you need to make the task of interpreting your image as clear as possible. In this example, I was interested in the model's beautiful golden hair and how it paralleled the mare's tail cloud formations in the background, so including anything else would be superfluous.

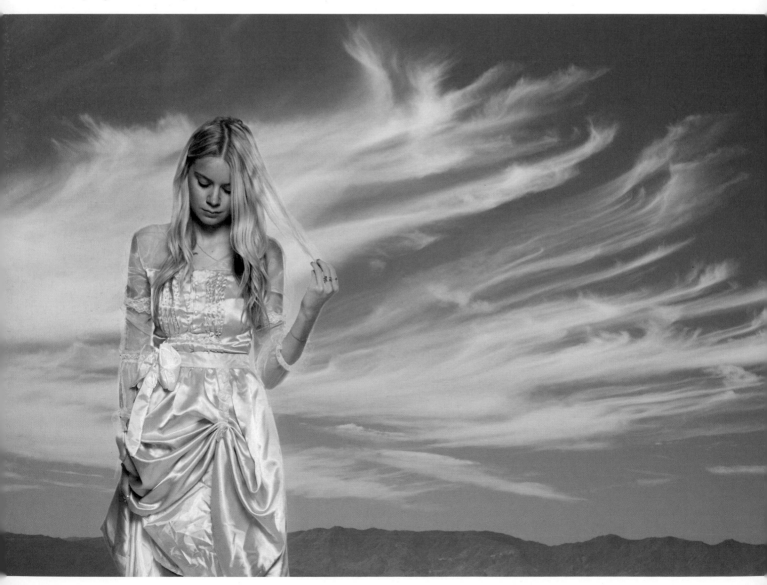

An issue sometimes overlooked concerns the number of similar elements that should be included in an image. For example, you have decided you want to photograph a row of apples, but just how many should you include? Is it better to include three or four, or just restrict the number to two? Some might question whether it really matters – strangely, it does. There is a tradition in composition that suggests you should only include an odd number of elements, but is that argument really sustainable? How many elements you include clearly is an important consideration, although the rules governing this are more flexible than you might think.

Working with a single focal point.

From a compositional standpoint, this is one of the most popular compositional strategies as it so easy to apply. By introducing a single focal point you are aiming to introduce a single element on which the eye can rest. This focal point could be a dominant feature, or conversely something that occupies only a very small part of the image. Clearly the context is important.

There are several ways to emphasize a single focal point:

• One solution is to make the focal object large in the frame, although in order to draw the eye it helps to include a neutral background; in this situation, the viewer should be discouraged from relating the foreground to the background

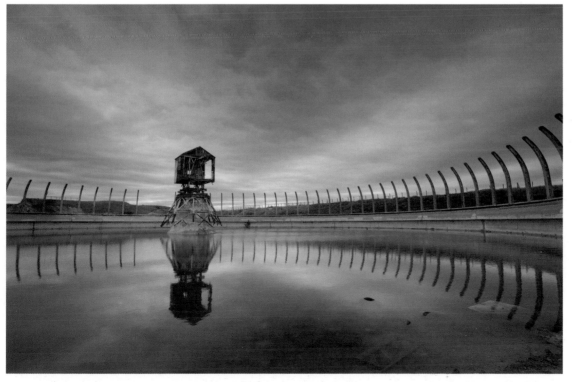

There should be little doubt what serves as the focal point in this image. Not only is the tower prominently located on the thirds, but also the retaining wall acts as an obvious lead-in. The pattern created by the posts is clearly broken by the structure, while the slight curvatures of the uprights gently bend towards this obvious focal point.

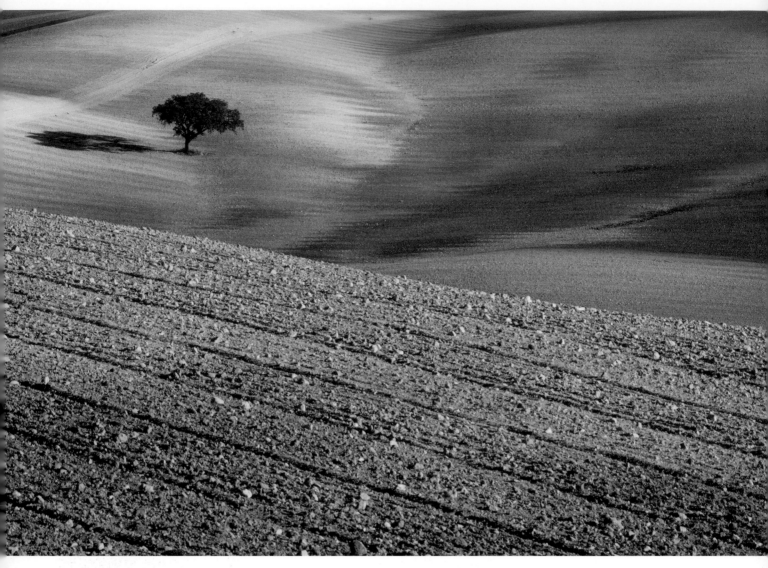

The tree in the top left of the picture is unmistakably the main focal point; this has been achieved in several ways. First, the tree serves to break a sequence of subtle patterns. Second, the flow of the lines naturally leads to the tree, and third, it is located in the area that reveals the greatest contrast.

• While the inclination is to give prominence to the single subject, occasionally making it very small within the frame can prove equally effective; here the context will naturally have a bearing.

• A particularly useful way of attracting the eye to a single focal point is to photograph it within the context of a pattern. If an element is introduced that breaks a regular pattern, this will immediately draw the eye.

• A technique used by many landscape photographers is to place the single focal point in the area of the photograph that shows greatest tonal contrast. For example, you may want to include a figure in your shot: waiting until the figure moves into a lighter part of the landscape will add impact; if that lighter area has adjacent darker areas the impact is further increased.

• Contrast is another very useful way of adding emphasis to the subject. Contrasting colours, perhaps in the form of a single red rose set against a neutral green background, is a good example, but there are many other subtle contrasts you may wish to explore – hard against soft, moving against static, or textured against smooth.

Working with pairs.

The conventional view is that photographers can only work with an odd number of elements – one, three, five and so on. This suggests that compositionally we should not group two elements together, although if we look at other arts this constraint seems not to apply. With a little thought, working with pairs should not pose a problem, providing you retain balance.

Follow these simple guidelines for best effect:

• If you take two very similar elements of equal size and set them against a flat background, while balance is retained the composition will look boring; by making just a few subtle changes this can be substantially improved. We are accustomed to seeing objects placed next to one another, but by overlapping them the design becomes more exciting. Making each of the two elements appear marginally different can also increase interest: a variation of colour, or a slightly different angle, can quite easily transform a boring image into something attractive.

• You may wish to photograph two identical elements, but because of distance and scale one appears larger than the other. In fact, this variation in size immediately introduces added interest. If you are using a landscape format, try placing the nearest element in the middle of the image, with the more distant element to the extreme left or right.

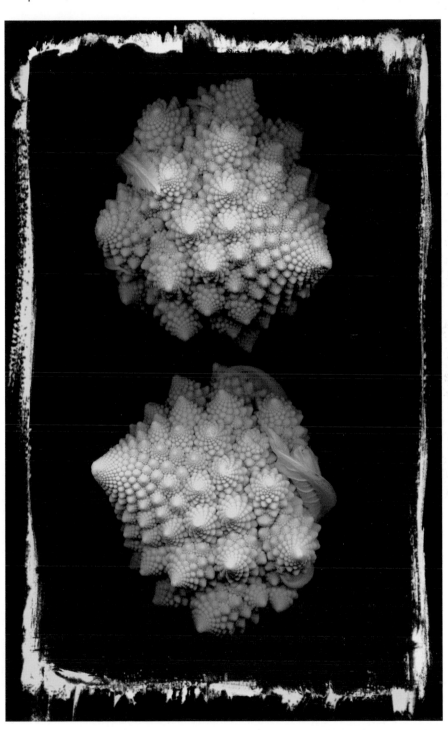

Illustrating two elements of very similar size can be a recipe for a very boring image, but presenting them in the portrait rather than the more predictable landscape format immediately increases interest. Rotating one of the featured cauliflowers also helped.

• It is possible to position both elements on one side of an imaginary middle line, providing there are other features within the picture to counterbalance them. Clearly scale will be important: if both the elements are similar in size and share other visual characteristics, place them close together so that they appear as a single unit. If one of the elements appears larger than the other, ensure that the smaller one is positioned nearer to the edge of the composition to create balance.

• Finally, if you are dealing with a more complex image look for features that naturally pair off. For example, if while photographing a location featuring two identical trees a single figure should appear, be patient and see if a second figure comes along to pair off with the first. This approach will produce more interesting results when composed asymmetrically.

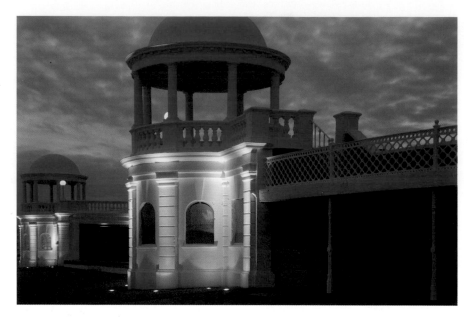

The two illuminated cupolas are identical, except that one appears much closer to the viewer than the other – this variation of scale immediately introduces interest. By placing the larger one roughly in the middle of the composition, it is possible to counterbalance this with the smaller one either to the extreme left or right.

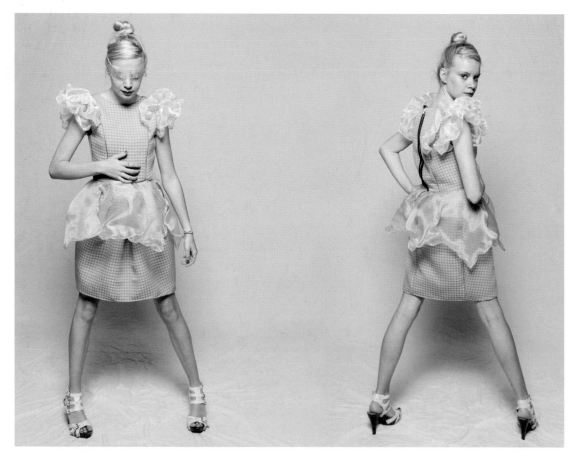

Of course this shows two shots of the same model, however by positioning both at the edge of the frame the main part of the image becomes negative space, which introduces a fascinating tension. The variation of pose adds further interest.

Working with odd and even numbers.

While you should be able to construct an image with just two elements, when you start to increase this multiple to even numbers of four, six or more, problems can arise. This is because the composition starts to look too symmetrical, but using odd numbers of elements will make an image appear asymmetrical, which immediately creates interest. The lack of absolute balance created by odd numbers encourages the viewer to scan the image with greater purpose to identify fresh and exciting combinations.

The problem when constructing images of even numbers is that the viewer mentally splits the image into two, thus dividing the composition – this is particularly noticeable when using elements of roughly the same size. Only if their relative sizes vary considerably is it possible to compose interesting and well-balanced images comprising even numbers greater than two.

Why exactly do we instinctively prefer to use odd rather than even numbers of elements, in particular three?

1 From a compositional standpoint, dispersing an odd number of elements through the image is considerably easier, particularly if there is a regular background.

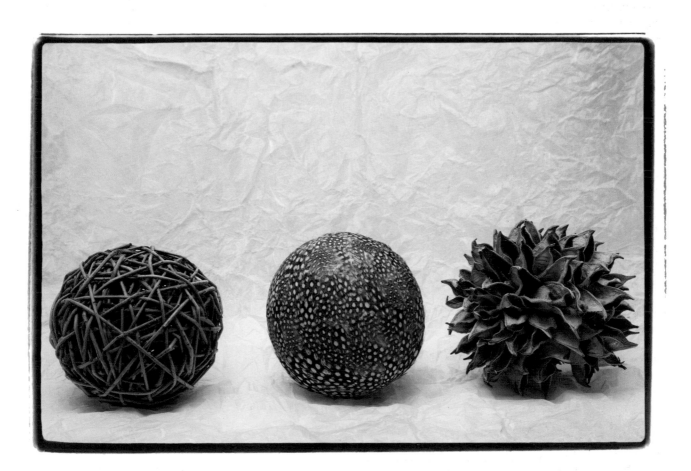

For all sorts of reasons, both psychological and cultural, three is a significant number. As all three spheres are approximately the same size, featuring just two would have appeared too symmetrical and uninteresting. Increasing the number to three adds an interesting asymmetrical balance.

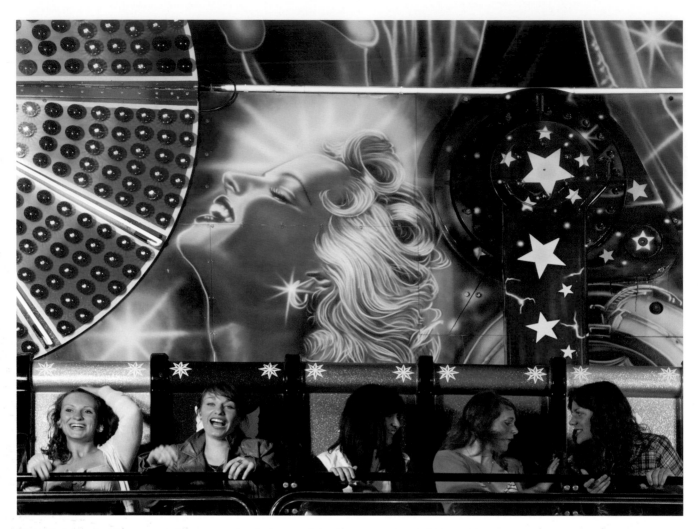

When I took this shot, there were six figures occupying the bottom of the picture – somehow it didn't work. By cropping out the sixth figure on the extreme right, an asymmetrical balance has been introduced that makes this image appear more interesting. Using an odd number, it is easy to imagine more passengers on either side of the featured figures.

2 For all sorts of cultural and psychological reasons, we are particularly drawn to the number three. When quoting examples, we are more inclined to list three rather than two or four. When telling jokes, we tend to restrict the characters to just three: I'm sure you are all familiar with countless versions of the Englishman, Scotsman and Irishman – somehow the Welshman does not fit.

3 By using three elements we are introducing an extension of the rule of thirds. We are more comfortable dividing the image into three zones, so by introducing three elements occupying about the same size we are able to achieve an asymmetrical harmony, although this principle becomes less obvious when the three elements appear in various sizes.

4 The triptych – an artwork comprising three related panels – has long been favoured by artists since the early Renaissance and is a presentation method popular with many contemporary photographers. Few however opt to construct a diptych comprising just two panels, or a polytych comprising four or more panels. The optimum number seems always to be three.

5 By using an even number of elements, the sequence appears finite. As soon as you employ an odd number of elements, one can easily imagine the sequence extending in either direction. The best way to visualize this is to imagine a group of birds sitting on a line: a row of six appears finite, but with a row of five it is easier to imagine it continuing.

Cropping to suggest more.

Imagine you have a row of seven trees but you want to create the impression that there are more. If you take your photograph leaving space beyond the two outside trees, the true number of trees will immediately become apparent. Matters are improved by removing the space beyond the two outside trees, but as you can only see seven trees, you are encouraged to think that there are only seven. However, if you slightly crop the two outside trees leaving just five trees plus an additional two half trees, the mind imagines the rest and assumes the pattern continues ad infinitum. It is a strange paradox, but by reducing what you show, you actually suggest more.

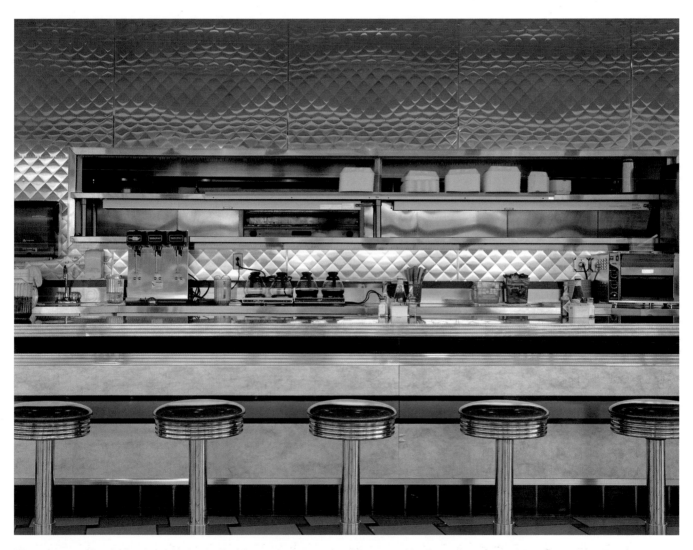

When photographing the interior of this iconic diner, I wanted to capture the pattern created by the stools and the stainless steel counter. I was conscious of people sitting on the periphery, yet including them in the composition would have spoilt it. By cropping the stools at either end of the line, the viewer's mind is encouraged to think that the pattern continues ad infinitum.

Matching numbers.

In the pursuit of clear-cut compositional outcomes some photographers shy away from constructing complicated images, which is a shame because more complex images are able to sustain our interest for a longer period. Yet how are we to compose an image which comprises numerous and seemingly disparate elements? One method is to match them off in equal numbered groupings. As an example, you may have identified three arches: you notice that there is a bench under each of the arches with figures sitting on the two outer benches – waiting for someone to come along and occupy the middle one would balance the composition.

The scenario I have described is possibly a little static, but hopefully the principle is understood. Matching the elements need not be quite so formal; indeed, this composition would appear considerably more dynamic if the constituent elements were randomly spread. The key to this kind of photography is to be aware of possible interesting scenarios and then to patiently wait and see what happens. Those of you who practise what is known as street photography will be familiar with this approach. Consider the images on this page to further explore.

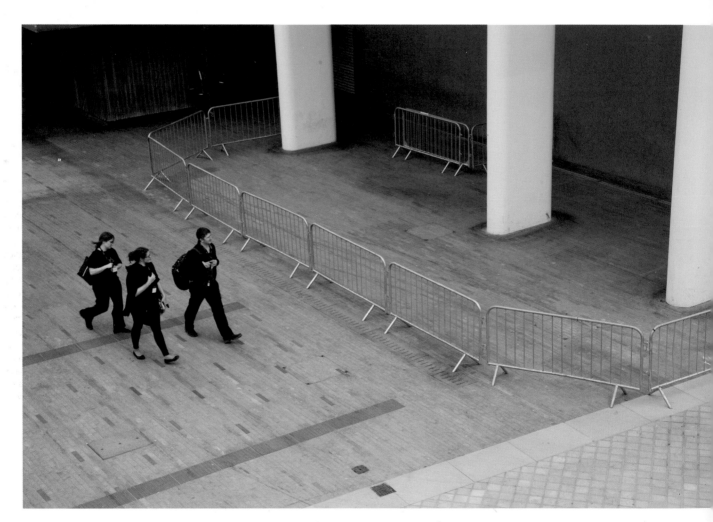

Scanning this pedestrianized location, the three white pillars on the right initially caught my attention. This plaza served as a stage, waiting for something to happen. Figures came and went, but I was keen to capture just three. It was also important that none of the individuals wore conspicuous clothing, otherwise that figure would stand out from the rest. In this case the colour of the clothing each figure wore proved particularly helpful: as the three white pillars appear against a dark background, it was important the three figures were wearing black in order to set them against the very light plaza. The positioning of the figures is also important, although in this context there was some latitude. Grouped together in this way they were captured very close to the thirds, but had they been more evenly spaced, capturing them as they appeared adjacent to each of the pillars would also have worked.

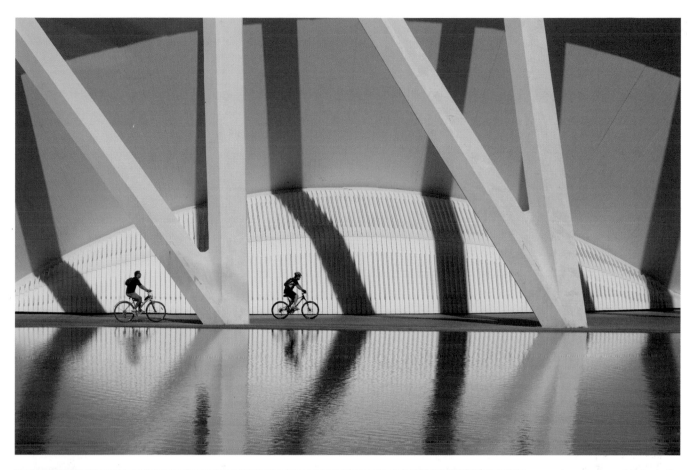

In many ways this is similar to the pedestrianized location shot. As I observed the detail of this modern building, my attention was initially drawn to the two powerful V-shaped structures; I then became aware of the many pedestrians and cyclists passing by. I was particularly keen to capture just two figures and tried a variety of design permutations. I was finally most satisfied with this design that captures a pair of cyclists on either side of one pillar.

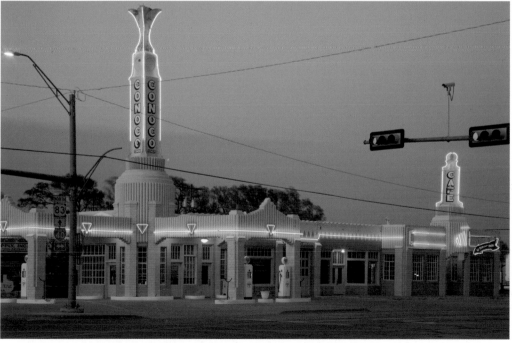

The matching numbers technique is far easier to apply when photographing a static scenario. In this example I was aware of the two towers on either side of the image, but as I looked more carefully further combinations of two became apparent; in particular a pair of petrol pumps in the centre of the composition, and the two sets of traffic lights on the extreme right. Pairing elements in this way helps to create cohesion throughout the image.

In order to compose effectively, it is important to understand the value of the respective visual elements – undoubtedly one of the most important of these is colour. By developing an understanding of it, you are able to design your images to appeal not only to the aesthetic but also to the emotional instincts of the viewer.

Understanding the psychology of colour.

It helps to be aware that some colours have defined cultural associations, which of course cannot be considered universal. For example, in the West we suggest that someone is yellow if they appear cowardly, although in Japan warriors traditionally wore a yellow chrysanthemum as a commitment of courage; red is used to symbolize the loss of profit in commerce, while blue is linked to royalty – as all these examples are tied to specific cultural values, their meanings are limited. However from a compositional standpoint what is of interest to us is the psychology of colour, because by carefully understanding its

psychological values, we are able to communicate with the viewer at almost a subliminal level.

Let us consider the psychological values of some popular colours:

• Red is possibly one of the colours most consistently used by photographers to draw the viewer's eye; it is a bold colour that demands attention. Often red is used as a focal point and photographers are frequently urged to

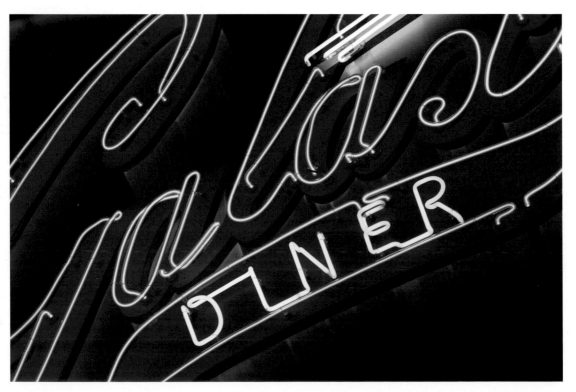

Red is unquestionably one of the most eye-catching colours, which is why it is so frequently used for signage. It is a bold colour that demands attention; it is also a warm colour that is very inviting. While this image is dominated by red, including a touch of yellow and blue greatly adds to its interest.

While blue is seen as a cold colour often associated with winter, it is also a restful colour. It is capable of inducing calmness and tranquility, which is why it is often used to decorate bedrooms.

include a figure in a landscape wearing a red garment, although that is to overlook its emotional value. Fiery and warm, it is an intense colour that can stimulate the heartbeat. The old adage that red is the colour of love holds true and a bunch of red roses continues to hold its appeal. Red can also be viewed as an aggressive colour, hence its popularity with high performance cars. It is a colour that promotes excitement, passion and anger.

• Yellow is another warm colour and, in common with red, it is often used for signs. It is the colour nearest to light so unsurprisingly it greatly attracts the eye. Associated

with the sun it is seen as a cheerful and invigorating colour, although when used in interiors it can appear overpowering. It is also a colour that has been shown to increase the metabolism and improve concentration.

• Orange is a colour that is adjacent to yellow and red and is the third of the warm colours. Associated with fire, it is viewed as having the cheerfulness of yellow but the intensity of red. It is also a colour that suggests endurance, pride and ambition.

• Purple is not a greatly used colour in photography, although it is a hue that often features in delicate landscapes. A colour

Yellow is also considered a warm colour; associated with the sun, it is seen as being cheerful and invigorating. One of the great joys of photographing in autumn is that it offers the opportunity to capture such wonderfully intense hues.

comprising both red and blue, it can appear either warm or cold depending on the context in which it appears. It is often viewed as an unquiet colour, linked with mystery and ritual.

• Blue is the colour of the sky and oceans. As a consequence it induces calmness and tranquillity, so it is no coincidence that it is a colour often used to decorate bedrooms. In contrast to red, blue is viewed as a cold colour and can sometimes be associated with depression. On a more positive note, it suggests the sea, height, truth and spirituality.

• Green is considered a cool colour and is strongly associated with nature; it immediately conjures up images of verdant green pasture. In common with blue it induces calmness, which is why it is a colour often used in hospitals as it has been proved to calm patients. Celebrities are invited into the green room (traditionally painted a soft green) prior to a performance in which they can relax. Green also suggests fertility, which is why brides of the Middle Ages wore green.

• Brown, like green, is seen as a terrestrial colour, and is once again linked to nature. Similarly to purple it can be viewed either as a warm or cool colour depending on the precise hue and the context in which it is viewed. Brown is a relatively neutral colour, and because it comprises the three primary colours of red, yellow and blue it can appear comfortably alongside any of them.

• If we view black and white as colours (although strictly speaking they are not, as they are more accurately classified as the lightest and darkest hue of any colour) we will find that they have a profound effect on the viewer. It is easy to view black as a depressing colour, but it can be stylish as well: the little black dress continues to be fashionable while a shiny black car will always pull the eye. When worn, black is a colour that can suggest power and authority, but it is also the colour of death and mourning. By way of contrast white appears light, optimistic and open; it is the colour chosen by brides to suggest purity and innocence.

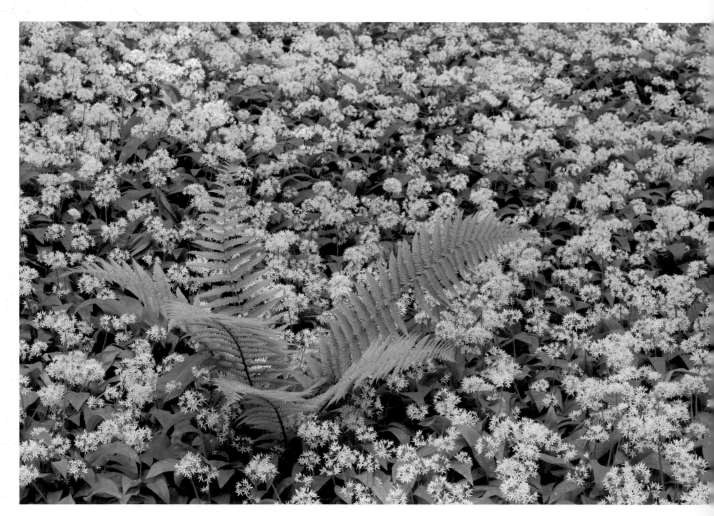

As a cool colour, green immediately suggests nature. It is also a colour that induces a sense of calmness, which is why it is often used to decorate hospitals.

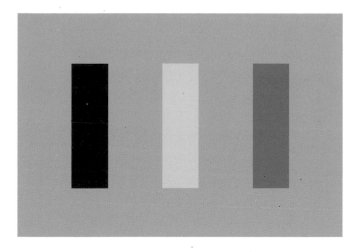

Setting a primary colour within a grey context makes that colour appear brighter and more intense.

• Grey is the most neutral of all the colours and can often be viewed negatively – we often refer to it being a 'grey day' – yet from a compositional standpoint it can be a very useful colour. Setting one of the primary colours within a grey context makes that colour appear brighter and more intense (see diagram).

By understanding the emotional value of colour you are in a better position to communicate your ideas to the viewer. It is unlikely that you will be in a position to change a specific colour, but knowing the effect it has will encourage you to think carefully about the other aspects of image design.

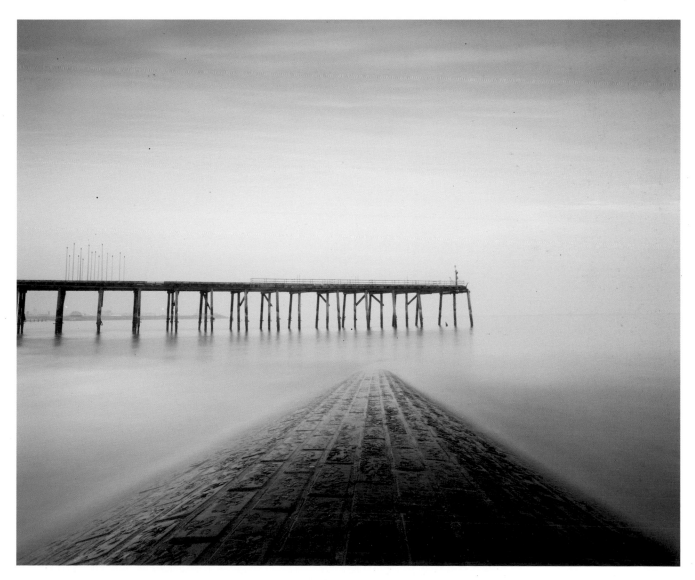

Blue, the colour of the sky and the oceans, invariably induces a sense of calm; the atmosphere of this image is passive and meditative. Interestingly, research has found that blue is the world's favourite colour.

Creating impact with complementary colours.

As an introduction to colour theory, it must be understood that there are thousands of hues but just seven pure colours – purple, red, orange, yellow, green, blue and indigo – which are often referred to as prismatic colours or the colours of the spectrum. All colours are made from just three primary colours: red, green and blue when dealing with light, but red, yellow and blue when dealing with pigments.

Colours can be further understood by viewing a colour wheel (see diagram). Colours positioned close together on the wheel have similar properties and are termed adjacent or analogous: for example, orange is adjacent to yellow because orange comprises red and yellow; green is adjacent to yellow because it is made up of blue and yellow. Colours that appear opposite to one another on the wheel do not share any common hues and are known as complementary colours, for example red and green.

Every colour within the colour wheel has a polar opposite that is known as its complementary: for example, the complementary colour of red is green, and the complementary colour of blue is orange.

The combination of red and green is undoubtedly one of the most attractive colour combinations. As red and green appear opposite each other on the colour wheel they are complementary colours; by using them together maximum contrast is achieved. The best way of understanding this is to imagine the flowers in a different colour; somehow a blue one would not have quite the same impact.

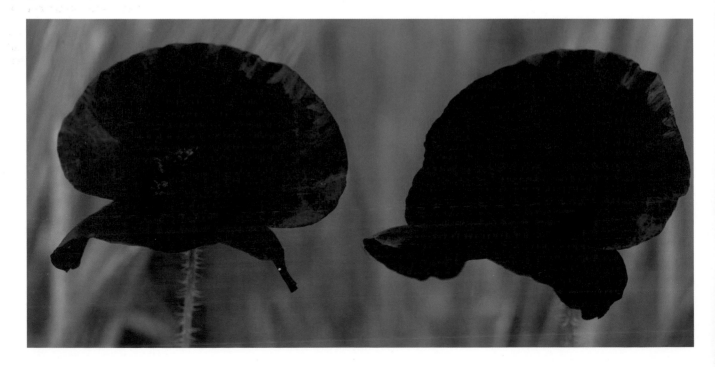

If we consider the primary colours as red, blue and yellow, then their respective complementary colours will be green, orange and purple. Any colour appearing on the colour wheel will have its polar opposite and introducing these complementary pairs to your compositions will provide maximum colour contrast and impact. The effect of complementary colours is best exploited by ensuring no other colours are present in the composition; the exceptions to this are black, grey or white, because these are considered neutral colours.

For example, if you were photographing a single sunflower head its colour would typically be between yellow and orange. By referring to the colour wheel you can immediately see that its polar opposite is a deep ultramarine blue. In this case, choose to photograph the sunflower against a blue sky to achieve maximum impact, employing a polarizing filter in order to increase the intensity of the blue.

Tip

The contrast achieved by setting one colour against its complementary colour is most apparent when both colours are fully saturated.

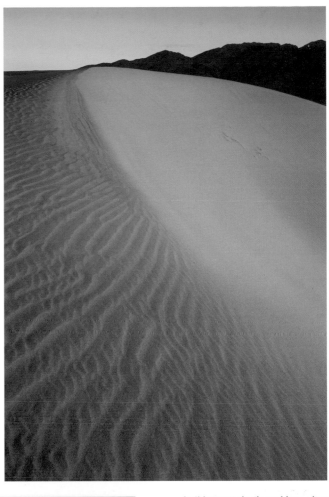

In this example, the golden colour of the sand dune provides a wonderful foil for the deep blue sky. As the mountains in the distance are rendered virtually black, the contrast between the two principal colours remains uncompromised.

Lit by tungsten, which creates a warm orange glow, this wonderfully iconic American motel contrasts beautifully with the deep blue evening sky.

Creating harmony with harmonious colours.

There are of course occasions when contrast is not appropriate, particularly when aiming to achieve a much quieter mood. Colours adjacent to one another on the colour wheel (see Creating impact with complementary colours) are known as harmonious colours because they introduce a concordant quality to an image – this is why they are so favoured by both painters and photographers.

Colour harmonies frequently occur in nature and the trick is to ensure that you do not include any additional elements that might jar. Think of the lovely variety of reds, oranges and browns one commonly sees in an autumnal forest, or the subtle blues and purples one tends to see in the receding hills.

Responding to harmonies is something we instinctively do: for example, when decorating our homes

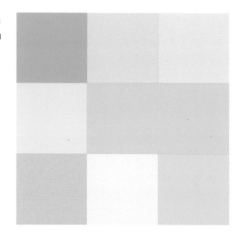

In this example yellow is present in all the hues, which creates a colour harmony.

It is often assumed that you cannot use two colours opposite one another on the colour wheel and still achieve harmony; certainly an intense red set against a rich blue would not work. In this example however, the pink in the sky has a bias towards magenta, which comprises both red and blue. The concordant tones and pastel hues increase the overall sense of harmony and invite the viewer into a quiet place.

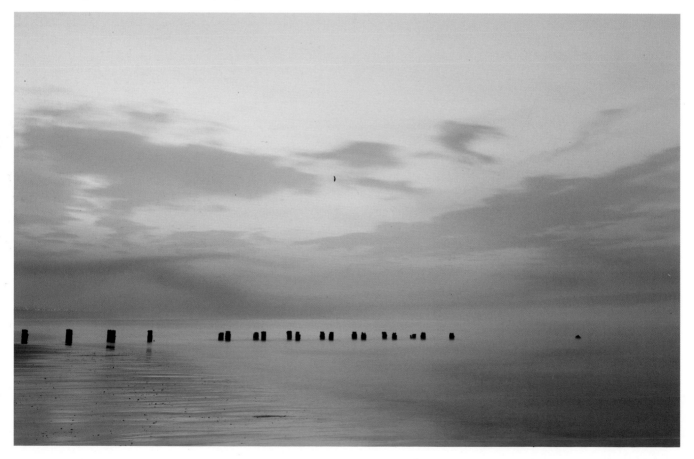

we often settle on a colour scheme that appears to harmonize. We make similar choices with our clothing, so transposing this expertise to our photography should not prove too difficult.

Creating colour harmonies in our images can be achieved in one of three ways:

• Ensure that the image is largely comprised of adjacent or harmonious colours. If your main subject is green then restrict the neighbouring colours to those that are closest to green on the colour wheel, such as turquoise, blue and yellow. You could include neutral colours such as white, grey or black, although use the latter with caution.

• Hues that share a single common colour will harmonize: as a simple example, green and orange could harmonize because they both share the primary colour yellow (see diagram), as would purple and green because they both share the colour blue.

• It is even possible to harmonize colours that are polar opposites – but only if they appear to mingle or are all presented in either high-key or low-key. For example, it is possible to weave elements of pale green into areas of pink (which of course is just a lighter shade of red), providing both hues appear sufficiently high-key.

Tip

High-key or low-key colours, irrespective of where they appear on the colour wheel, will harmonize.

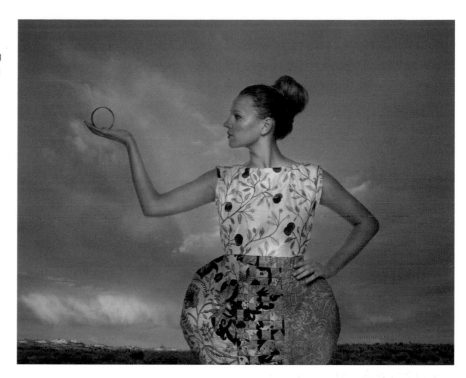

Colour can appear either warm or cold. Cold colours are blue, green or turquoise, while warmer colours are pink, yellow and orange. This image clearly uses warm colours and – while there is a hint of blue – orange, yellow and brown predominate.

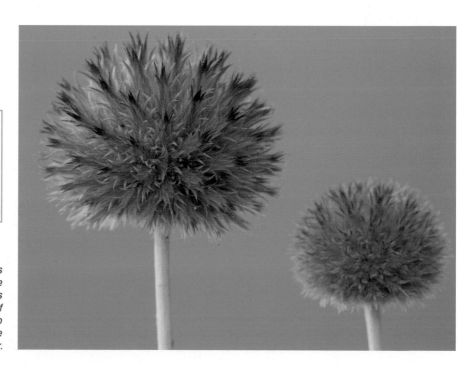

When establishing whether a group of colours will harmonize, you need to identify a single common primary colour. While most of this image comprises green, which is made up of blue and yellow, the small flecks of purple also harmonize as they comprise blue and red, blue of course being the common primary colour.

Creating depth with advancing and receding colours.

A strange notion perhaps, but colours have the capacity either to advance or recede. Colours that advance are primarily warm colours – notably red, orange and yellow – while colours that recede tend to be the colder colours – green, blue and indigo. To illustrate this effect, if you photographed a bright red car adjacent to a similarly sized blue car, the red car would appear closer than the blue car (providing of course that they do not overlap).

Understanding this principle allows you to manipulate colour in a purposeful way. If you wish to introduce depth, set a strong warm colour against a much cooler one. Tone can also play its part, so a slightly lighter red set against a darker blue will increase this effect. Conversely, if you wish to reduce depth set one warm colour against another warm colour, or alternatively you could set a cold colour against another cold colour.

The red circle on the green background gives the illusion that the circle is in front of the background; essentially it looks like a red ball placed on a green background.

In this example the blue circle appears to recede while the red area appears to advance forwards; it looks like a red wall with the sky showing through.

If you are in doubt about the attractiveness of the colours red and yellow, consider the many road signs that feature one or both of these colours – they are chosen to grab your attention. It is no coincidence that the burger chain McDonalds has designed a logo comprising just yellow and red; they are well aware of just how eye-catching these two colours can be when set against a strong blue sky.

Perhaps the most universally recognized signage that exploits this principle is the target. Typically it has a yellow centre ringed by red, while the outside colour is blue. The reason of course is that from a distance the colours yellow and red are far easier for the marksman to see.

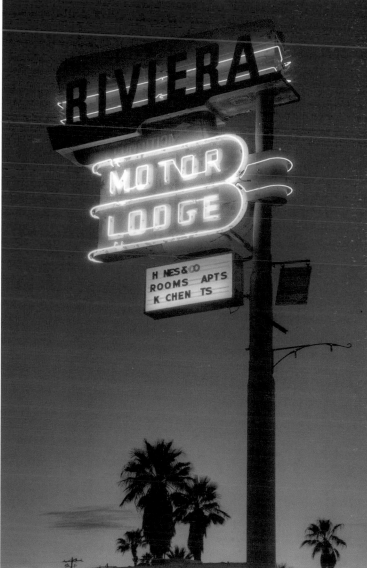

While there is quite a bit of detail in this image, the eye is instantly drawn to the red tail-light. Set against a blue background, it immediately stands out from the rest of the image.

Aware of just how eye-catching the colours yellow and red are, this combination is regularly used when designing neon signs in order to attract passing trade.

Adding a splash of colour.

The great virtue of colour is that you can select to use as much or as little as you like, depending on the mood you wish to create: for example, a photograph displaying a wide colour gamut conveys energy and excitement. However, grouping together a random selection of bright colours can appear jarring and discordant, perhaps even naïve and childlike. When creating an artwork a child will typically use every colour in the box, and while this does exude a certain charm, its aesthetic appeal is limited. I'm sure you will all have received a personal card crafted by a child in which each letter in the message is accorded a separate colour.

As photographers we need to be more selective when working with bright colours, the exception being when grouping together a range of prismatic colours that have been either heavily or very lightly saturated, as this strong tonal element will temper the overpowering nature of each hue. If you do decide to use a range of prismatic colours, it is far better to restrict yourself just to the three primary colours. What constitutes a primary colour varies: if you are dealing with pigments then it is red, yellow and blue; if you are mixing colour using light, then it is red, green and blue (hence RGB). Not surprisingly, it is possible to create a dazzling effect using either of these combinations.

While we all respond positively to colour, a riot of colour can sometimes prove an eyesore; the secret is to restrict your palette to just three or possibly four distinct hues. In this example, by concentrating on just the three primary colours – namely, red, yellow and blue – the image is vibrant without appearing unduly discordant.

Introducing monochromatic colour.

Working with monochrome is an approach that finds favour with many contemporary photographers. Essentially a monochromatic image seeks to use a limited palette of just one colour, instead relying on a full range of tones to bring compositional interest – this approach can work equally as well with landscape or portrait photography. Typically monochrome images evoke a sombre tranquillity and, while this is a style of work that may not immediately catch the eye, it often gives rise to some subtle and evocative compositions.

When photographing an image with a limited colour palette, you need to assess the tonal values particularly carefully to ensure that they really sustain interest. When looking through the viewfinder, it is important that the relationship between the light and dark areas is balanced otherwise you risk producing an image that looks flat. Ideally you should organize your composition so that the greatest tonal contrast appears at the main points of interest. If you have had some experience of working in monochrome, then you will immediately have empathy with this kind of work.

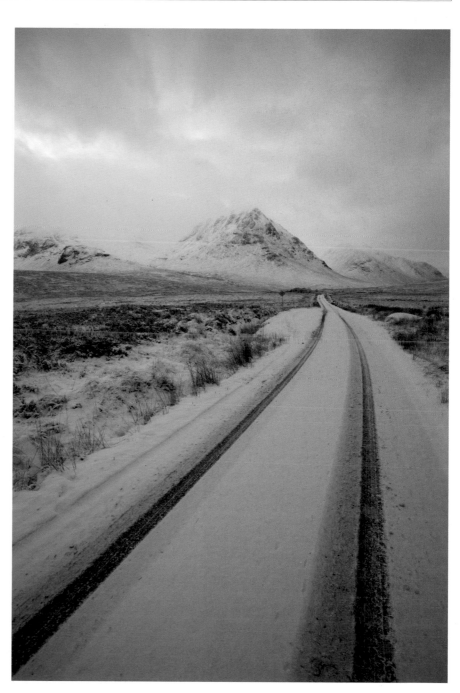

There will be occasions when you are faced with a much reduced colour palette, but these offer unique charms. Monochrome images exude a quiet moodiness that is difficult to achieve when using a wider range of colours – the secret is to concentrate on the tonal values.

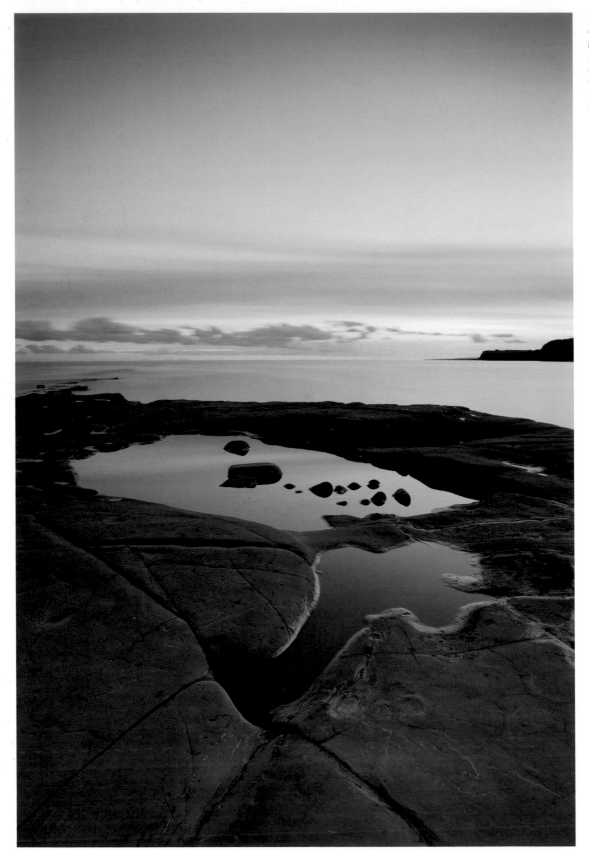

The overwhelming sense of blue is gently broken by the hint of orange, however the success of this image is still very dependent on its tonal values.

The art of composing an image is to encourage the viewer to see what caught your attention. When dealing with a single focal point that is not difficult to do, but when you are dealing with slightly more complex situations this task becomes a little more challenging.

Using frames.

A particularly useful way of drawing attention to parts of the picture is to frame the area you want to emphasize by using other elements within the composition to create an informal border. How we achieve this is part of the challenge, but the more imaginative the frame, the more interesting the image is likely to be.

There are several advantages to using this technique:

• A frame will help to place your picture within a context. For example, if you are photographing a ruin within interesting countryside, by shooting just one small part of the building while allowing the viewer to see the surrounding landscape through it you are able to present a more holistic picture.

• Depending on your choice of frame, you are able to introduce an enigmatic quality to your work. This can work particularly well if there is no obvious link between the frame and the background. Very often the most intriguing photographs are those that pose questions.

• Framing can introduce added depth to your picture. Whether to retain your added frame in focus will always prove debatable and sometimes it is worth experimenting just to see which approach works best.

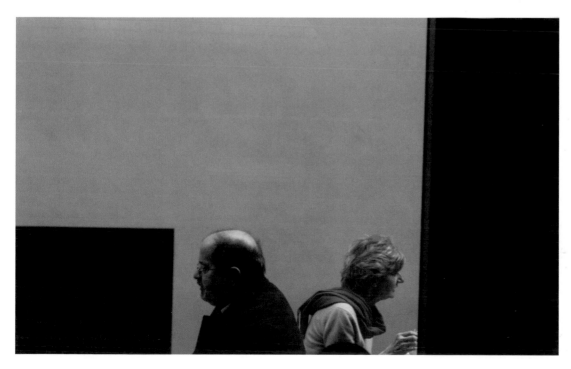

(Photographer: Roy King) Frames can take on all shapes and sizes, and it is even possible to use the background to emphasize details you wish to highlight. The photographer here has been particularly astute: the large black areas on either side of the two seated figures draws the eye towards them, while the asymmetrical nature of the framing adds further interest.

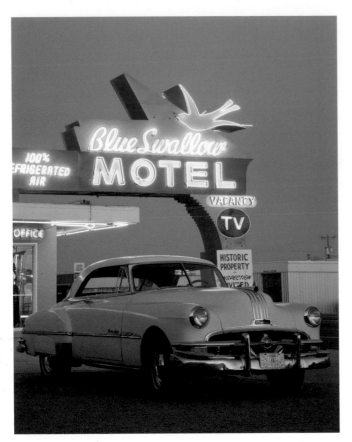

It may not have occurred to you to use a frame, so here is a short list of framing ideas you may like to try:

• **Windows, arches and doorways.** This is undoubtedly the most conventional and popular method of framing an image. One of the great advantages of this method is that it does allow you to connect two quite disparate visual elements. Often used in landscape photography, a window, arch or doorway is used to create an interior/exterior situation. The process of moving in and out of a building certainly offers wonderful photographic opportunities. When we are inside a building we are concerned with entirely different issues from outside, but visually interesting things can happen just at that moment when you step into the open. The landscape will still be obscured by parts of the building, which presents subtle ambiguities.

• **Parts of the body.** A contemporary method for framing an image is to use parts of the human body. When considering a potentially interesting scenario, some photographers instinctively construct an informal frame using their hands, removing them to take the shot. But what if you asked someone else to do precisely the same thing leaving their hands in shot? In a strange way your image would become a parody of how one should compose a picture. Of course you do not need to be quite so blatant. Imagine lying on a beach with your family or friends stretched out nearby: a bended knee or a resting elbow could easily serve as an interesting frame without anyone even being aware.

• **Still life using frames.** There has been quite a fashion in recent years for constructing still life using boxes or frames. What the photographer does is to place an object or objects within a structure, which then serves as a border. This can be achieved by using just a single frame or possibly by creating a highly complex image using a multiple frame. Part of the challenge of this genre of photography is identifying unlikely structures that can be used in this way.

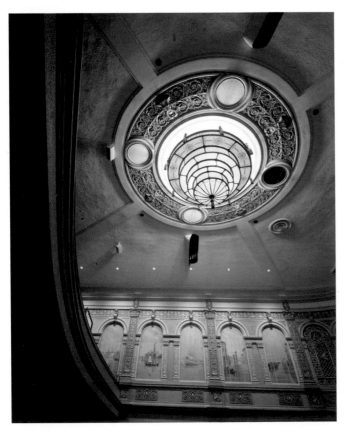

While photographing inside this wonderfully preserved interior, my attention was drawn to the ornate light fixture at the top of the image. By including the darkened ceiling to the extreme left, an informal asymmetrical frame has been created.

• **The understated frame.** Sometimes even the most innocuous elements can be used to create interesting frames. Most landscapes feature elements that we would normally wish to exclude such as fences or telegraph poles. Occasionally purposely including elements such as these can help your composition, particularly if they are used to frame an important part of the image – it is a matter of converting a vice into a virtue.

• **The conventional picture frame.** Possibly bizarre, but have you considered getting somebody to hold a conventional picture frame in front of your camera in order to highlight a distant feature? Where photographers have tried this, it is almost as if they are making a statement about a compositional technique; in this sense the roles are reversed and the frame becomes the subject, and what appears inside is of only secondary importance.

Using an interior to highlight a specific feature outside is a popular framing technique. In this example, by including the overhanging canopy attention is drawn to the abandoned kiosk. It is also worth noting that several other important compositional strategies also apply. First, the white kiosk is counterbalanced by the dark suspended frame on the left; second, the image is split in two by the black upright in the middle of the scene, which immediately introduces a certain tension. It helps to appreciate that several compositional techniques can be applied within a single image.

A more traditional example of framing: I have used the archway to highlight the remnants of the abbey and the landscape beyond. This is a helpful technique to use when dealing with a relatively cluttered situation.

Identifying patterns is recognized as one of the most fundamental aspects of intelligence, influencing all aspects of our lives. On a superficial level patterns appear in the clothes we wear, the buildings we inhabit, and in many of the objects we buy. On a more conceptual level, astronomers frequently scan the solar system looking for patterns as a way of identifying possible alternative intelligence. It is not just a visual thing: talk to any musician, mathematician or scientist and they will also acknowledge the importance of patterns, so it is hardly surprising that photographers are frequently drawn to them.

The appeal of patterns.

I have been keen to show that those elements of design that relate to photography also apply to the visual arts generally, and this is particularly evident with pattern. It is a theme that has been embraced by artists and craftsman throughout the centuries: from the intricate motifs decorating Hellenistic pottery to the large canvases of the pop art movement of the 1960s, the appeal of patterns is universal. From a compositional standpoint, one of the great virtues of photographing patterns is that they immediately introduce cohesion, to such an extent that you are in danger of indulging the inane – the secret is to identify patterns that reveal subtle variations.

Here are some ideas for different sorts of patterns you might like to capture:

• **Natural patterns.** Nature certainly provides a rich source: look in detail and you will identify patterns of stunning complexity and beauty. You only need to examine the structure of a simple leaf to understand this. If you own a macro lens, it really is worthwhile exploring your garden. Geological structures can also offer wonderful opportunities for pattern photography.

Nature offers an impressive array of patterns, particularly if you are prepared to look in detail. By cropping quite tightly I was able to isolate just a small part of a much larger plant. Fanned and fluted, this section of a palm leaf is curiously regular yet surprisingly beautiful.

• **Manufactured patterns.** These tend to be more regular and could be the architectural detail of a large building, or the intricate patterns created by a circuit board. The secret is to reduce any sense of depth: when photographing something large, such as a building, use a long focal length lens.

• **Fractals.** Fractal patterns are fascinating geometric shapes that often occur in nature; they are capable of being immensely sophisticated and often reveal complex mathematical structures. In detail a fractal appears quite random, but when seen as a whole forms part of a complex pattern. For example, at ground level the creeks flowing into an estuary seem unstructured, but if the entire estuary is viewed from above the pattern becomes apparent. Something possibly more accessible is the structure of a fern leaf, which also illustrates this principle remarkably well.

While many examples of pattern are found, they can also be constructed. When designing this still life parodying the notion of big fish and small fish, I purposefully placed the fish and callipers to create a loose but telling pattern.

Modern buildings can prove a rich source of patterns. Designed by the much celebrated Spanish architect Santiago Calatrava, one imagines the inspiration for this noteworthy example has been drawn from his observations of regularly latticed organic forms.

The broken pattern.

When photographing patterns, a balance must be struck between producing an image in which the pattern appears regular but possibly rather dull, with one in which the pattern is less regular but runs the risk of compromising the composition if the pattern is not immediately apparent. One way to overcome this problem is to create a broken pattern by introducing a further element that interrupts the otherwise tight design.

This can be achieved in two ways:

• By placing a subject within a regular pattern, with the aim of drawing attention to it. For example you may choose to place a figure against a regular section of wooden fencing. As the figure breaks the pattern, the eye is immediately drawn to it. In this instance, the pattern will play a subordinate role even though it occupies a larger part of the image.

• By introducing an element that disrupts the pattern. Consider for example a line of trees all leaning to the right, except for one that is leaning to the left. Even though it is still viewed as part of the whole, it nevertheless serves to interrupt the pattern.

A regular pattern is created by the crazed green tiles on the wall of this bathroom, which is interrupted by the metal soap holder at the bottom of the image. As the soap holder is so obviously different from the patterned background the eye is immediately drawn to it.

Exploring texture.

The best way to describe texture is as the quality communicated by touch – something may be coarse or smooth, bristly or velvety, lumpy or even – although when we refer to texture we generally tend to consider rougher materials, referring to 'textured' wallpaper or a 'textured' fabric. The great thing about texture is that it is apparent whether looking at a subject in detail, or from a distance. Viewpoint is an important consideration: for example, the textural qualities of a landscape may not be so obvious when viewing from the ground, but when seen from above in an aircraft, they become considerably more apparent.

In order to best exploit the qualities of texture, careful thought needs to be given to lighting. Often side lighting works best but not always, as occasionally the texture can appear unnecessarily exaggerated under this kind of lighting. One of the great attractions of photographing texture is that it can so easily suggest a visual analogy. For example, as you view the detail of flaking paint on an interior wall, it is easy to imagine that you are viewing a landscape of canyons from above. One of the virtues of photography is that it is a stimulus for the imagination, and focusing on textural detail is one way of engaging with this.

Devoid of shape, colour or form, this image is reliant on texture to sustain interest. This example has been enhanced by the use of side lighting.

CHAPTER 2

Achieving style through composition

What perhaps not all photographers appreciate is that an eclectic use of composition allows us to develop a personal style. Once we are able to disregard the more conventional aspects of composition, we begin to appreciate that other areas of the visual arts have something to offer. By understanding the emotive and intellectual value of minimalist or abstract art for example, we are able to introduce a fresh compositional angle on our own photography. Being prepared to consider the appropriate format is also something we should not overlook. The more we look outside the box, the more dynamic and interesting our work will become.

The conventional way of looking at composition is to consider how the constituent parts are organized, but when developing style it sometimes helps to think about the overall structure of the image as well. For example, the dimensions of the image, or whether you decide to structure it relative to a central line rather than employ the more traditional rule of thirds, are also important factors.

The central meridian.

The so-called 'rules' allow some leeway when composing an image, but the one that it seems should never be broken is never to structure your image from the central meridian. The argument for not placing something centrally suggests that by doing so, you create two equal halves that ultimately appear uninteresting. Yet when considering compositional alternatives, it sometimes helps to take a look back in history.

The Ancient Greeks viewed their many gods as ideal human figures, so it is not surprising that the human form and its ideal proportions occupied a central place in Greek art, particularly sculpture. I raise this point because one of the fundamental tenets of Greek sculpture was to achieve figurative balance by constructing on either side of an imagined central line. While there was never an attempt to create absolute symmetry, elements of the sculpture were designed to balance either side of a perceived central meridian.

The principle of a central meridian works by positioning the elements on either side of an imagined central line. Many newcomers to photography are reluctant to do this as it appears to counter the Golden Section, although it is important to appreciate that the rule of thirds is just one of many compositional conventions.

Given such a compelling landscape, it is hard to imagine anyone not achieving a satisfactory composition. By placing the large rock centrally, one instinctively balances the amphitheatre on either side of it. While there is a danger that this image could appear too symmetrical, there are numerous elements that prevent this from happening – the sky plays an important role in this respect.

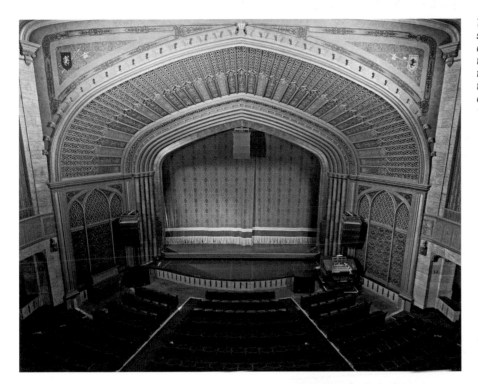

The interior of this stunning theatre appears symmetrical, which is how the architect had designed it. Once again it has been impossible to achieve absolute symmetry although it is tantalizingly close. The position of the organ on the right and the piano on the left breaks an otherwise perfectly symmetrical design.

At first glance it is easy to assume that this image is perfectly symmetrical, after all the figure is centrally positioned. However on closer inspection we notice that the architectural detail on either side of the cinema is different; moreover, the window to the right has been bricked in. It is precisely these slight visual anomalies that add interest.

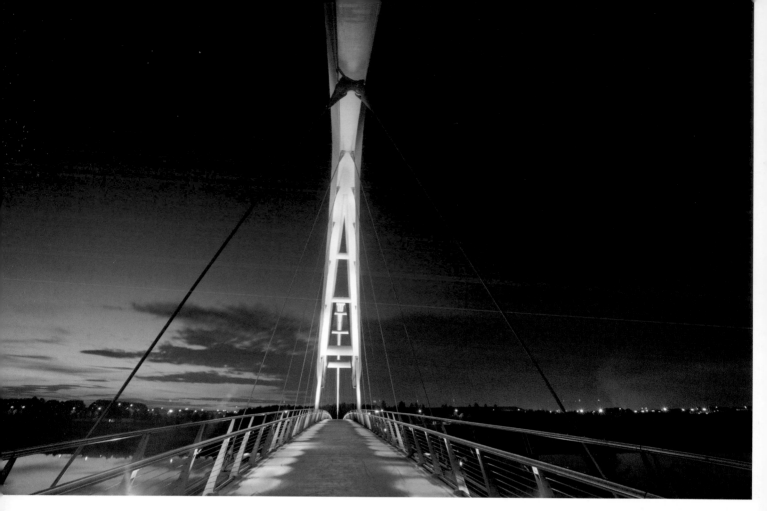

This dramatically illuminated footbridge assumes an almost abstract quality when seen at night. The struts create a sequence of resonating triangles and to illustrate this, it was important to photograph the supporting structure as centrally as possible. It is the uneven colour in the sky that introduces that much needed element of asymmetry.

You can almost imagine the drawing of the architect who designed this elegant pier: there certainly would have been a central line down the middle of his drawing. Shooting in panorama seems to suit this type of work.

Understanding the central meridian

Setting aside the human form for a moment, the principle of the central meridian is a simple one. Design your images relative to an imagined central line, so that features to the right mirror features to the left. Some may argue that if you do this, the resulting image will appear too symmetrical, something conventional photography appears to condemn.

To explore further, let us consider a situation in which a beautifully illuminated building in the distance is reflected in an area of still water in the foreground. Tradition tells us to place the horizon on the thirds, yet somehow this approach just does not work. Placing the horizon centrally proves a much better solution, as we are then able to give due prominence both to the subject and its reflection. In reality, slight aberrations will prevent the reflection from appearing quite the same as the source so a perfectly symmetrical image will never be achieved, which is why it retains interest.

Graphic design is perhaps the art form that most closely parallels photography. In fact the blurring between these two disciplines is remarkable and yet it really is revealing how relaxed so many designers are about applying the central meridian to their work. If you are in doubt, just check out some recent album covers.

The notion of beauty

It is relevant here to explore the notion of beauty, as this has a large reliance on symmetry. Beauty is perhaps most easily identified in the human face, yet the first thing that we notice is that conventions of beauty vary depending on culture and history. In some societies a long nose is admired, while others value a petite mouth. Nevertheless, irrespective of the cultural variations there does seem to be a single common factor that defines a beautiful face – one that is evenly balanced.

Once again try to imagine an invisible central line, with the features of a face appearing evenly on either side. Paradoxically, when someone is lucky enough to have been born with such a face, anything that slightly disturbs absolute symmetry – an expression, a crooked smile or possibly a wink of the eye – makes it even more appealing. The same applies to photography: absolute symmetry should not be our goal, but symmetry with a twist should. Fortunately achieving a perfectly symmetrical image is surprisingly difficult, but if you do capture one make sure that one or two of the smaller elements break the rigidity of the design, then you will create an image that appears structured yet interesting.

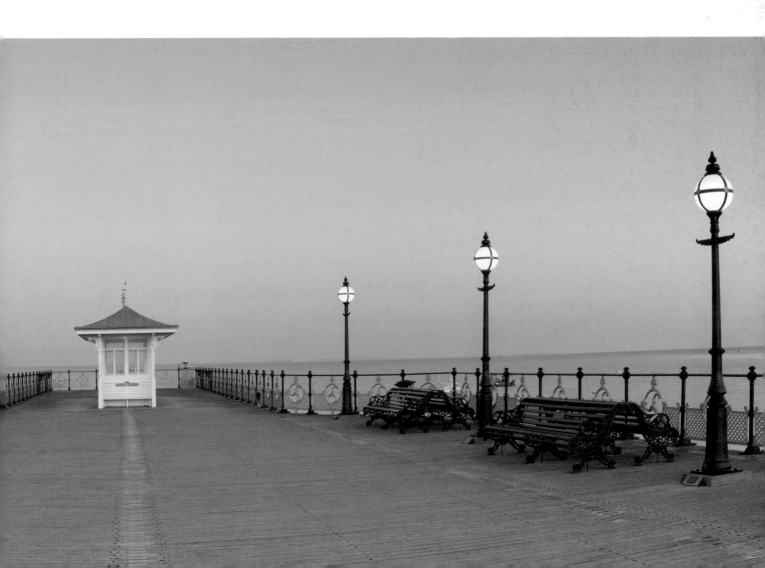

Working off-centre.

Positioning your subject centrally may not suit every subject; similarly, positioning it on the thirds does not always work either. However, placing your main subject within that rather tantalizing area between the central meridian and the thirds can often prove highly successful. It is surprising just how often photographing the main subject slightly off-centre offers an interesting compositional alternative.

Each situation will bring its own challenges, but if you do opt for an off-centre alternative, the closer you are able to bring the subject towards the centre, the stronger the final result will be. Clearly the nature of the subject will have a bearing. Placing the subject centrally creates a sense of stability, but placing the subject off centre creates a slightly unsettling effect. This could be viewed as a mistake, but as we shall see in the final chapter, some images benefit when a disquieting element is introduced to them.

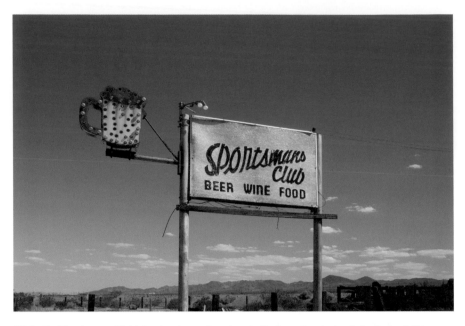

While the 'Sportsmans Club' sign has been placed centrally, the yellow tankard sign to the left has introduced an interesting asymmetry. This creates a slightly unsettling effect, adding to the sense of pathos in the shot.

The lighthouse is unquestionably the main focus of attention, and placing it centrally should not pose a problem as the cloud formations provide an interesting layer of asymmetry. The small building to the right also plays an important part of the composition as it slightly unbalances the effect, but in a rather interesting way.

Choice of format.

Can the choice of format determine whether an image is well composed? The answer is simple – yes, it can. When sizing up a possible photograph a process of recognition takes place, but it is not until the subject is seen through the viewfinder that it is possible to assess the full potential of the image.

Initially newcomers to photography tend to focus on the subject and pay little regard to the context. Then we learn to scan the edge of the frame before finally pressing the shutter: how the subject relates to the edge of the frame soon becomes an important consideration. We also learn that the composition we design using a square format camera differs from one using a panoramic camera. In other words, the process of composing occurs the moment our eye is placed at the viewfinder; in this way the composition will be influenced by our choice of format.

This principle cannot be underestimated. When commenting on the achievements of the great French photographer Henri Cartier-Bresson, the celebrated war photographer Don McCullin stated `...Henri really

Fechner found that the ideal ratio for a vertical rectangle was 5 to 4 or 1.25 to 1, although it is worth noting this does not apply to all subjects.

introduced the concept of the perfect composition...He was the first to teach us to compose within the specific shape of the 35mm frame and to utilize the very nature of that camera and format.'

For a horizontal rectangle, the ideal proportions are 4 to 3 or 1.33 to 1. As the aspect ratio of most DSLR cameras is 3 to 2, you may need to consider cropping your image to apply this; it does however perfectly match a medium format 645 camera.

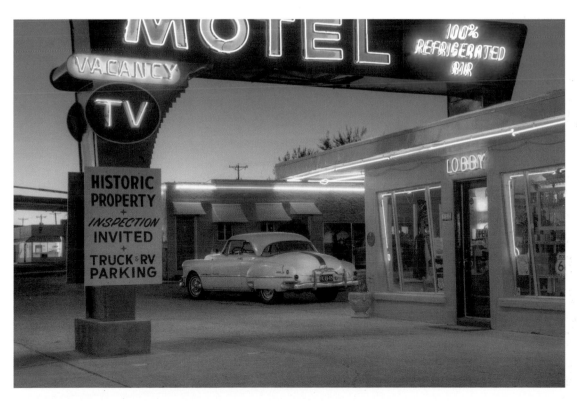

The landscape format is well named, because it is often the orientation of choice when shooting most types of landscape, including the urban scene shown here.

Rectangular format

As most photographers work with a rectangular format, we are immediately faced with a decision on the camera's orientation – whether to choose 'landscape' or 'portrait'. However I feel that this is unfortunate terminology. The notion that when photographing a figure we should automatically hold our camera vertically, but should opt to hold it horizontally when photographing landscapes is unhelpful.

When photographing figures we tend to fill the frame more effectively using the portrait format, but of course from an aesthetic standpoint this is not always the best option. If a subject screams out to be photographed in the vertical format, controversially try turning the camera to the horizontal instead – you are much more likely to achieve an interesting compositional result.

The term 'rectangular' is vague, as it can span dimensions that are slightly longer than square right through to panoramic. Is there an ideal proportion for the rectangular format? While the camera we use will partly govern this, it should be noted that artists do have considerably more latitude and will construct their canvases to reflect very precise proportions, depending on their subject.

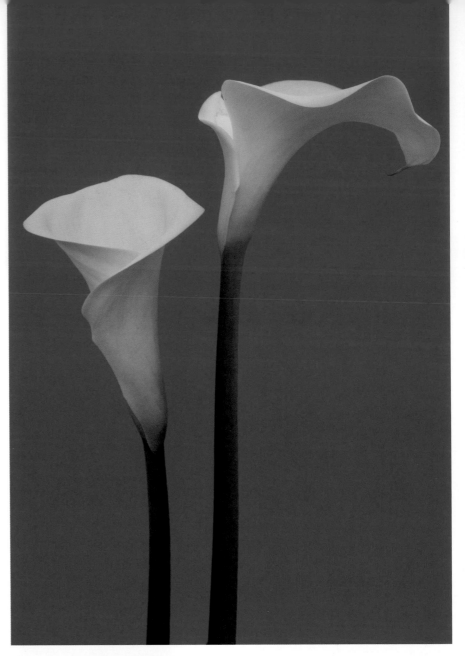

Newcomers to photography often fail to appreciate that many subjects require shooting in the portrait format rather than the more frequently favoured landscape format. In this example I have deliberately ignored the Fechner principle, choosing instead to lengthen the format in order to accentuate the elegance of these slender lilies.

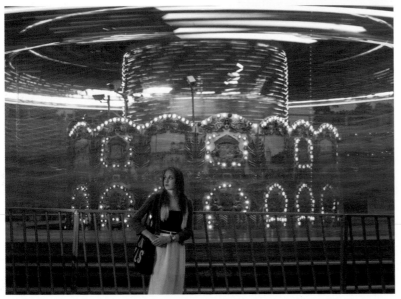

It always helps an image if you can introduce a narrative element; photographed in a fairground, the viewer here is left wondering who the model is waiting for. As the moving carousel in the background has been centrally placed, positioning the model off centre introduces a slight tension. Irrespective of this, the classic horizontal format proportions of 4 to 3 have been applied.

An interesting piece of research was conducted by the German scientist Gustav Fechner, a pioneer of the newly emerging science of psychology in the 1860s. He presented rectangles of white card on black backgrounds and asked people to list them in order of visual preference. Rather interestingly, he found that for vertical images the preferred ratio was 5 to 4 (or 1.25 to 1), while for horizontal ones, most opted for a more elongated ratio of 4 to 3 (or 1.33 to 1) – see diagrams.

Of course the elongated ratio of 4 to 3 perfectly matches the aspect ratio of a medium format 645, although the majority of photographers use a DSLR that has an aspect ratio of 3 to 2. If you use the latter you may need to consider cropping your image, if you want to work with a perfectly proportioned format. Of course if you adopt this principle it runs counter to Cartier-Bresson's notion that you compose for the precise format of the camera.

The best way to work with this contradiction is to apply the Fechner proportions only when photographing highly constructed subjects, where you are able to factor in the degree of cropping required at the shooting stage; for example, this could apply when photographing a still life. Certainly in situations where you are composing intuitively, avoid cropping the image.

Finally, there are occasions when the portrait format benefits from being presented even more elongated. When photographing a particularly slender vertical subject, cropping slightly on either side can increase this sense of verticality.

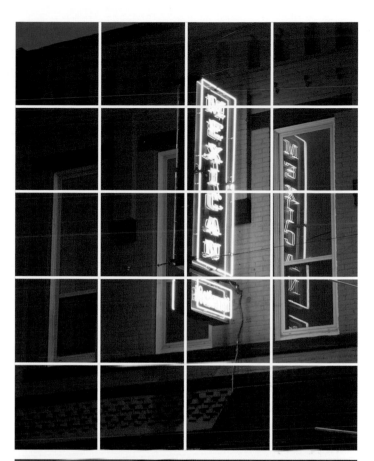

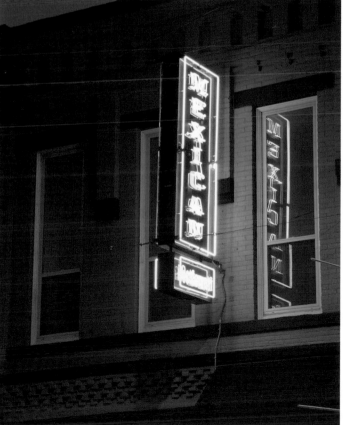

According to the Fechner principle, in order to achieve the most balanced proportions when using a vertical rectangle, apply a ratio of 5 to 4. If you are using a standard DSLR camera, this will require cropping the image.

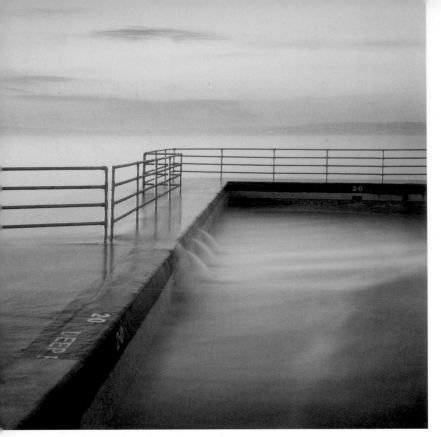

Traditionally, the square was seen as a difficult format to use, as it so clearly resists the Golden Section. Yet when looking for parallels in other areas of the visual arts, we find that the square is used, viewed as a static shape that helps to evoke steadiness, stillness, dignity and wholeness, rest and repose. A useful feature of this format is that it appears to introduce order to an otherwise chaotic scenario: for example, if you were photographing a tangled area of undergrowth, using this format would help to introduce structure.

By way of contrast, it is particularly easy to use simple geometry within a square, most notably the circle and the triangle. Taking the first of these, the circle in the square is a design that features in numerous artefacts throughout history. It is an important element within Islamic architecture and frequently appears in oriental manuscripts. Even today, many contemporary painters use the circle within the square as a powerful yet simple design format. This idea is developed more fully in Circle within a square.

Square format

This particularly interests me. Square format cameras were initially designed to allow the photographer to shoot in either portrait or landscape format without having to adjust the orientation of the camera, assuming that the image could be cropped later on. It quickly became apparent that photographers composed for the square and consequently there was no need to crop; more fundamentally, the nature of these images changed as a consequence of using this square format.

Panoramic format

An increasing number of photographers are opting for the panoramic format. Generally, an extended horizontal format gives rise to a sense of calm, particularly if the horizon starts and finishes at the same level. Using a panoramic format is rather like photographing a narrative, as it actively encourages the viewer to 'read' the image from left to right.

Conventional formats frame the subject, which can sometimes serve to isolate it from its context. Usually this is a good thing, but occasionally it helps to set the image within its terms of reference, which is where the panoramic format can prove so useful. The shopkeeper and his shop exist within a traditional high street, and illustrating this context is important to this image.

Used in this way you are able to create beautifully flowing images, which is often why panoramic cameras are used for taking landscapes. Typically, the foreground elements weave in and out while the horizon provides a fixed frame of reference. It is tempting to view the panoramic format as a means of developing the image horizontally, but occasionally subjects work by using the dimensions of a panorama vertically; as a simple case in point, photographing a tall slender tree might benefit from this approach.

As a final observation, I would suggest that it is better not to crop an image unless that had been your intention at the time of taking it, as your sense of design intuitively accommodates the format being used. If you are using a panoramic format, your mind instinctively takes this into account when designing the image. As soon as you start to crop, you make compromises and then the temptation is to revert to design stereotypes.

Points to consider:

• Your composition will undoubtedly be influenced by the format you choose.

• Unless it is absolutely necessary, avoid the temptation to crop your work as this action could seriously compromise your initial design.

• When using a rectangular format, be prepared to experiment with various orientations, regardless of your initial instincts when assessing the shot.

• An interesting development: some cameras now offer a choice of formats, which positively encourages the user to design the image for the selected format.

It is easy to assume that a panoramic image should always be presented in the horizontal format, but occasionally it works in the vertical. In this example I was particularly fascinated by this harbour-side building and the near-perfect reflection it created. Presenting it as a vertical panorama was the obvious approach.

Capturing reflections.

We should constantly be seeking out fresh compositional angles, and finding interesting reflections to serve as a foil for our main subject is one way of achieving this. The opportunities for shooting reflections abound: the reflections in still water are an obvious choice, particularly within a landscape situation, but there are so many other materials that also reflect – glass, chrome, polished metal, wet mud or sand. I have seen examples where the human eye is used as a reflective surface creating stunning results.

There are different sorts of ways to work with reflections:

• **The mirrored image.** Some reflective materials or situations positively encourage you to compose with the entire reflection in the image. This does require composing with a division midway through the image (which of course runs counter to the rule of thirds), but as I have explained earlier this rule need not be applied in every situation. The fact that the reflection appears inverted should offer sufficient variation

to sustain interest. Without question a mirrored image will assume a strong cohesion, while the subtle variation between the subject and its reflection invites the viewer to make comparisons.

I am an admirer of modern architecture, in particular designs by the talented Spanish architect Santiago Calatrava. One of his creations, the Hemispheric Cinema in Valencia, has been intentionally located adjacent to a large constructed pool so that the reflection in the pool will mirror the building, thus creating a perfect visual palindrome.

• **The partial reflection.** From a compositional standpoint, this approach can offer the most interesting opportunities. What this means is that just part of the main subject is reflected in a small mirror, a pool of water or a nearby metallic object. The results can often prove quite tantalizing, as the reflection will appear as just one of several elements supporting the main subject in the image.

• **The distorted reflection.** This is yet another means of adding interest. The nature of the distortion can vary: for example, by capturing the subject reflected in slightly moving water, the reflection will appear to ripple. If the reflection appears within a curved surface then an entirely different kind of distortion will occur.

It is not always necessary to include the entire reflection to sustain interest. Only part of the cinema appears in this reflection, yet a sense of cohesion has been introduced. Moreover, the slight distortions within the reflection further add to the interest.

Still water offers wonderful opportunities for identifying simple and cohesive compositions. An hour earlier there was a noticeable breeze and the water was quite choppy, but as dusk fell the water becalmed, offering an almost near perfect reflection.

Exploring depth with aerial perspective.

The illusion of depth can be created in a number of ways: for example, by using lead-in lines (see Using a lead-in line to create perspective). However another and possibly more subtle method uses a principle called aerial perspective where rather ironically, the illusion of depth is created by capturing a sequence of flat shapes, with those nearest to the camera looking darkest, while the ones furthest away appear considerably lighter (see diagram). The effect is not dissimilar to a sequence of cardboard cut-outs.

Aerial perspective is an illusion one generally sees in the landscape, particularly in mist. It can also be captured when shooting contre-jour on a sunny day, although the sun does need to be low. While it is possible to capture this wonderfully ethereal phenomenon with a standard lens, it becomes considerably more evident when using a telephoto. As these have the effect of compressing the image, the sense of linear perspective is significantly reduced; instead, the sense of depth is created by a sequence of overlapping shapes.

The overall effect of aerial perspective is slightly simple and abstract; these images are typically characterized by a subtle rhythm, so it is important to avoid discordant elements that could interrupt this. Colour is suppressed at the expense of tone and often the finest examples of this approach are high-key in nature.

Under certain light or weather conditions, atmospheric haze will appear to lighten shapes as they recede into the distance.

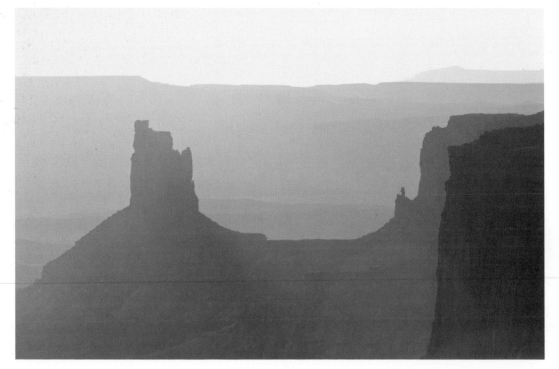

Photographed as the sun was setting, I needed to use a powerful telephoto lens to capture this shot. It was important that I attached a lens hood otherwise I would have encountered lens flare. The sense of distance is created by a sequence of congruent shapes that appear increasingly lighter the further they are from the camera. The simplicity of the design is not unlike a traditional Japanese print.

The process of composing is largely down to the selection and organization of components; the more complicated the image appears, the greater the demand on the viewer. As a general rule aim to include only the detail that is required to communicate the message – everything else is superfluous.

The various shades of grey.

One way of restricting the content of an image is to reduce the colour palette; this can be achieved by presenting the image as a monochrome. By significantly restricting colour, the viewer is made much more aware of the tonal values; moreover when viewing images comprised largely of tone, the sense of mood is greatly enhanced.

A monochrome effect is most easily achieved by desaturating a file then presenting it as a black and white image, although sometimes there is no need to be quite so extreme. Wonderfully subtle pictures can be captured that comprise gentle hues of grey – the mood these images convey is unique.

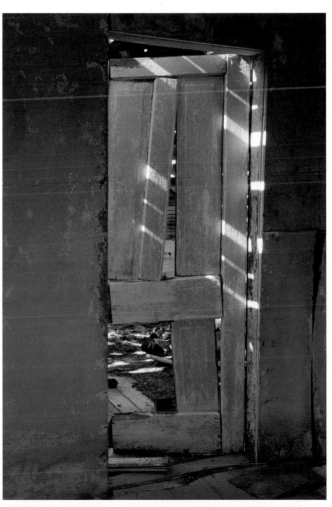

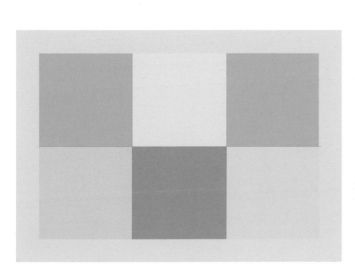

Achieving a totally neutral grey is difficult, as any dedicated monochrome printer will tell you. Most greys will reveal a very subtle bias towards a specific colour.

At what point does a hue cease to be a colour? On first glance this image appears grey, but after just a short time the viewer becomes aware of a range of subtle colours. Rather than a single blanket grey, one begins to identify gentle pink-greys, green-greys and even yellow-greys. These are known as chromatic greys, because while they lack saturation, they are nevertheless distinct colours. While vibrant colours will always have their place in photography, so indeed should subtle hues.

Grey is a particularly neutral colour and can be presented in a dispassionate way. As the interior of this washroom lacks colour, the viewer is drawn to its other visual attributes such as tone, shape and form. A parallel can be drawn with somebody wearing a grey suit: as there is very little colour, we become aware of the garment's cut and shape.

There is of course an emotive aspect to the colour grey, which is particularly apparent in this image. Dominated by an oppressive grey background, a distinct element of melancholy is present. By way of contrast, notice how the model's hands and face appear to glow precisely because the context is so overwhelmingly grey.

There are several aesthetic reasons for pursuing this:

• While the colour grey exists, in reality we hardly ever see a true grey hue. Colours vary in intensity and while some may appear saturated, others can appear elusively faded: what we normally see as a grey might well be a blue-grey or possibly a yellow-grey. Grouping a combination of these various greys can give rise to beautifully understated images, although it does require time for our eyes to adjust; the longer you look, the more apparent these subtle differences become (see diagram).

• The mood created by a subtle range of greys depends largely on the content. With some images the hues appear neutral and as a consequence, because of the lack of colour, the remaining visual elements such as tone, shape or form come into much sharper focus.

• By way of contrast some subjects can appear extremely moody, which the lack of colour accentuates. We often refer to a 'grey day', suggesting that it is dour and gloomy. If you wish to communicate a sense of dreariness or despair, using a restricted grey colour palette is one way of achieving this.

The aesthetics of monochrome.

It was assumed that once colour film became commonly available monochrome would disappear; yet it has sustained its appeal right to the present day. It works equally well with landscape, portrait, still life or reportage photography, and enjoys more than just niche appeal, regularly featuring in the imagery of stylish advertisements, album art or lifestyle magazines.

Undoubtedly monochrome has an aesthetic all of its own: reduced just to tone, black and white images in particular are able to convey a sense of mood that cannot be rivalled when using colour. When composing a monochrome image, by focusing on just one of the visual elements a certain abstract quality is introduced. Moreover, the monochrome approach seems to work particularly well in low lighting conditions when colour is unable to cope with them.

To 'see' in monochrome, it is important to reduce the image down to just its tonal values, which of course is not as easy as it sounds, as the eye sees in colour. To do this you really need to concentrate on the relationship between the light and dark areas, ensuring that an aesthetically pleasing balance is created. Remember that the contrasts one might expect to see by setting red against green become meaningless once those colours have been reduced to black and white.

Tip

If you are seeking to achieve a perfectly balanced monochrome image, apportion the areas of black, white and grey in relation to the Golden Section.

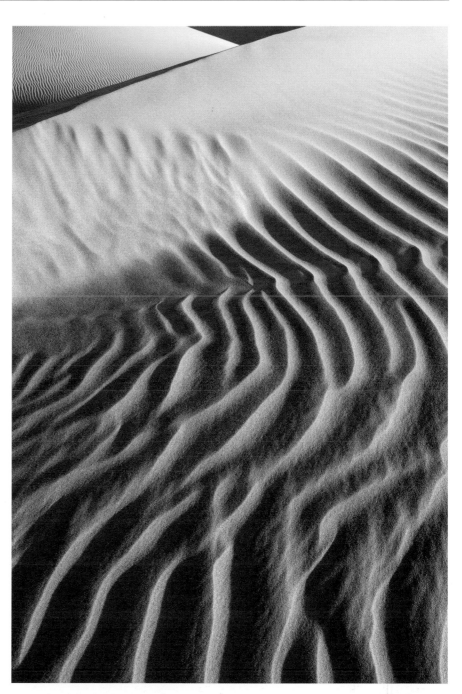

Presenting your image in black and white can introduce a graphic quality that is more difficult to achieve in colour. Reduced to its tonal values, contrast can be greatly increased, which makes the graphic elements more apparent.

One of the appealing aspects of monochrome is its capacity to capture mood. When working in colour, it is often a struggle to produce a meaningful image in overcast lighting, but monochrome seems to excel in these conditions.

One of the reasons so many photographers continue to work in black and white is because it is so adaptable. You are able to exaggerate the tonal values far more when creating a black and white image than with colour; similarly, you are able to present the image with a greatly reduced tonal range – the choice is largely dependent on the mood you wish to create. Furthermore, the opportunity for expressive photography is considerable; you may wish to present the image as 'soot and whitewash' or possibly introduce an exaggerated graininess. When creating a colour image it is recommended that the highlights and shadows are not clipped, but with monochrome the reverse applies: ensuring that you have a small element of pure black and pure white positively improves the image.

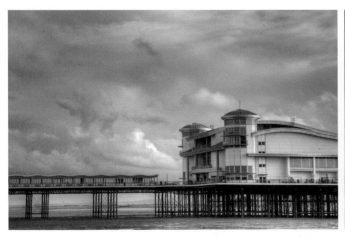

When making adjustments to a colour picture it is recommended that the highlights and shadows are not clipped, as this will often result in distorted hues. The general lack of colour suggests that this is an ideal image for converting to black and white.

One of the reasons so many photographers continue to work in black and white is because it is so adaptable, as you are able to exaggerate the tonal values far more positively. For those with darkroom experience, the contrast in this image equates to a Grade 4 hardness of paper.

The extremes of high- and low-key imagery.

Conveying a sense of mood should be a key consideration when composing an image, and manipulating the tonal values is one way of achieving this. It is often when you are working at extremes that interesting things start to happen, particularly if you are creating either a high-key or a low-key image with limited tonal range.

A high-key image uses a very limited range of light tones and conveys a sense of optimism and light; this limited range makes the viewer feel positive and upbeat. While this is a technique often used in portraiture, it can equally be applied to a landscape, still life or indeed any subject where you are aiming to lighten the mood. From a technical standpoint, while a successful high-key image should reveal a range of delicate tones, none should burn out to pure white. Compositionally, including just the smallest amount of black can

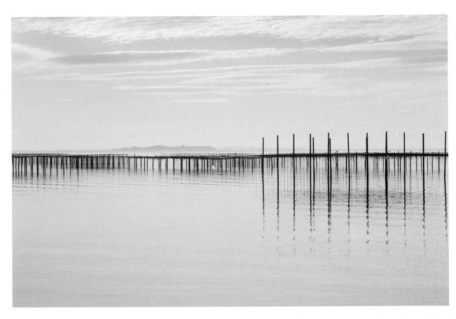

High-key images can evoke a sense of detachment and other-worldliness. From a technical standpoint, the aim is to make all the tones appear as light as possible without allowing any of them to burn out to pure white. Whether this is achieved at the shooting stage or post camera, it does require a great deal of care. High-key images often benefit from just the smallest hint of black.

This low-key image has been presented in monochrome. Unlike a high-key image, a low-key one positively benefits from having a small element of pure black and white present; it is the mid-tones that are principally dark.

(Photographer: Eva Worobiec) The advertising industry is acutely aware of how alluring a low-key image can be, which is why they often use this technique to promote a new car. It does not matter if some of the shadow detail is lost, as the viewer's imagination can easily compensate.

often add substance to a high-key image, but this is in no way a requirement.

By way of contrast, a low-key image is restricted to just the darkest tones and expresses a sombre mood, possibly a sense of mystery. For example, a low-key portrait will convey a gravitas that simply cannot be achieved when working in high-key. Black is also seen as a stylish colour, so advertisers often use a low-key approach to feature a sought-after object such as a high performance car or the latest smart phone. From a compositional standpoint few low-key images work well when all the tones are dark, as it usually requires a few well chosen lighter tones in order to introduce depth.

While high-key and low-key images communicate different moods, they do share certain characteristics:

• Because of the extremely restricted tonal range, contrast is subdued. For those who shoot digitally, you will notice that the histogram bunches to the right with high-key images, but with low-key images the tonal information groups towards the left.

• There is a distinct lack of shadow and modelling that introduces an almost surreal quality to the image; this can be a great stimulus to the viewer's imagination.

• As the emphasis of both high and low-key images is tonal, they can be equally presented in monochrome or in colour.

The benefits of a restricted tonal range.

The normal expectation is that an image should reveal a wide tonal range – a flat one is seen as a mistake. Manufacturers therefore go out of their way to highlight the brilliant colour gamut their film or cameras are able to capture, working on the assumption that nobody wishes to produce a flat image. Yet this is not always the case – once again it comes down to the message you are trying to convey.

There are some subjects, or rather interpretations of subjects, which positively benefit from using a restricted colour and tonal range; this technique can introduce a mystical, romanticized or nostalgic feel to the image. Again this approach has a history: some darkroom workers deliberately process prints in tired developer to significantly reduce contrast. By purposefully restricting the tonal range, the viewer is invited to interpret the picture relative to their own experiences; it is almost as if the photographer is offering just part of the image, leaving the viewer to make up the rest.

Here are some methods for exploiting the emotional value of the restricted tonal range:

• If the image is restricted to just a lighter range of tones, it will resemble a faded snapshot. How often have you examined an old photograph and tried to identify information that has long disappeared? Colour photographs in particular discolour and fade with age, but in the process assume an alluring mystery. Dreamlike, they encourage the viewer to scan the picture, looking for traces of detail. To mimic this effect, you need to deliberately overexpose the image at the shooting stage. If you are shooting on colour film, the exposure and subsequent developing process causes the film emulsion to thicken, which exaggerates the faded effect.

Lacking a specific focal point and featuring a restricted tonal range, this image appears like a distant recollection or possibly a dream. When dipping into the past, our memories are vague and unclear, but strangely reassuring. From a technical standpoint, this differs from a typical high-key image that tends to feature some small area of dark.

• Images that feature a restricted range of darker tones can appear particularly moody, mysterious or even threatening. This technique is often used by moviemakers to create tension and suspense. They feature dark locations such as abandoned buildings or urban wasteland, knowing that as the eye struggles to adjust a sense of dangers lurks. As the tonal range is limited, shapes and forms are not immediately apparent, which stimulates the imagination further. Manipulating colour and tone in this way immediately puts the viewer on the photographer's wavelength.

• Creating an image comprising largely of mid-tones may not create the same sense of drama as using darker or lighter tones, but it is still an effective means of producing highly evocative images.

Tip

If you are attracted to this style of photography, study the techniques of the best moviemakers.

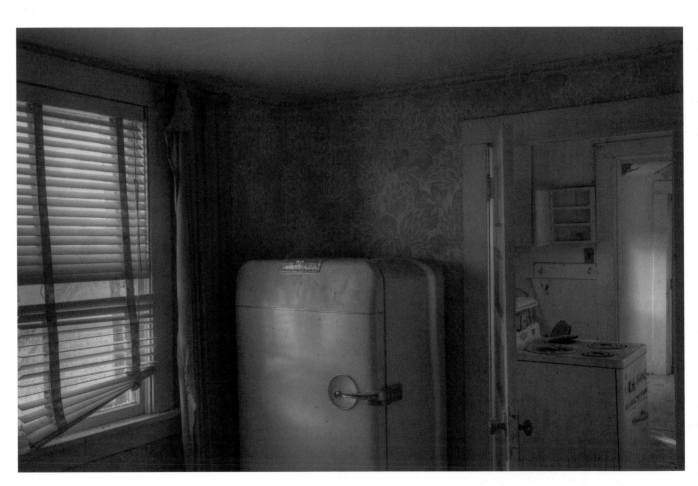

Comprising largely of mid-tones this abandoned interior exudes sadness, which is exaggerated by the restricted tonal range. It also suggests an inadequately lit space, which adds to the sense of pathos – one can almost imagine the accumulating layers of dust. When composing an image, you should always consider the mood that you wish to convey.

The virtue of empty space.

No other medium captures detail as well as photography, but there is sometimes a temptation to include too much in our images. Newcomers to photography are often inclined to fill empty space, although with care these features can be used to add emphasis to the main subject. Clearly, a balance needs to be struck between creating an interesting, well balanced image and one that appears sparse.

When taking a photograph, our attention is focused on one or maybe several principal subjects, therefore we are not always aware of the surrounding space. Possibly we are more concerned with setting our subjects on the thirds, consequently giving the surrounding areas insufficient thought. Yet in order to achieve the very best from our composition this negative space should be considered, as it helps to define the main subject.

Possibly a truism, but the simpler the photograph the more successful it is likely to be. Remember, the purpose of composition is to help the viewer understand your thinking when you took the photograph; presenting the subject within a cluttered background adds confusion, so unless it has a direct bearing on the message, keep the content simple.

Setting the subject within a minimalist environment adds emphasis to it, although finding a suitably simple background can often prove challenging. If you are working in a studio then matters are much more controllable, but finding an uncluttered landscape is not quite so easy. If you do experience difficulties, an uninterrupted area of sky often works well.

This image would appear to contradict some of the more established rules of composition: first because of the large empty space, but also because the figure is located in the corner rather than on the thirds. Yet it is precisely because of these two compositional anomalies that this image appears interesting. The rich detail of the model's costume coupled with her severe pose is countered by the empty space to the right. Ensuring that she faces into the space is critical to the success of the design.

An empty space can help the composition in several ways:

• It helps to emphasize the main subject. Confronted by an empty space, the eye is naturally drawn to detail. Clearly the relationship between the main subject and the background is important, so you might apply the rule of thirds, although you do have other options as well.

• Whether the empty space is large or small, it should serve as a balance to the main subject. So if the subject appears dark, making the surrounding background light will certainly help.

• The proportion of the background to the main subject can enhance the meaning of the subject. So if you are illustrating detail for scientific purposes – for example, a species of moth – a small background would be

appropriate. If you want to promote a sense of agoraphobia, place a figure in a large open space; the smaller the figure appears, the more dramatic the visual effect.

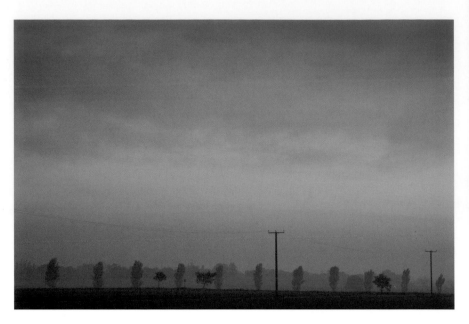

Convention suggests that I should have placed the horizon on the thirds, but what would that have achieved? Photographed in a notoriously flat area of landscape, I wanted to increase that sense of agoraphobia. This is best achieved by emphasizing the large expanse of sky.

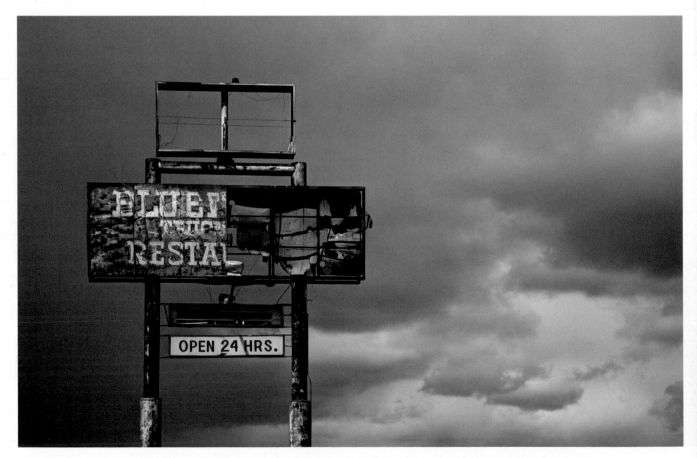

What caught my eye was this derelict and damaged motel sign, so to include anything else would have been superfluous. By using this simple sky as a backdrop, the eye is immediately drawn to the sign, although as good fortune would have it the character of the sky is entirely sympathetic.

Connecting your subject with empty space.

Placing the subject within a sparse setting provides it with emphasis, but it will further assist your composition to ensure that the subject appears to engage with the empty space. This is most easily achieved by ensuring that your subject appears to face back into the picture. Using a figure positioned on the edge of the frame is an obvious example: if the subject stares out of the picture it will appear detached and unrelated, but by ensuring that the figure looks into the picture, it will seem engaged and connected.

It does of course depend on the message you want to communicate. The idea of 'anti-composition', where the photographer deliberately seeks to promote a sense of disharmony, is covered more comprehensively later, but if you wish to introduce an element of edginess, photographing the figure looking out of, rather than into, the frame will undoubtedly help. Whether the subject is animate or inanimate, the same principle applies.

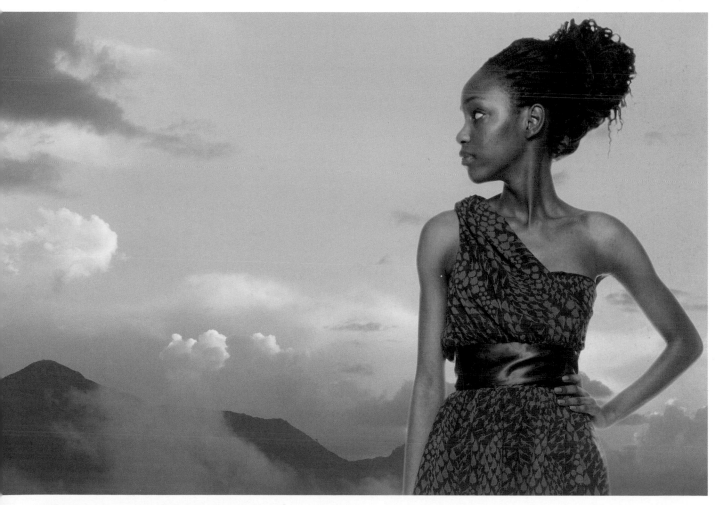

While the model is not engaging directly with the viewer, she is connecting with the rest of the image by looking back into the empty space.

Cropping text.

There will be occasions, particularly when shooting the urban environment, when the composition appears compromised by text – for example, when including signs. If the entire sign is included in a shot the balance of the composition is compromised; achieving a balanced composition requires some of the lettering to be cropped. In these situations you need to ask yourself what it is that you are trying to photograph. The general rule is that the integrity of the composition should take precedence over the text – unless the text plays a pivotal role within the image.

Fortunately, cropped text can actually increase interest. If you photograph an image that includes a sign the viewer's natural inclination is to read it, which can prove an unwelcome distraction. By deliberately cropping the text you introduce a strange contradiction: on the one hand you are seemingly reducing its importance, yet at the same time you are also increasing its interest, as it invites the viewer to anticipate what has been written.

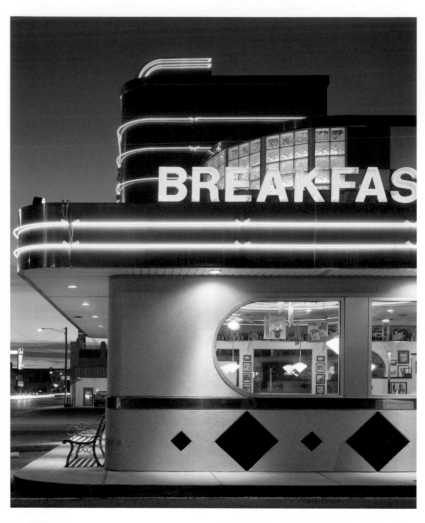

The diner illuminated in this beautiful evening light was the main focus of attention although there was a danger that the eye would be seduced by the word 'Breakfast'. Moreover, including the entire word would compromise the design of the image. This is where you must decide what the subject should be, the signage or the kiosk: in this example I opted for the latter.

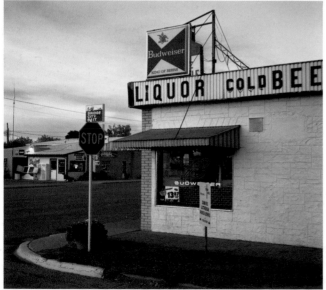

I assume that the sign should read 'Liquor Cold Beer', although it does not matter that part of the image has been cropped – what is more important is that the overall composition has been preserved. There appears to be an interesting triangle created by the stop sign, the 'Budweiser' sign on the roof of the kiosk, and the red neon sign below it – just left of centre this triangle occupies an interesting part of the composition. By moving the camera slightly to the right to include the entire signage, I risked losing that important balance.

Exploring minimalism.

We compose an image for a variety of reasons, but the principal aim is to draw the viewer's attention to what interested us; this becomes particularly apparent when dealing with minimalist images. A minimalist image is one that is stripped down to the barest essentials, and minimalism is a genre that celebrates simplicity, completely exemplifying the axiom that 'less is more'. In order to achieve minimalism you need to remove all superfluous elements, which can prove surprisingly difficult; it is not as if you are starting with a blank canvas, after all. Moreover, your compositional sense needs to be particularly acute; yet get it right, and the results can be stunning.

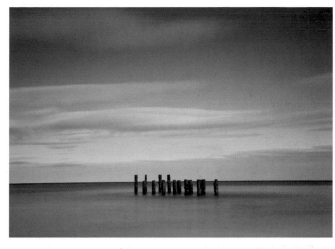

In order to achieve a successful minimalist image you need to rid it of all distracting elements, which can often prove surprisingly difficult. This example is well on the way to becoming a minimalist image, except that the orange groynes in the foreground and the rich blue sky present an unwelcome contrast. By using a relatively strong neutral density filter the exposure has been greatly extended, which has helped to diminish the textural qualities of the moving sea.

By taking this shot at dusk we are presented with a more homogeneous colour range; the subtle blues and pinks gently merge creating an atmospheric, yet minimalist image. Presenting the groynes smaller in the frame also appears to have helped.

The art of minimalism

Minimalism in photography draws its inspiration from minimal art; by definition, this art form is sparse and can certainly make demands of the viewer. One of its earliest exponents was the controversial sculptor Carl Andre who produced an installation of 120 house bricks as part of a much-heralded exhibition entitled *Equivalents*. In this he explored how form could be altered using a specific quantity of identical units, his ideas making way for photographers to explore the compositional potential of greatly reducing the content of their images. Another equally interesting artist was Ad Reinhardt, whose series of *Black Paintings* completed in the 1960s uncompromisingly developed the notion of 'less is more'. On first viewing, each canvas in the series appears to have been entirely covered with black paint, although on closer inspection one becomes aware of subtle variations, which become more apparent the longer they are viewed.

The tradition of minimalism in photography has now been well established. The American photographer Joel Meyerowitz produced a particularly interesting body of work called *Bay/Sky* in which he completed an entire study of the relationship between the sea and sky. Photographed in Cape Cod, Meyerowitz presents a featureless horizon from virtually the same vantage point, but observes the delicate changes in light, tide and weather. Structurally each image is the same, and yet in other ways they are all subtly different.

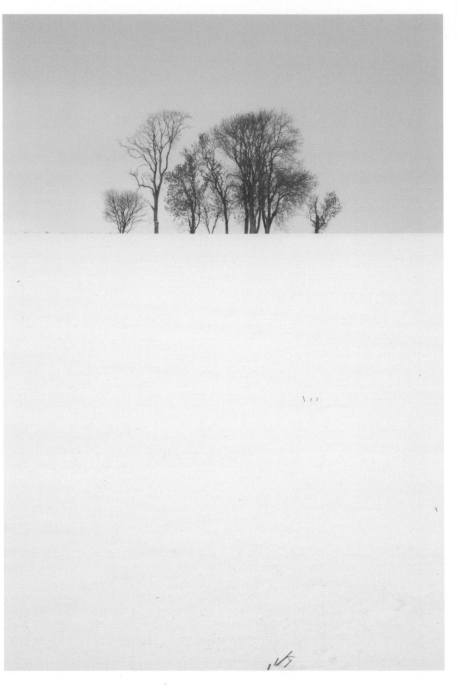

In a landscape situation there are certain climatic conditions that lend themselves particularly well to minimalist photography: snow and winter mist are high amongst them. With these defoliated trees set on the horizon, there are no other apparent features as snow has blanked out the entire foreground. I returned the following day just to see if this image could be improved: the mist had disappeared, and as a consequence I was able to see a distant hill and a line of trees just beyond the horizon. With this increase of detail, the magic of the original shot was lost.

Tip

Producing a minimalist image is viewed as the supreme compositional challenge; the simpler the design, the more sensitive you need to be with the elements that remain.

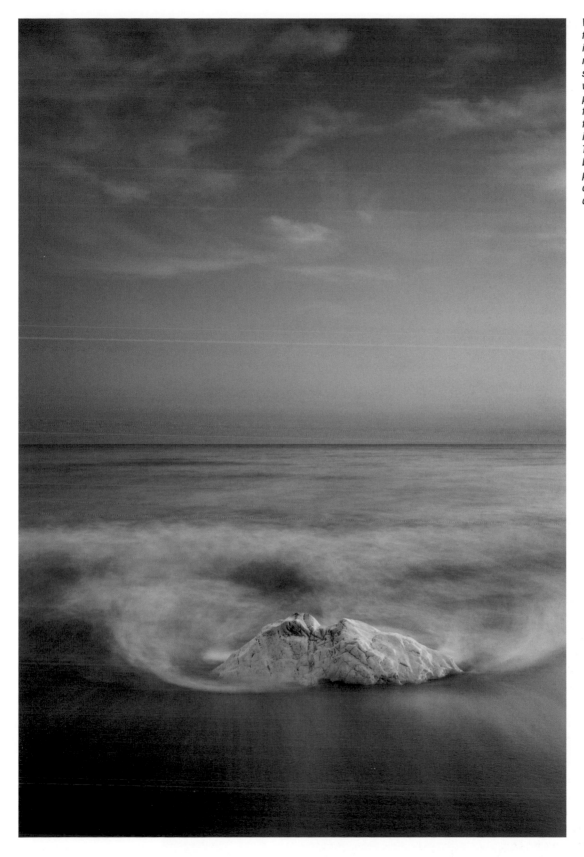

While this beach featured some impressive and noteworthy geological sites, my attention was drawn to the patterns created by the receding tide and this small, seemingly insignificant stone. The subtle interplay between the blue and pinks is sufficiently contained not to prove a distraction.

Working with silhouettes.

Just how simple can the main subject afford to be? A silhouette is essentially the dark mass and outline of a subject against a brighter background, and therefore comprises one of the simplest presentations of subject matter. It is achieved by photographing the subject against strong light; as the ambient lighting is excessively contrasty the lighter areas will appear correct, although the main subject will be underexposed.

A silhouette can often be viewed contemptuously, seen as a mistake made only by the very inexperienced photographer, but it does have a tradition and if it is carefully done it can look impressive. One of the great strengths of a well constructed silhouette is that it appeals to the viewer's imagination; clearly some thought needs to be given to the subject, but some gestures are so universal or monuments so iconic there is no mistaking the subject. Who, for example, could ever be confused by a silhouette of the Eiffel Tower?

Sometimes it is worth considering a partial silhouette, where the subject appears dark against the light background, while retaining some discernible shadow detail. The rim lighting that characterizes this kind of work can prove particularly appealing; it is an approach that works particularly well when photographing plants.

The tradition of creating silhouettes dates back to the eighteenth century, when a portrait in profile was created from a single shape cut from a sheet of black card. The silhouette appeared as a solid mass, but the secret was for the subject to adopt a striking pose. If you are photographing a portrait

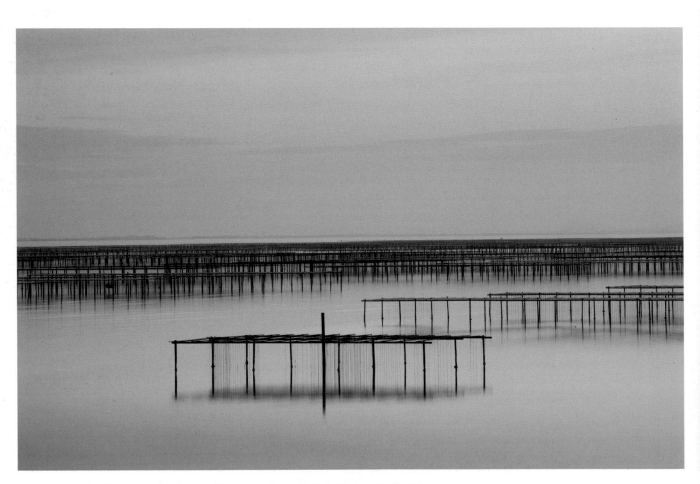

These oyster beds offer a wonderful photographic opportunity, particularly when seen silhouetted against the night sky. The delicate nature of this subject makes it ideal to photograph as a silhouette: the simple linear designs that the beds create are both holistic and visually interesting.

in silhouette shoot from the side, as the shape of the face and hairline becomes immediately more apparent and recognizable.

In a landscape situation, delicate structures such as towers, bridges or piers make excellent subjects, but avoid large indistinguishable masses. The background also plays an important part. In fact, the relationship between the silhouette and the background should not be underestimated because with no apparent detail in the subject, it is the area of the image most likely to sustain interest.

Silhouettes of figures within a backlit landscape often work – the more animated they are, the more successful the shot. When creating images of this nature the design needs to be clear-cut and apparent, and it helps to have a sense of theatre for this to work. It is a technique regularly used to illustrate novels, as the designer, not wishing to be too explicit, presents the hero as a silhouette, offering the reader just a fleeting impression.

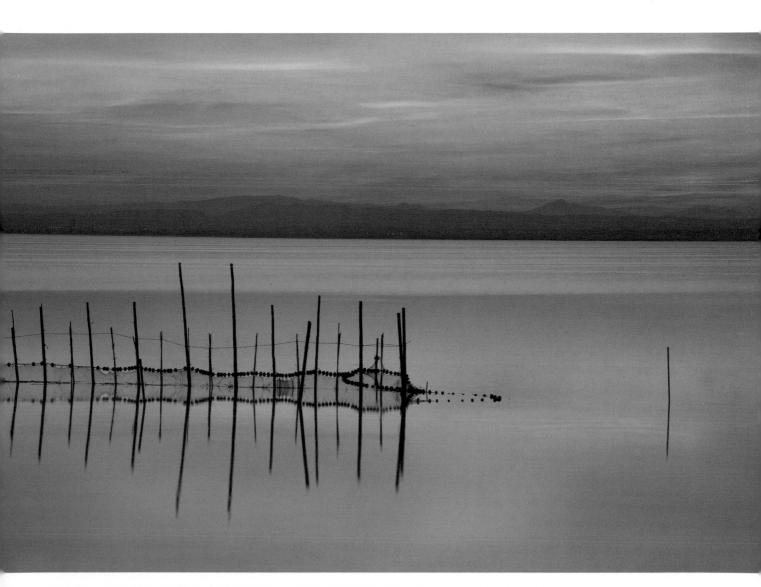

Silhouettes are created in backlit situations. With the sun setting directly behind the nets in the foreground, the sky becomes a pivotal part of the image.

The impact of splendid isolation.

Placing a single object or individual within a large area creates a sense of isolation – it is a technique frequently used by moviemakers to introduce a sense of isolation and tension to a scene. Think of those movie shots where the cameraman focuses on a single vehicle travelling through a hostile environment; the sense of isolation begins to grow in the viewer as the camera zooms out to reveal an empty expanse of barren landscape.

Imagine then a photograph of the ocean: when seen on its own the expanse of water appears benign, but by placing a small fishing boat within it everything changes, as the sheer scale of the ocean dwarfs it. If you then include a harbour, no matter how distant, the image ceases to appear threatening.

Consider yet another scenario: a panoramic view of sand dunes does not necessarily cause us concern, but by placing a single figure within it our sense of danger is aroused.

For this approach the choice of format matters: placing a subject within a square format does not create the same sense of menace as its placement within a landscape or possibly a panoramic format. In order to heighten the tension make the background as vacuous as possible; a gentle pattern can also contribute to this effect, particularly if the subject appears to break the pattern. Finally the subject needs to be positioned close to the edge of the frame, as placing it more centrally suggests a greater sense of belonging.

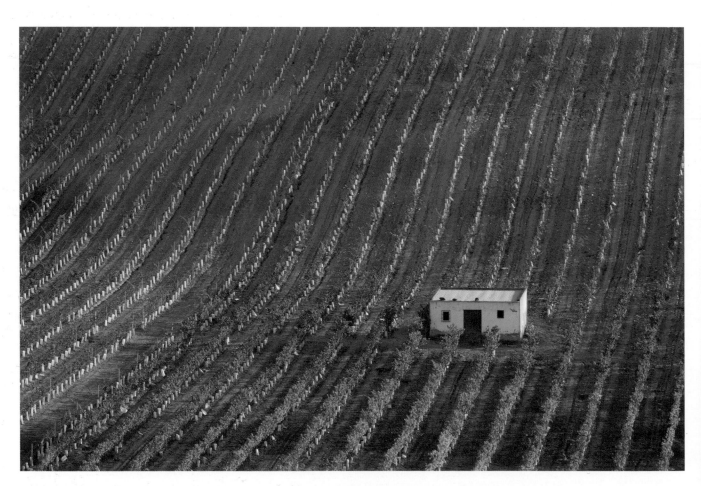

Had there been some other element such as a track to the farmhouse, a vehicle parked nearby or possibly another small building, then this farmhouse would not appear quite so isolated. While scenic, the thought of living in the middle of this vineyard is just not appealing. One needs to have some sense of contact with the rest of the world for it to appear reassuring.

There are several common photographic practices that can be applied to improve your composition. For example, by being aware of those areas that reveal maximum tonal contrast, or maybe by adjusting the depth of field, your intention when taking the photograph immediately becomes clearer. Your choice of lens will also have a bearing.

Illuminating the focal point.

A compositional ploy sometimes overlooked is to position the main focal point in the area of greatest contrast within an image, where the eye will be naturally drawn to it. As a simple example, you wish to photograph a dark figure; looking for a shaft of light and then placing the subject within it will immediately reward you with an eye-catching image.

(Photographer: Roy King) The photographer has patiently waited for the figure to move into the only area of light within this murky urban environment. Our eyes are drawn to the figure because it is located in the area of maximum contrast. Placing the figure centrally rather than on the thirds seems not to matter in this case.

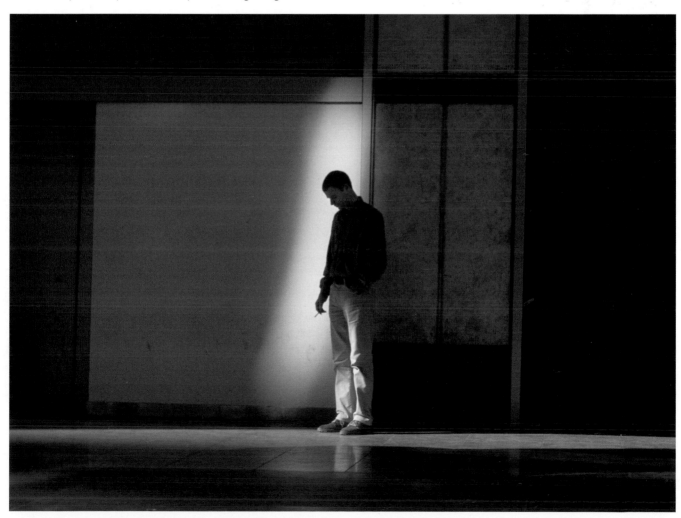

There are various ways to ensure maximum contrast of your focal point:

• **Use natural light.** The best way of achieving an illuminated focal point is to make use of natural light. For example, if you were photographing a tree within a landscape on a cloudy day the shot will appear flat. With a bit of luck the sun will break – although the areas it affects will be random – and by remaining patient the light will eventually illuminate the tree creating an area of maximum contrast.

• **Use fill-in flash.** If you are photographing in low light or at night, directing artificial light on the main focus will immediately create contrast. The more specific the area of light, the clearer your intent will be. While the conventional way of doing this is to use a flashgun, you might find that more unconventional light sources such as a torch or car headlights prove equally successful.

• **Shoot an artificially illuminated subject.** If you are accustomed to photographing the urban environment at night, you will constantly chance upon subjects that are illuminated by artificial lighting. As these will appear much brighter, they will immediately draw the eye so it makes sense to make these the focal point of your shot.

• **Use colour contrast.** Contrast need not necessarily be tonal, as you can use colour equally as well for this purpose. Setting one complementary colour against another is a useful way of creating contrast.

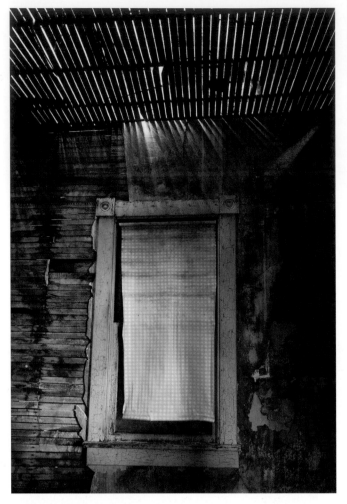

The light shining through the rafters of this abandoned property serves to illuminate the boarded-up window. While the remaining part of the image appears dark, the contrast created by the lighted window instantly draws the eye.

With the softly rising mist this landscape is illuminated by a quiet light, apart for the ruin that is dramatically lit by the early morning sun. The tones are much more contrasty in this limited part of the picture.

Reducing depth of field.

An aspect of photography not always appreciated is that the choice of aperture can greatly improve a composition. Your purpose is always to draw the eye and with very busy images this can sometimes be difficult, particularly when using a wide depth of field – with so much going on, the viewer has difficulty deciding where the main focus should be. By using a narrow depth of field, the eye is automatically drawn to the areas of the image that appear sharp.

We tend to associate a shallow depth of field with close-up or macro photography, yet stunning images can also be captured when using a standard or long lens; it helps to use the widest available aperture. This is a technique much favoured by fashion photographers; while the background is chosen with care it is often thrown out of focus, included just to set the mood – the garments worn by the model always take priority.

While enjoying a cup of coffee, my attention was drawn to this wonderfully iconic tabletop jukebox nearby. While the interior of the café set the context for the image, I really wanted the jukebox to be the main emphasis of my shot. By using a very narrow depth of field, I was able to ensure that the background did not distract from the main subject.

When photographing this cactus, my main preoccupation was the needle-like spines at the edge of each of the leaves. By focusing on just a few to the exclusion of the rest, the purpose of the photograph becomes clearer.

Choosing your lens.

Your choice of lens can also affect the composition of your image. The standard 50mm lens (when using a full frame DSLR) comes closest to what the eye naturally sees, however other lenses, notably telephotos or wide-angle, can introduce an element of distortion that can be viewed positively or negatively.

Points to consider:

• Wide-angle lenses increase the apparent sense of depth and are particularly popular with landscape photographers. If you want to exaggerate the sense of

perspective, these are the lenses to use. As they are capable of covering a wide angle of view the results can appear busy; they are not the ideal lenses to use if you are seeking a minimalist effect.

• By way of contrast telephoto lenses tend to flatten images, reducing the sense of depth. The longer the focal length of the telephoto, the more likely this is to occur. While these lenses have the obvious advantage of getting you closer to the subject, they can also encourage you to shoot interesting abstract images.

• Zoom lenses positively encourage good composition, because you are not only able to explore a variety of focal lengths, but you are also able to decide what to include and what to leave out. Being able to make immediate comparisons in this way helps enormously.

Your choice of lens will affect the composition of your image. In this example, by opting for a wide-angle lens I was able to include the entire structure in what was a relatively confined space. The exaggerated sense of depth these lenses introduce is another aspect one should consider.

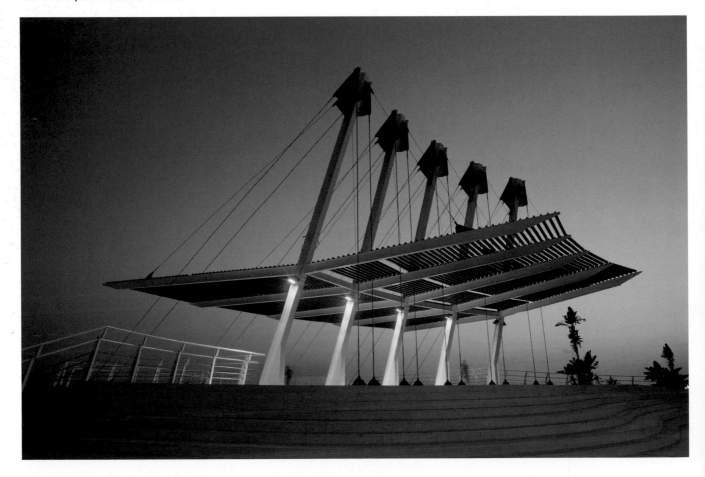

A point I hope that has not escaped your attention is that composition does not exist in a vacuum; many of the conventions that apply to painting, architecture and graphic design also apply to photography. The more you familiarize yourself with alternative ways of constructing an image, the more confident you will become with your own photography.

Abstract in photography.

The term 'abstract' is borrowed from art and describes a genre that is totally removed from reality, where the artist organizes the visual elements to appeal to an inner order. Essentially such work is non-figurative, as the artist makes no attempt at representation: seen within this context abstract photography is an oxymoron, because the one thing photography does is reflect reality. If we follow this logic it is impossible to create a genuine abstract photograph, yet this should not discourage us from being inspired by abstract art.

Here are some guidelines to approach abstract composition in your work:

• Abstract photography is really about responding to a set of visual elements in a dispassionate way. Aim to celebrate them for their own sake, and not see them as contributing to a wider visual statement in the usual manner. Often the best abstracts will feature just one or possibly two visual elements.

• The secret of producing a good photographic abstract is to reduce any sense of depth by concentrating on shape rather than form. Even when photographing a relatively flat surface, try to minimize perspective. From a photographic standpoint, using a macro or long focal length lens tends to disguise depth far more effectively than using a wide-angle lens.

Abstracts can be found anywhere. In this example the movement of foam fascinated me as the tide dragged it back into the sea. Using a fast shutter speed would have proven too literal, so I decided to use a slow one instead; the effect has been to create interesting abstract marks. It was important that no other detail was included.

The more you familiarize yourself with examples of abstract art with its rejection of illusionistic space, the more accepting you become to new photographic possibilities. This detail was found on a large rusting gate.

• When shooting an abstract, be guided by your natural sense of design. If the composition looks good to you, then others will find the image interesting as well. It does not require any hidden meaning – it should simply exhibit cohesion and visual appeal.

• The great thing about abstract photography is that potential subject matter can be found anywhere. If you have not tried anything like this before, modern architecture is an obvious starting point, although you will quickly discover abstract subjects in the home, in the local scrapyard or in close-up shots of nature. Seek out relevant websites or visit art galleries; the more you see, the less resistant you will become to experiment with this fascinating area of photography.

It helps to acquaint yourself with a wide range of artists because the more you see, the less resistant you will be to new ideas. The abstract expressionists, who in the 1950s celebrated the abstract qualities of the calligraphic line, influenced this shot. While this image illustrates a slow exposure of water reeds gently blowing in the breeze, it parallels the spontaneous brushwork that became the hallmark of this fascinating art movement. The mix of sharp and blurred lines mimics paint marks upon canvas.

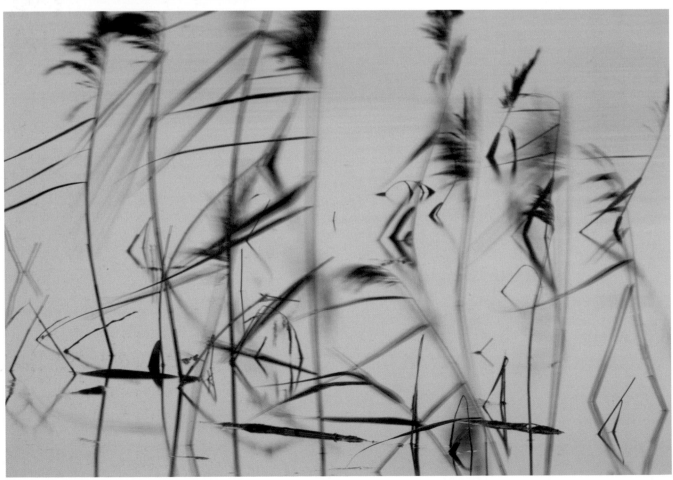

Rhythm in photography.

Rhythm applies to all areas of the arts – music, architecture or literature – and we are constantly responding to its appeal, so identifying rhythms within an image should really come as second nature. There is a need to distinguish rhythm from pattern: while natural patterns can evoke a rhythm, identifying a rhythm is more complex.

It helps to compare the photographic image to jazz, as one can identify a regular succession of strong and weak elements, sometimes discordant, usually harmonious, but all contributing to the same score; to make this analogy just a little more visual, try to imagine intersecting patterns instead.

Identifying rhythms

It helps to be aware of the variety of rhythms we constantly encounter such as staccato, jagged, flowing, arabesque, and so on. View any new situation and we are faced with a visual chaos, but as we examine it more closely, clusters of patterns begin to emerge.

We see this in all aspects of photography: when scanning the skyline of a large town or city the view will appear chaotic until our eyes identify a part that appears to conform to an order. Once we concentrate on that part, we then begin to identify other parts that also contribute to that order – thus a rhythm is recognized.

The same process occurs when photographing a random crowd of people: as each individual goes their separate way, identifying a structure is almost impossible. However if we watch for long enough, there will come a moment when many of the figures randomly conform to a loose pattern or rhythm, which of course is the moment we press the shutter.

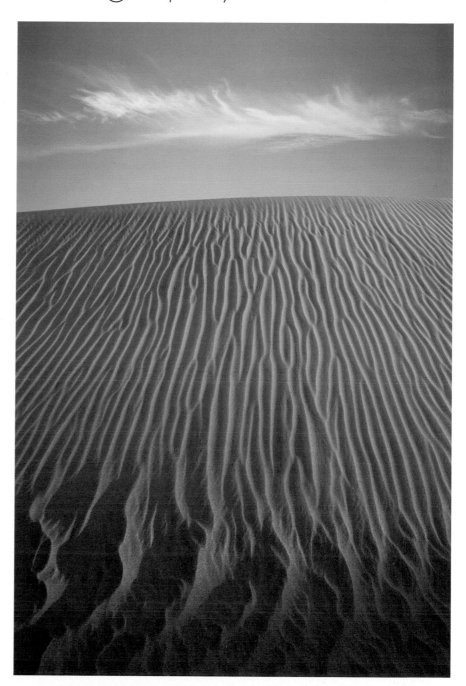

It needs to be appreciated that rhythm is not the same as pattern; in this example, there are three quite distinct patterns. The pattern of the simple rill in the sand dominates this image, however this changes at the bottom where a larger, less defined pattern emerges, which is countered by the wispy cloud in the sky. Rhythm is made more interesting by identifying several varying layers of pattern.

Rhythms are perhaps most apparent in landscape. There are occasions when we are able to clearly see the formation of the land, especially in more arid regions. But all landscape has an underlying structure that can be revealed if sympathetically viewed; all landscape has an intrinsic rhythm that reveals its essential character.

Wind, rain and the extremes of temperature all leave their highly idiosyncratic mark on the shaping of the land. The varying pulses of wind produce ever-changing crescendos and troughs in the desert or over dunes, while leaving its rilled mark over the surface of the sand.

By contrast, the erosive forces of flowing water seek out the weakest faults and penetratingly exploit these to produce an undulating network of rivers and valleys that may take thousands of years to produce. But this is only to see landscape on the grand scale; seen in detail, one can observe the very same forces at play in small streams and rivulets, in riverbeds and in boulders of rock, each element a microcosm echoing the whole.

Unlike other agents of erosion, the sea has the power to erode vertically, nibbling away at the edges of the land, exposing layers of strata and folding schist. At the bottom of cliffs one can

see stones that have been tumbled by breaking surf until all the sharp edges are worn away, leaving them polished to a fine finish.

Finally, there is the last great agent of change – man. There is a somewhat romanticized view of the landscape that seeks to exclude man, but that is unrealistic. Viewed positively the construction of walls and fences, the tilling of the land and the introduction of crops adds to the landscape a manufactured rhythm that can prove appealing. Similarly, fields of agriculture can often reveal the underlying topography that an uncultivated covering might otherwise disguise.

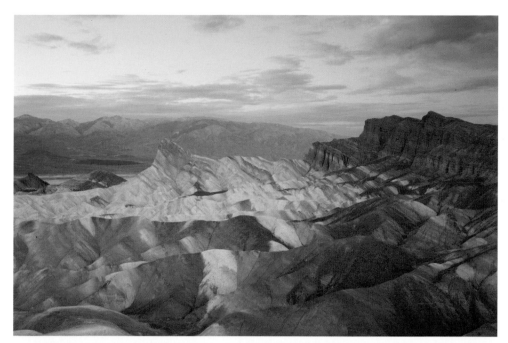

The rhythms here are not immediately apparent as they are distorted, however the strata in the rock create a fascinating interplay between the light and dark areas.

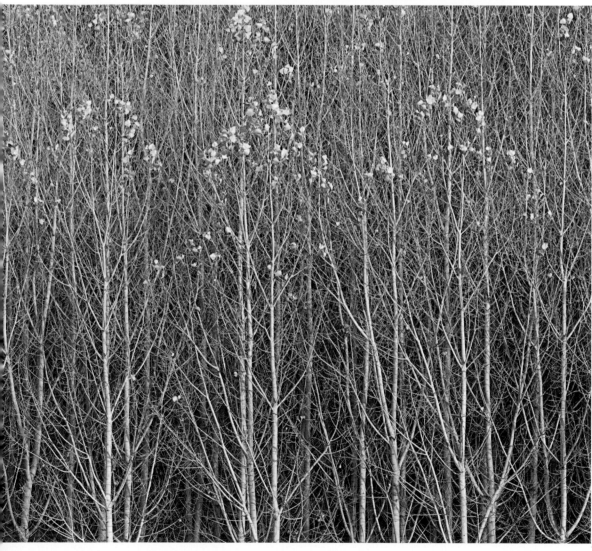

The landscape is constantly revealing wonderful rhythms. Apart from the staccato effect created by the light trees set against the dark background in this image, there is another more tenuous rhythm created by the scalloped lines of the yellow leaves at the top of the image.

CHAPTER 3

Composing post camera

It is sometimes assumed that the process of composition only occurs at the taking stage, but of course you can also compose post camera. Simple decisions such as whether to crop your image will have a bearing on how your image is communicated to the viewer. Your negative or digital file is a means to an end and how you choose to interpret it is a matter of personal judgment.

It is sometimes assumed that composition is a process that occurs only at the taking stage, yet quite important decisions relating to composition can also be made post camera. There are various standard techniques we can employ in the darkroom or in Photoshop that can help to introduce an added clarity to the image.

Cropping for effect.

As I suggested in Choice of format, we tend to design our images for the format we are using. This means that cropping is not something you should undertake casually, but there are occasions when it can prove useful.

Here are some examples of cases where it may be appropriate to crop at the editing stage:

• If you are using a standard camera with a rectangular format, then you will be discouraged from composing using other formats, notably square or panoramic. Yet both these formats promote quite a different emotional response in the viewer, something you may certainly wish to explore further. In order to achieve this, remain aware of the limitations of the format you are using and design the image with a view to cropping at the editing stage.

• In the excitement of taking your photograph, you failed to check the edges; this results in elements appearing within the frame that you do not want – perhaps an unplanned figure or an irritating highlight. With a little judicious cropping post camera, the overall composition can be improved.

• Sometimes it helps to alter the proportions in order to improve the composition. For example, having reviewed your image you decide that the main focal point should appear on the thirds. This is sometimes difficult to do at the taking stage and is more accurately achieved once the image is viewed on screen.

• Occasionally the main focus of interest is contained in just one part of the image file. As the resolution of sensors improves, it is possible to crop quite savagely without

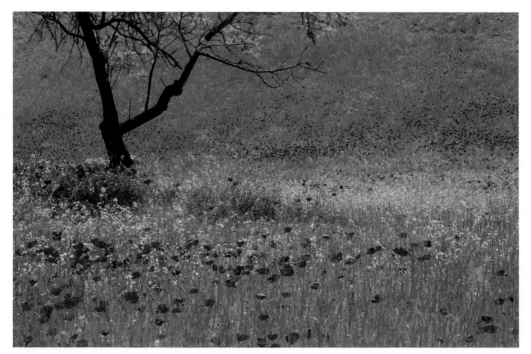

When taking this shot, I sensed that much of the area to the right was redundant, although I was quite pleased with the composition to the left. I took the shot knowing that the composition could be cropped at the editing stage.

compromising quality. It may be that you were using the wrong lens, so this is one way of resolving the problem at the editing stage.

• While continuing this concept of cropping, it can of course be very effectively applied at the shooting stage. An aspect of composition sometimes overlooked: interesting, possibly even challenging images can be created by severely cropping the main subject in camera. Initially this might look like a mistake, but by deliberately framing the subject so that only a part of it appears, a new dynamic is introduced.

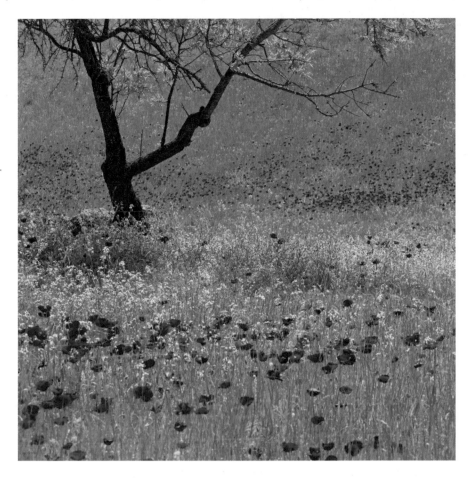

By cropping this image to a square format, not only have I got rid of the superfluous elements, but also the tree now plays a more prominent role within the composition.

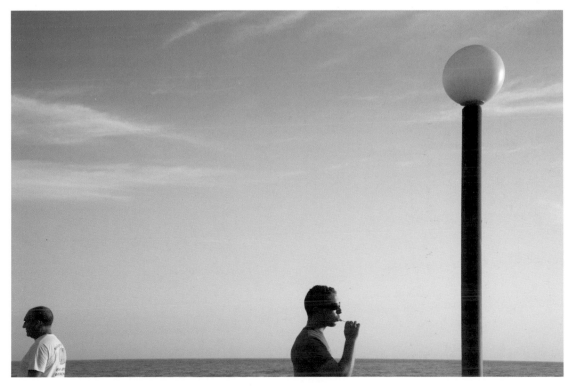

This shot was taken while enjoying a leisurely cup of coffee; my attention was drawn to the lamp, but as I framed it I realized I was also including various pedestrians walking by. By savagely cropping the figures, we are presented with various cameos that may well have remained unobserved. The cool dude in the centre is sucking a lollipop, while the figure walking out of frame appears deep in thought.

Manipulating tonal values using HDR.

HDR (higher dynamic range) is a technique for overcoming the shortcomings of digital sensors not capable of handling excessive contrast in the same way as film can. All new processes create their own spin-offs, and HDR software systems offer almost limitless controls that can be used to manipulate composition post camera. There is always a danger you'll mess up an image by over-processing, but if used with skill this can be an effective method for adjusting both the colour saturation and the tonal values of your images.

Here's how to use HDR to improve composition:

• It is an excellent means for fusing together the subject and the background. There are several specialist software packages currently available for this, although Photomatix is viewed as the industry standard. More recent editions of Photoshop also offer a HDR option; to access it go to File > Automate > Merge to HDR Pro. Comparisons have been made with painting insofar as you are able to retain rich detail in all areas, although if taken to excess the photograph loses its sense of depth – this could of course be the user's intention.

• HDR is an effective method by which to exaggerate texture. Used with care, you are able to introduce localized contrast and create detail that is impossible to create using conventional photographic processes.

• HDR can introduce an enhanced graphical quality, which is its defining characteristic; love it or hate it, HDR does offer you this option.

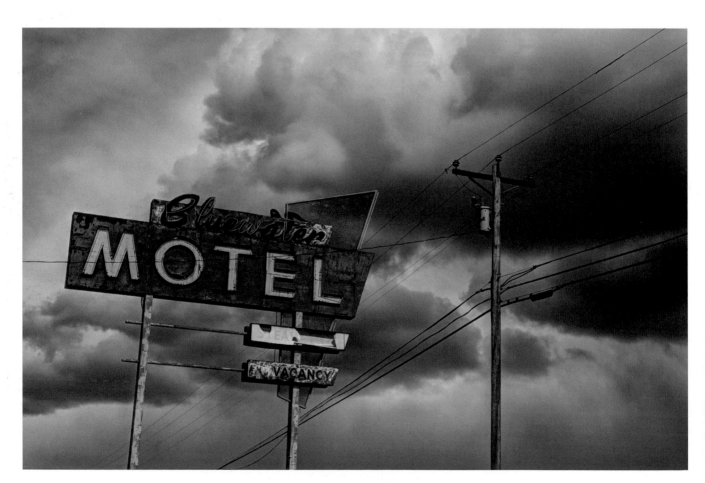

One of the features of HDR is that it does introduce an almost painterly effect, where the detail is equally apparent in both the foreground and background. In this example, the thunderous sky adds a certain mystique.

If we are to continue seeking parallels with other aspects of the visual arts, it might help just occasionally to view photography as a process of image capture, and to use the elements created to construct something unique and personal to the photographer. There are various conventional and possibly less conventional methods you may wish to consider.

Embracing the constructed image.

Once we move away from the notion that photography should only reflect reality then new ideas emerge concerning how the image should be composed. The pop artists of the 1960s explored ways of merging painting with photography to develop innovative ways of constructing images; as they were no longer seeking a realistic view of the world, they were able to design their images in a more novel way.

It is quite conspicuous how enthusiastically contemporary graphic designers have adopted these new ways of creating images. Look at current book design or album covers and you will notice that they experiment with layers and textures in order to create visually exciting compositions. With the advent of Photoshop, this is an approach available to us all and I would urge you to embrace the potential offered by constructed imagery. One of the great virtues of Photoshop is that it allows the user to work with overlapping layers. By applying varying opacities and the numerous Blending Modes, it is possible to achieve truly unique images.

This image was inspired by an exhibition of paintings I recently visited where the artist had constructed her images using a single large central panel surrounded by a number of uniformly sized satellite panels. While these images were exclusively abstract, I quickly appreciated that the structure of her work could easily be applied to photography. Thus, I first copied the fly using a flatbed scanner and then captured further biological specimens, merging them into a single composite. Sometimes it helps to look outside photography for inspiration.

The constructed kaleidoscope.

Developing the idea that the image can be constructed, one very effective method of creative composition is the constructed kaleidoscope. This is where an original image or images are mirrored and then joined together to create the final composite photograph. The result will have a strong abstract quality, not dissimilar to viewing your original subject through a kaleidoscope.

Start with an image that already has abstract qualities: ideally the colours should be muted otherwise the final result

will appear too busy; it also helps if some of the edges within the image are straight. How you structure the composite is a matter of personal judgment, but starting with a rectangular image you have four sides to play with, so experiment to discover the permutation that works best. While the various options appear on screen, try rotating or flipping each of them to assess the visual impact. The outcome will not always be obvious so developing an open approach to composition in this instance helps.

The original image: often the best kaleidoscopes start from something quite abstract, in this case a stack of chairs.

The appeal of the constructed kaleidoscope is that it is both ambiguous yet familiar. Constructing something like this was relatively straightforward: with the original image on screen, the Canvas Size was extended to the right and the file was then duplicated, flipped horizontally and repositioned. With this part of the task completed, the Canvas Size was then extended upwards and the new file duplicated and rotated 180 degrees. With a composition such as this you take it as far as you want to go.

The visual palindrome.

Similar effects to the kaleidoscope can be achieved by creating a visual palindrome. A palindrome is a word or sentence that reads the same backwards and forwards; much quoted examples include the words 'oxo' or 'madam'. Thus a visual palindrome is where one side of an image exactly mirrors the other (see diagram). These kinds of images can occur naturally. One immediately thinks of a subject reflected in a mirror, although there will be other less obvious examples as well; architectural detail tends to follow this pattern, while nature can often provide us with similar examples. The appeal of the visual palindrome is that it introduces an immediate sense of structure and balance.

It is of course possible to create a visual palindrome in Photoshop by extending the Canvas size, copying and

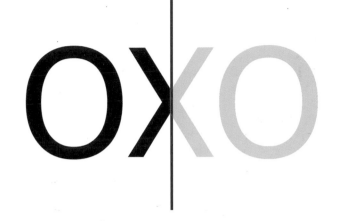

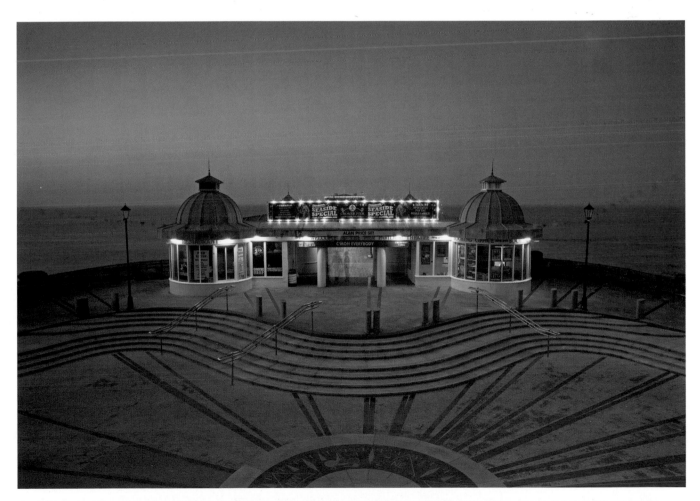

Occasionally we encounter a mirrored design that looks so perfect the viewer is tempted to believe that it has been constructed. Here it is not just the pier head that appears mirrored, but the area of foreground as well. The bland sky in the background does not offer any clues and it is only after careful scrutiny that the viewer fully appreciates that this is an authentic photograph. Small details such as the bunting on either side of the image reveal subtle variations, and of course you would expect to see the text 'Seaside Special' inverted on one side or the other, but in most respects this is a perfectly observed visual palindrome.

then flipping. The results can be either plausible or blatant depending on your intended visual statement. Interesting things can happen if working with a portrait: take the subject looking directly into the camera, select just one side of the portrait and then copy and flip it in Photoshop to construct the other side. While it is rare for a human to have such apparently even features, it is nevertheless plausible. On a slightly different tack, it can be quite interesting to repeat the same exercise with the other half of the face then compare the two palindrome images; they will often appear like two quite different people.

From a compositional standpoint, the visual palindrome is both appealing and cohesive. Generally the 'join' will appear down the middle, yet that should not deter you from adjusting it slightly to the left or right to create an asymmetrical design, although clearly if this is overdone the structure of the design will be lost.

A visual palindrome can be created not just by flipping the image horizontally, but by inverting the copied layer as well. This is a design principle that can be applied in various ways. If you are wondering where you have seen this design format elsewhere, just look at a pack of playing cards. The principles of design are universal and can be applied to photography as well as any other art form.

When experimenting with compositional ploys such as this, there is no need to observe them to the letter. This constructed still life appears to conform to the notion of the visual palindrome, but by exposing the inside of the pods in the top left of the image that sense of absolute uniformity is lost.

The negative of a positive.

Have you ever held a colour negative to the light and marvelled at its mystery and beauty, only to be disappointed when seeing the resulting print as a positive? Similarly, how often have you been disappointed with a digital image on screen, but as soon as you hit Invert the image seems to come alive? No doubt you wished that you could retain the image as a negative, but convention tells us that is just not acceptable. Why not! Composition is about making aesthetic judgements and occasionally it is worth pushing yourself a little further.

In fact the tradition for presenting a positive image as a negative is not entirely new and dates back to the first half of the twentieth century. The surrealist painter and photographer Man Ray experimented with photograms (often referred to as rayographs) in which areas that should have been dark appeared light, and areas that should have been light appeared dark. While this might be an affront to reality, it does encourage us to examine our imagery afresh. Countless photographers have carried on the tradition including the British 1960s pop artist Richard Hamilton.

With certain subjects, it seems not to matter whether they are presented as a positive or negative. In this example the viewer is encouraged to enjoy the novel juxtaposition of shapes, tones and the strangely diaphanous colours.

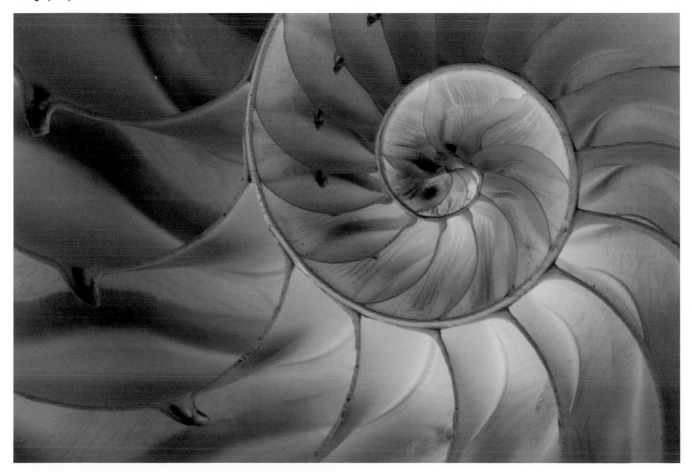

Creating translucent layers.

Have you ever either purposefully or accidently double-exposed a frame? Either way the results are often quite a surprise, as an element of randomness is introduced. Rather than anticipate what you are likely to achieve, you need to react to what emerges. From a compositional standpoint this makes certain demands; as we are not able to control precisely what occurs, the process of editing becomes considerably more important. We evaluate the various juxtaposed layers and then decide whether we like the image or not; clearly colour, texture and form will prove particularly important in this decision-making process. It does take courage to deliberately misrepresent an image in this way, but the more open you are to fresh challenges the more successful you are likely to be in your composition work.

Once again this is an approach that has a tradition. The impressive American painter and photographer Robert Rauschenberg excels in this kind of work. While I am fond of quoting twentieth century painters, it is also a technique that seems popular with contemporary graphic designers. It is easy to see why: layered images suggest layered meaning and it is an invitation to interpret the picture at a more personal level. As we look at photographs of this kind, different elements resonate depending on our personal experiences. Sometimes they will stimulate thoughts and ideas the photographer had not intended, but that is part of the appeal.

There is a concern that photography can appear too realistic, leaving little room for the imagination. Introducing layers helps to introduce an enigmatic quality that encourages the viewer to interpret the image on a more personal level. The pose of the dancer contrasts with the random marks created by the added layers.

When creating images of this nature restrict them to a simple theme; having a single dominant focal point introduces cohesion. The more layers you introduce, the more challenging the image becomes, so having one feature that binds the rest of the composition together undoubtedly helps. You need to be aware of the possibly conflicting visual elements, in particular texture and colour. Overlapping images tend to create interesting although unintended patterns; on a similar note it is important to consider how the colours of the various layers interact, or you might introduce an unwelcome sense of discord. Finally, always have other options available. When doing this kind of work there will be aspects of the composite that appeal, but parts that do not; by slightly altering some of the layers, those areas that initially gave cause for concern can easily be improved.

The appeal of working with layered images is that it opens the opportunity for layered meanings. While this model was photographed in a studio, the added layers have introduced a slightly threatening element to the piece. From a compositional standpoint, it does help to have just a single main feature otherwise the image might appear confusing.

At what point does a photograph cease to be one? All the detail has been drawn from photographic sources, so in that sense this is still a photograph, but by introducing five overlapping layers merged together, a new reality is created.

Adding a vignette.

The purpose of composition is to direct the viewer's eye to those parts of the image you consider most important. As we rarely compose from the edge of the shot, the main focus tends to appear in the more central parts of the image. As light areas attract attention far more than darker areas, it helps to scan the edge of the frame when taking the photograph to ensure there are no light areas intruding into the image. If there are, either crop them out or darken them – light areas on the edge of the frame become a distraction.

The extension of this principle is vignetting, when the corners of the image appear darker than the rest of the image. There are several reasons why this might occur accidentally: for example, if you stack too many filters on to the lens at the shooting stage, expect some parts of it to appear in the image. Possibly the most common cause of vignetting is a poorly fitted lens hood and is especially common when using a wide-angle zoom. However it is caused, unplanned vignetting is something to be avoided.

There is of course a positive side to this: a vignette can be added to softly frame an image in order to focus the viewer's attention to the centre. It is a technique regularly used by wedding or portrait photographers to add emphasis to the main subject. Whether you are working in the darkroom or producing your images digitally, vignetting the corners can greatly improve them.

This very simple seascape features a single dark rock on the left and a headland in the distance, but as the rest of the image comprises light tones there is a tendency for the eye to wander.

By adding a gentle vignette in the corners, the viewer's attention is drawn away from the edge of the picture and towards the areas that matter.

Whether to add a border.

The decision whether to add a border at the editing stage is a tricky one, as sometimes it can help, but on other occasions it could prove an affectation.

The **advantages** of adding a border:

• If you are dealing with a high-key image, particularly if the background is light, there is a danger that the image could bleed into the background. Applying a thin black or dark grey keyline prevents this from happening, and remains sufficiently discrete so that it does not detract from the image.

• Occasionally – and this really must be stressed – some images can benefit from an extremely elaborate border that becomes an integral part of the image. More common in graphic design than in photography, a grandiose border can be made that mirrors the image it contains. For example, having produced an image of a garden you may wish to construct a border comprising garlands of flowers. Thought would need to be given to the colour and textures of the border, as it needs to be sympathetic to the image as a whole.

The **disadvantages** of adding a border:

• It could be viewed as being ostentatious.

• Unless the border is chosen with care, it could serve to draw the eye and prove a distraction.

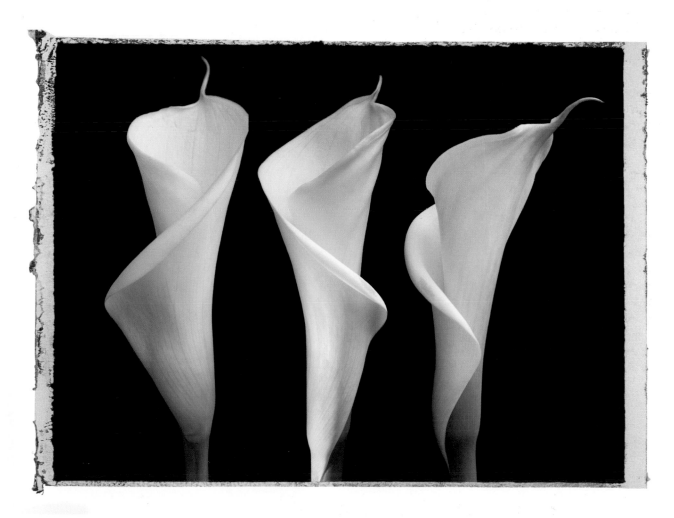

Whenever you introduce a border, you need to be sure that it will benefit the image and will not draw the eye away from the main subject. In this example the impenetrable black background appears rather severe, so introducing this lighter frayed background is one way of countering this. Others of course might view this as needless ostentation.

CHAPTER 4

Taking a fresh look at composition

Composition applied to any art form is designed to inspire harmony and balance, but sometimes you need to question whether this is always required. By deliberately ignoring the so-called rules, you are introducing a disquieting element which might heighten that sense of pathos you wish to communicate. Also, the more open you are to what is meant by composition, the more able you are to design your image to reflect your aims. The key is to consider what your intended visual statement is and then to appropriate those aspects of composition that best serve the task.

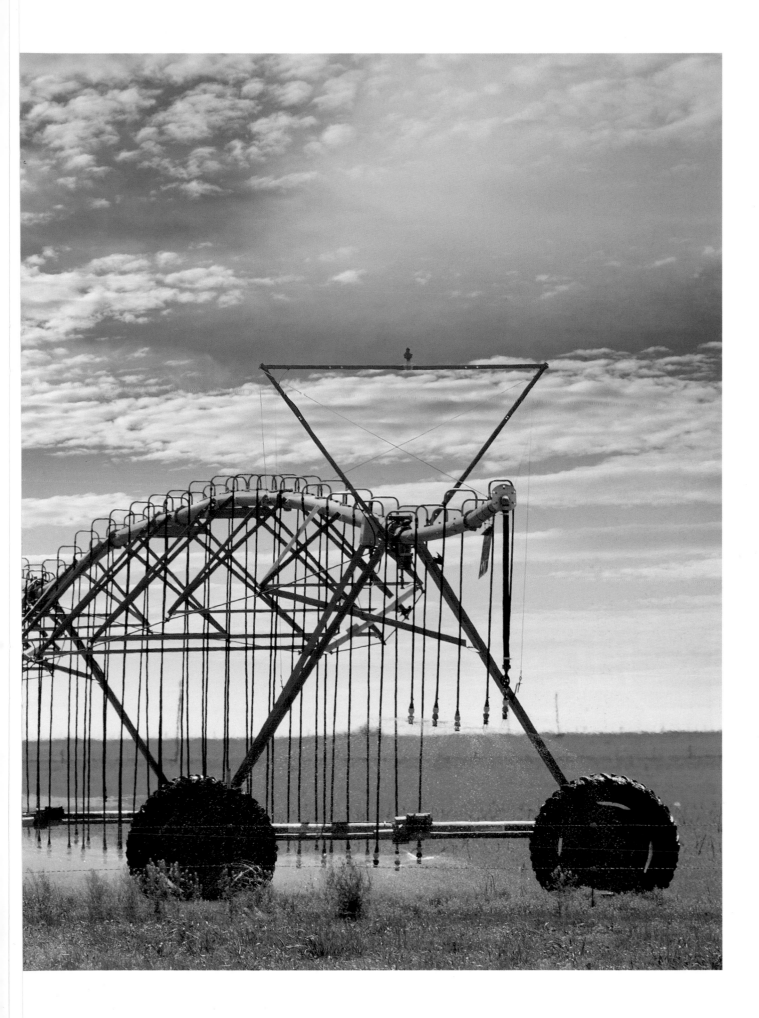

Identifying order amid chaos.

Identifying order within a situation of chaos happens far more frequently than we sometimes appreciate. This process is possibly best illustrated by imagining a tumultuous crowd of people below you. The situation is completely random as each individual goes their separate way, but as you watch there may be a moment when the moving figures briefly conform to a pattern. You have just a second or two before that sense of order melts away. Capturing this requires great timing – and confidence. You need to be sure that you have chosen the precise moment, because you do not have the luxury of analysing the situation.

A less demanding situation, but one that nevertheless requires a confident approach, is photographing uncultivated flora. Plants grow randomly and identifying a pattern can be elusive, but by carefully looking and experimenting with various options, a sense of order will emerge amid the apparent chaos.

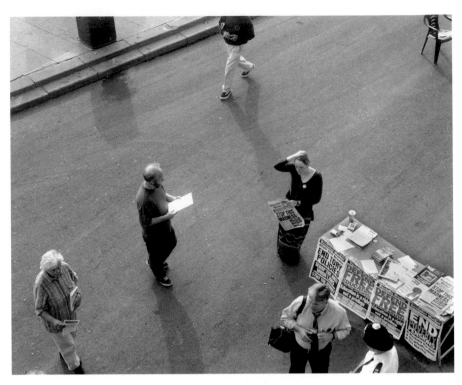

(Photographer: Roy King) Work of this nature requires great patience and a quick mind. The photographer had no control over the moving figures below, and needed to rely on his innate sense of composition to decide when to press the shutter.

Wild flora can prove particularly difficult to compose because the various species occur quite randomly, but by carefully looking an order emerges amid the chaos. In this example the interweaving rhythms created by the red poppies and the yellow canola creates a loose but distinct pattern.

Planning for the critical moment.

One of the truly impressive aspects of photography that sets it above all other visual arts is its capacity to freeze a moment in time. Whether you are shooting sport, natural history or possibly fashion, anticipation is a crucial part of the process. However this is a tradition best exemplified in the work of the legendary French photojournalist Henri Cartier-Bresson; typically he would explore urban areas capturing life as it unfolded and has since inspired a whole generation of street photographers. It is quite easy to imagine Cartier-Bresson scouring the alleyways, noticing some interesting subject matter then making a split-second decision to capture it. While this scenario may well have occurred, the majority of so-called street photography is actually carefully planned.

Recognizing that a particular scenario has potential, street photographers, sports photographers or natural history specialists will wait to see what happens, planning for the critical moment when all aspects of the composition are in place. While looking through the viewfinder, they will organize the static elements into a strong composition, hoping that the moving and of course entirely unpredictable elements position themselves in key parts of the composition. To be successful at capturing this kind of critical moment, your sense of composition needs to be particularly astute, although a measure of flexibility is also required.

Points to consider:

• Identify an interesting scenario where you anticipate possible action; view this rather like a theatre, waiting for the main actors to arrive.

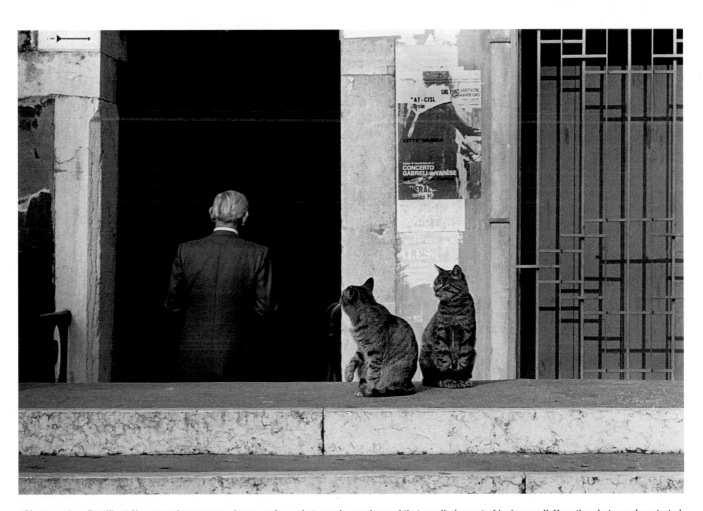

(Photographer: Roy King) No matter how prepared you are for a photograph, you do need that small element of luck as well. Here the photographer started with a simple scenario featuring two cats with a window on one side and an open doorway on the other. Anticipating a figure moving into the doorway the photographer briefly waited, but pressed the shutter precisely at the moment the cat on the left turned to look at the passing figure.

• Having already anticipated the required shutter speed and aperture, compose the various non-moving elements. At this point, you should have some idea where the subject or subjects should be ideally placed. Pedestrians often follow a set pattern and anticipating the route they will follow is not difficult.

• Be prepared for the unexpected; while you may have a particular composition in mind, things do not always run to plan. If the moving elements stray into areas you had not anticipated, take the photograph anyhow then review your work at the editing stage. If your overall composition is strong, it can certainly withstand the odd unplanned element.

• With the scenario already composed, you are able to concentrate on the main subject; look for that one special gesture that makes it unique.

• There will always be a small element of luck with this kind of photography; embrace it when it happens.

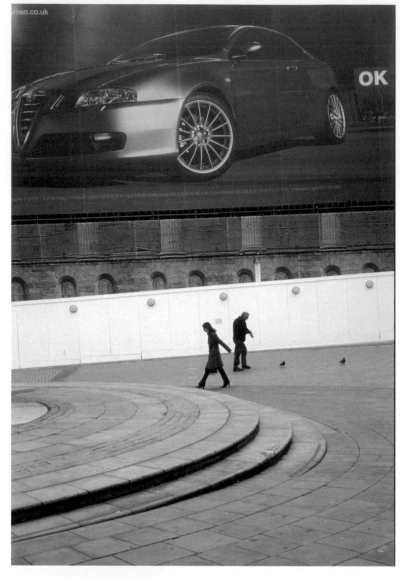

(Photographer: Roy King) This is a wonderful example of where the photographer had both planned the scenario and then anticipated how the composition would be improved with the inclusion of moving figures. That little bit of luck was added in the form of the two pigeons. Good street photographers show an astute sense of composition, but react instinctively to an ever-changing situation.

With street photography, it helps to initially identify an interesting scenario that will serve as your theatre for the unfolding drama. Photographed at night, I was fascinated by the quality of light and the simple patterns created on the paved area. With the camera focused on this area, I simply waited for figures to appear.

Understanding the role of editing.

The word 'luck' can sometimes appear condescending as it suggests something that is outside the photographer's control, yet there are countless examples where luck plays a part in the success of an image. As we saw in Planning for the critical moment, while luck often has an important part to play, particularly when photographing a constantly changing event, credit must also be given to the photographer's sense of anticipation.

Camera technology has changed substantially in recent years and one feature that was not available several years ago is live view. This feature has several advantages: first, you are able to follow a sequence of events as they unfold, allowing you to take the photograph at precisely the right moment; second, as you are not raising the camera to your eye, you are able to view your subject unobserved.

(Photographer: Roy King) The photographer in this example illustrates a very keen eye – having spotted an interesting situation he waited to see what would happen. Undoubtedly he would have taken several shots, each capturing slightly different gestures. The man on the mobile is deep in thought, which is wonderfully mimicked by the large poster behind him. With the photographer's attention focused on his subject, it is unlikely he would have seen the figure emerging from behind the poster, but when editing his work he realized what an important contribution this adds to the composition.

(Photographer: Eva Worobiec) This is an excellent example of the photographer responding to the bizarre. Sitting in a café her attention was initially drawn to the vase of flowers on the table, but looking beyond them she noticed another customer further away. By carefully framing the image, she makes it appears as if the flowers are growing out of her subject's head.

Editing in composition

There is often an assumption that the process of composition occurs just before taking a shot, but this is not always the case. There are occasions when much of what you capture is beyond your control; you should therefore take numerous photographs with a view to editing your work later on. So when working traditionally, it is not uncommon to shoot off an entire film. If shooting digitally, do not be in too much hurry to remove files; you may have amassed 20 or 30 shots of a single subject but carefully whittle them away at the editing stage, just one at a time.

Editing is a skill that should never be underestimated. In the hurly burly of taking shots, possibly with other people around you, it is difficult to assess which images have worked. Just keep shooting and worry about composition at the editing stage. Some cameras now feature a video mode that allows you to capture multiple frames. While I am not recommending that you regularly review hours of video looking for the best shot, it might be helpful when used just for the occasional burst of frames.

This is a classic example of where luck plays its part. In order to capture the movement created by the retreating tide, I needed to use a shutter speed of four seconds. Once I pressed the cable release, I had no way of predicting how the water would move. I shot over 20 separate frames and waited until I got home before deciding which of them had been successful.

While walking the streets, my attention was drawn to a poster in a shop window. It was not until I knelt down that I noticed a reflection of another head from another poster attached to the window opposite, which offered a strangely appealing juxtaposition.

Composition is undoubtedly important, although it is much too complex an issue to be distilled into a simple set of rules. Providing we rid our minds of certain cultural prejudices, we are capable of achieving this intuitively. In our quest for the perfectly composed image, we can sometimes lose sight of what it is we are trying to achieve, which of course is to convey our thoughts and emotions. Our natural desire is to create a sense of equilibrium, although sometimes that runs counter to the subject we are photographing.

Exploring imperfect composition.

We do need to question whether we should aim to promote a harmonious balance in all our photographs, since there are occasions when we may wish to evoke a different response. Sometimes we deal with sad or disturbing subject matter that works counter to the calming serenity promoted by 'classical' composition; on these occasions we should reject traditional compositional conventions, introducing drama and menace into our work by using the imperfect composition. We also need to allow for those situations when the shot has been taken hurriedly or possibly under duress, when there is little time to compose. Much can be done at the editing stage, although we should never be afraid of celebrating work that, although compositionally imperfect, retains integrity and authority.

The traditional view is that you should never allow a strong vertical line to divide your composition into two, although by doing so you are acknowledging the spontaneous nature of photography. Rather interestingly, the great French painter Edgar Degas regularly used this ploy in order to introduce new tensions into his work.

It is possible to see photography from two viewpoints: on one hand we have highly constructed images where the guidelines of traditional composition are very important, while on the other hand we have images that are compositionally lacking, but are still capable of expressing intense human emotions. We can view our own photography from either of these positions, or somewhere in between, depending on the statement we wish to make in our work.

I would also like to mention a few words on the role of digital imaging. In common with most photographers I welcome the endless possibilities that editing software offers, but there are attendant dangers. If we become too critical of our initial attempts and aim to produce sanitized

I doubt anyone could ever imagine that this is an example taken from the 'chocolate box school of photography'. A 'hot-hatch' photographed in front of an industrial complex is not the sort of image to inspire balance and harmony. Shooting the model looking out instead of into the picture and deliberately sloping the horizon has introduced a certain edginess.

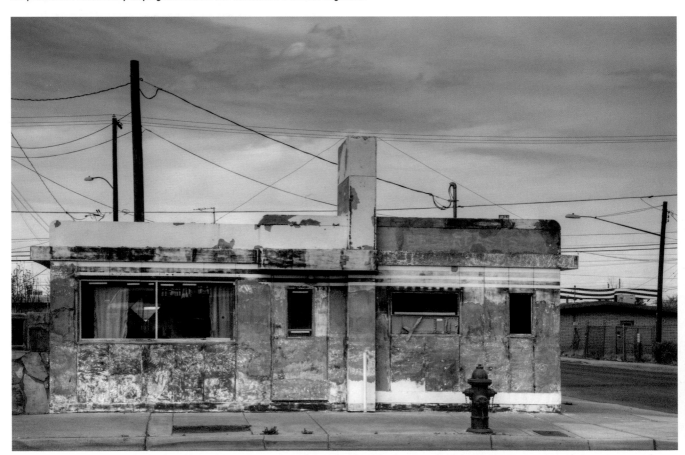

This abandoned café is clearly the main subject of the photograph, but it appears to be surrounded by a chaotic tangle of telegraph poles and wires. These seemingly imperfect elements not only place the main subject within a context, but they also introduce haphazard rhythmic elements that create a slightly disquieting mood.

This isolated building appears strangely distorted as a result of the chosen vantage point. It would have been easy to correct this, although the unsettling mood it conjures is consistent with the subject; the large expanse of grey sky coupled with the truncated lamp post on the left also add to the edgy feel. There are some images that benefit from a more traditional interpretation of composition and others that do not.

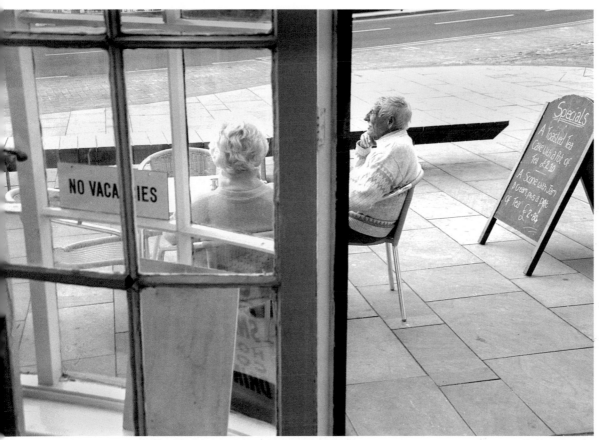

(Photographer: Roy King) This is another image that follows the Degas tradition of dividing the image in two. One might assume that the couple sitting outside the café are related, yet because of the strong vertical line the figure on the right appears visually separated from the one on the left. This compartmentalizing introduces an element of tension.

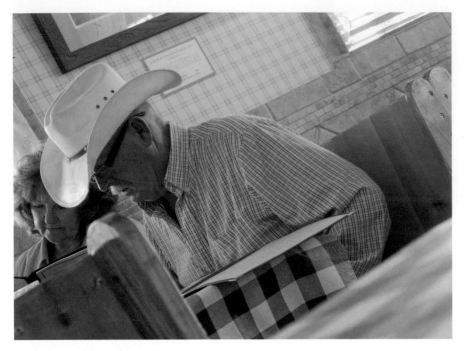

perfection post camera, we run the risk of producing compositionally perfect, antiseptic photographs that essentially communicate very little.

So how do we as photographers introduce an added element of pathos or edginess into our work? One answer is by deliberately working against the acknowledged rules of composition and the following list suggests some of the possibilities available:

• **Using a right to left flow.** In the West we read from left to right, so we find it comfortable to view a picture that has a strong left to right flow. Reversing this makes the viewer feel uncomfortable.

(Photographer: Eva Worobiec) Often the most revealing images are taken in a split-second. Having observed the couple studying the menu, the photographer made a snap decision to capture this, with the resulting sloping horizon. This of course can easily be remedied post camera, however the photographer decided to retain the feature as it conveys a questioning informality that enhances this image.

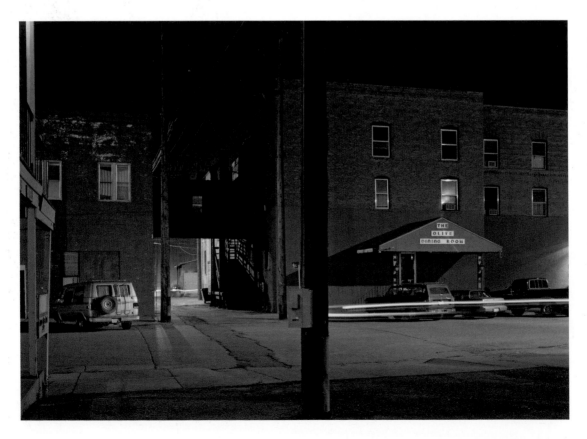

When you include a strong vertical line in your composition, all sorts of interesting possibilities are introduced. We need to accept that photography has its own unique characteristics and the 'accidental' division of an image celebrates its spontaneous nature.

• **Using unweighted counterbalance.** The notion of balance and counterbalance is an important compositional consideration, as the photographer establishes the relative visual weight of each of the visual components. By deliberately ignoring these balances, a tension and a sense of unease is created.

• **Sloping the horizon.** Whenever we view a horizon we expect it to be straight, so by sloping it we introduce an unsettling feeling into the mind of the viewer. Paradoxically, this sense of unease is most apparent when the horizon is only slightly skewed; if it slopes 45 degrees for example, our minds establish a pattern that compensates for this.

• **Introducing wide-angle distortion.** Many photographers are attracted by the exaggerated angle of view offered by ultra wide-angle lenses, and these undoubtedly add impact to a composition. The exaggerated perspective works well with certain subjects, but is less appropriate when a more 'romantic' approach is required.

• **Interrupting a rhythm.** Rhythms can be broken by introducing an element or elements that are visually unsympathetic to the general flow of the image, causing the viewer to question the picture.

• **Introducing areas of imperfection.** In the same way as we expect to hear a singer hit their note, we expect a photographer to produce a perfectly balanced image. Yet if we develop this analogy, occasions when the singer does not quite hit the note can make the piece more interesting. The same applies to photography, as sometimes an intended flaw can positively enhance the image – this could be a key area slightly out of focus or a small degree of camera shake. I am not advocating sloppy craftsmanship, but merely suggesting that a conspired imperfection can introduce qualities that a technically perfect image cannot.

(Photographer: Eva Worobiec) The man in the striped shirt occupies a position that would appear to conform to the rule of thirds, but the real interest is created by the two figures on the edge of the frame. The partially cropped figure on the extreme right serves as a visual full stop, while the figure in the black T-shirt acts as a counterbalance. What is particularly interesting is how the photographer has included just a small part of the woman's face, leaving the viewer sufficient scope to imagine the rest. The truncated figures create a continuum that introduces an animated quality to this image.

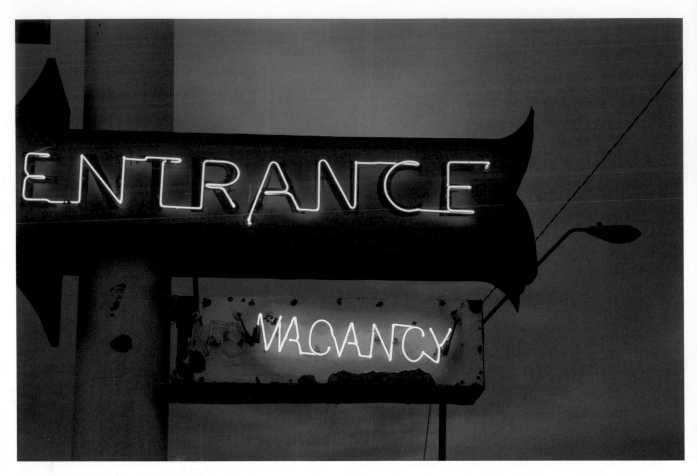

The traditional view of composition is that it should create a sense of harmony, but we do need to question whether this is appropriate for all of our photographs. There are occasions when we want to evoke a different response: in this example I wanted to suggest abandonment, by 'roughing up' the composition. Cropping the image so that we are not able to see the entire arrow on the left, while including the silhouetted lamp post on the right, heightens that sense of neglect.

• **Dividing the image.** Dividing an image is anathema to traditionalists, although when you include a strong vertical line interesting possibilities are introduced. We need to accept that photography has its own characteristics and the 'accidental' division of an image emphasizes its spontaneous nature. This compartmentalization often introduces a strange ambiguity. Once again it is an approach that has a tradition: the post impressionist Edgar Degas was one of the first artists to recognize the potential of photography as an aid to painting. In his much celebrated horse racing series, he frequently included a post that served to divide the image in two. As a painter he had the option of removing it

entirely yet chose to include it because he saw these 'accidents' as a defining idiom of photography.

• **Placing key elements at the edge of the frame.** The first 'rule' many photographers learn is to set the subject on the thirds, thus placing it on the edge of the frame so that part of it appears to be cut off runs contrary to traditional compositional practice. Yet a truncated figure or portrait can give rise to interesting and thought-provoking imagery. Placing the entire subject within the frame can make the image appear static, but by positioning key elements on the edge an illusion of a continuum is created.

Celebrating the 'ugly'.

Classical composition dates back to the Ancient Greeks, whose sculptures celebrated the idealized human form; the idea of creating images of realistic human beings was anathema to them. In order to establish a heroic pose, there was a great emphasis on symmetry as they sought an embodiment of balance and harmony. A visual equilibrium was achieved around an imagined vertical axis and each gesture or movement of the limb was designed to balance or counterbalance this.

This tradition was resurrected during the Renaissance period. One has only to look at the many depictions of the crucifixion, illustrating Christ devoid of pain and anguish, to understand how the artists of the time were also concerned with illustrating human perfection. If we examine the gestures of so many figures from this period they fail to reflect the true torment of their situation.

As many of our traditional compositional conventions stem from this period, it is not surprising that some photographers feel that they too ought to instil a sense of balance in all their images. Sometimes there is an assumption that only beautiful things should be photographed – a breath-taking landscape, a stunningly attractive woman, a posy of flowers in full bloom – but as we are all aware photographic subject matter is far more wide-ranging than just these types of subjects.

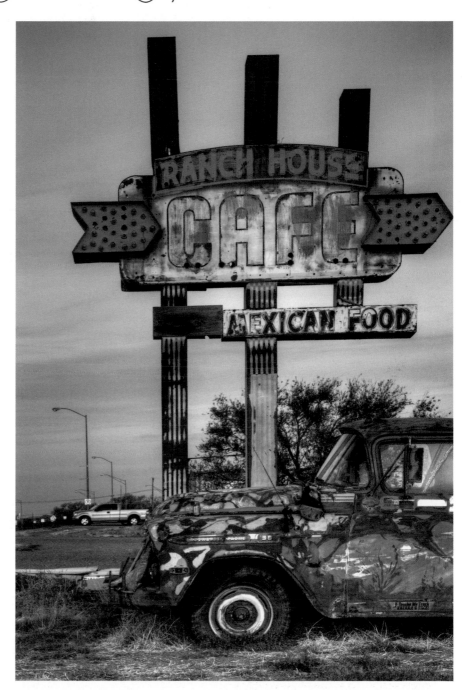

Abandonment and dereliction evoke a mood of pathos, so in this example a conventional approach to composition seems pointless. I created a HDR file in order to exaggerate the sense of texture. By positioning the vehicle in this way, the viewer is encouraged to read the image from right to left, which creates an unsettling mood.

A conventional view of composition is that it should suggest harmony and balance, but is that always required? Reading about the making of the highly applauded movie *Macbeth*, the director Roman Polanski was trying to create a threatening scene featuring lines of marching soldiers; each time he attempted it, that sought-after sense of threat was missing. It eventually dawned on him that he had been filming the soldiers marching from left to right (our reading direction in the West); by reversing this that illusive aura of menace was finally introduced.

While composition is an important aspect of designing a picture, it should also be appreciated that there are other factors that contribute. Rather like the painters of the Renaissance period, if we become over-concerned with composition, we may not truly engage the viewer. With some images the creation of a disquieting mood is more important, and it may be necessary to introduce 'ugliness' and imbalance in order to achieve this.

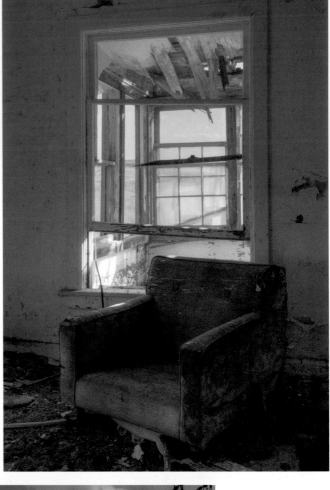

What is ugliness and what is beauty? This is a common dilemma that many photographers face. This trashed interior does not immediately suggest beauty and yet there are visual hotspots; setting aside one's initial sense of revulsion, the shattered timbers in the top of the image and the rich textural detail in the armchair each reveal a strange beauty.

Faced with this colourless location, there was a temptation to commit the image entirely to black and white, which would not only introduce a certain abstract quality, but would sanitize or even romanticize an otherwise bleak scenario. By retaining the image in colour, albeit it minimal, a true sense of melancholy is conveyed.

How do we compose?

While considering the vexed issue of exactly how we compose, I have discovered that culture and tradition are important factors, as are the so-called 'rules' because they are easily understood – yet I came to the conclusion that there are no simple answers. However there is another view: that we all have an innate sense of design that should serve as our guide when composing images. This design sense can be dulled by doubt or lack of use: if somebody keeps telling you that your work is failing because it does not conform to an arbitrary set of rules, then it is not surprising that you start to question your own judgment. There is however a well supported body of opinion suggesting that as the eye scans the randomness of a subject through the viewfinder, it will stop at a point when the inner eye intuitively 'recognizes' a specific design or pattern. Moreover, these numerous designs or patterns are broadly universal, therefore when somebody else looks at your work, they can also sense when it looks right – this is known as the Gestalt theory (see Positive and negative shapes).

Research that might help to shed some light on this was an investigation of children's preschool drawings, because it suggests that we all have a natural capacity to design, even at an early age. I found Rhoda Kellogg's highly praised publication *Analysing Children's Art* particularly relevant. The author methodically collated thousands of drawings, some little more than scribbles, initially from preschools in and around the San Francisco area, and was able to make several observations. First, that when very young children draw, they do so free of cultural influence, and second, that they follow the same patterns or schema. This led her to examine the early drawings from children from other parts of the world: their drawings rather remarkably revealed precisely the same schema. It is only as the children matured that their artwork began to reflect their own individual cultures.

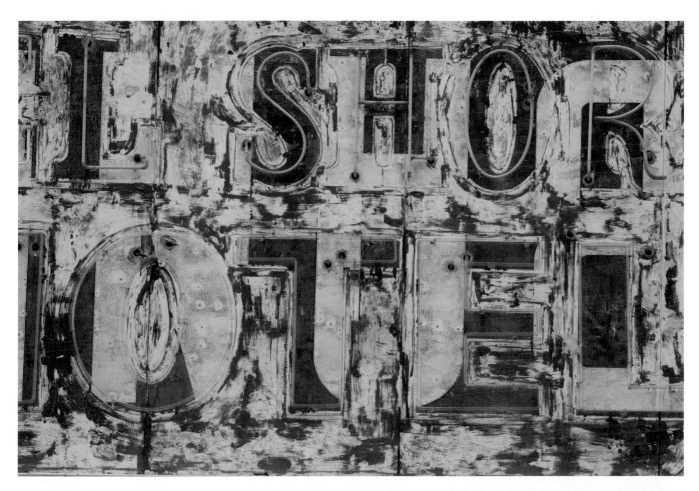

Look at examples of visual arts that exist outside your comfort zone; this could be photography, graphic design, painting or even tattoo art. A personal hero influenced this work: the American pop artist Jasper Johns, who recognized that the positive and negative shapes created by text make interesting images.

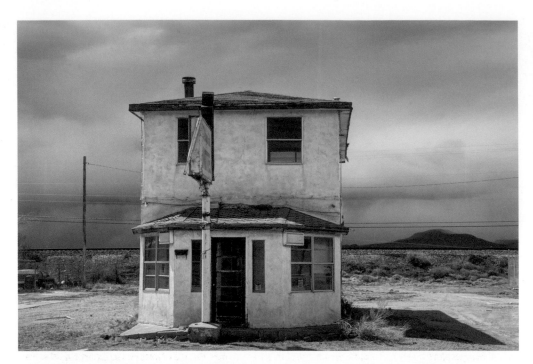

This abandoned hotel is clearly the main focus, but where do I place it, on the third or in the middle? In this example, I chose neither and relied instead on instinct. Looking at this image afresh, I sensed that the telegraph pole on the left and the dark mountain on the right determined where the hotel was positioned, even though this placement does not conform to any of the recognized rules of composition.

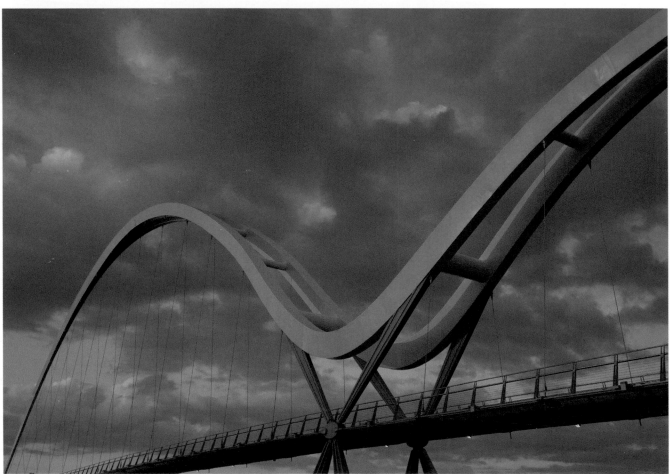

You cannot expect a rule to cover every situation and simply identifying a clear-cut shape is often all that is required. In this example, by ensuring that the orange structure started in the bottom left corner and disappears in the top right, a powerful S shape emerges.

The choice of format can greatly affect how we view an image. When looking at a panoramic photograph, we tend to 'read' it from the left to the right, rather like a book, so in this example the horizon plays a very important part in the design; note also how the line of trees on the extreme right serve as a visual full stop.

The significance of Kellogg's research suggests that we all share a fundamental sense of design that we are in danger of losing as cultural influences takes hold. Her hypothesis is supported by independent research done by the art historian Herbert Read, who stated that 'Every child, in its discovery of a mode of symbolization, follows the same graphic evolution.' So how does this research affect how we compose?

It might suggest that our sense of design emanates from three sources. First, there are the cultural influences of which most of us are aware: as a fledgling art form in the nineteenth century photography naturally looked to art as a role model, adopting many of its conventions regarding composition. Second, we have come to recognize that visual perception can also be conditional on psychology; the Gestalt theorists suggest that we respond psychologically to certain visual phenomena. Third, we all have a fundamental sense of design that stems from a shared set of schema. If you are a little uneasy about this last point, consider how closely

Tip

Without hard and fast rules, some photographers find it difficult to compose; try turning your image upside-down – if it still looks good your composition is spot on.

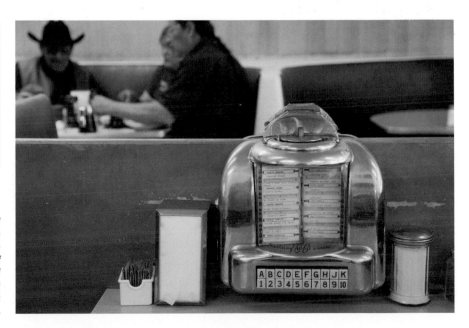

Being aware of a range of compositional strategies helps us to photograph more appropriately. In this example, while the table jukebox was the main focus of my attention, the group of figures add an appealing counterbalance. Placing each in diametrically opposite corners introduces an interesting tension.

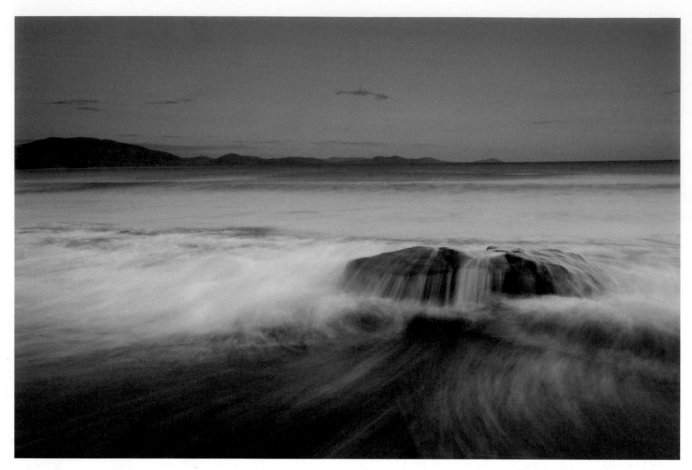

Balancing the elements is a fundamental aspect of composition. While the main focal point is the moving water tumbling over the large rock in the foreground, the two distant stacks on the extreme left play a pivotal role in retaining an overall sense of balance.

your doodles parallel those of others. For example, think how often you have absentmindedly drawn a mandala, a spiral or possibly a cross in a circle, because these designs come to you naturally. Might it not be that when we take a photograph, we design it subliminally using one of the schema identified by Kellogg, and that when someone else looks at the photograph, they are able to empathize at a subliminal level? It is often argued that the best photographers compose their images instinctively. Might this be the reason?

Clearly reducing composition to a simple set of rules is not enough; as I have already suggested, we are all born with a capacity to make sophisticated aesthetic judgments, but as with all things we need a helping hand. Why not visit your local art gallery, or possibly a photographic exhibition that takes you outside your comfort zone, just to see how others compose? Rather than get too concerned about

the rules of photography, have a simple shape in mind. For example, you may wish to construct a still life, but rather than trying to place each of the various objects on the thirds, ensure that they all fit into a triangle, a diamond or a semi-circle.

Points to consider:

• Composition is far too complex an issue to relegate to a simple set of rules; it requires a great deal of personal input.

• Good composition should be intuitive; as we look through the viewfinder, a process of 'recognition' occurs.

• Look at examples of the visual arts that exist outside your comfort zone; these could be from the areas of photography, graphic design, painting or even tattoo art.

Conclusion.

What can be drawn from all this? There are quite a number of compositional guidelines, many of which I have attempted to highlight. However it is important to understand what you are trying to achieve when composing an image: often your main purpose is to add clarity but also to introduce a sense of balance. Occasionally, perhaps when wishing to convey pathos or sadness, you may decide to deliberately ignore these guidelines in order to add that pathos.

Understanding how the visual elements of tone, colour, line, texture, shape and form can add to an image is very important, because you are then more able to use these in a constructive way. It also helps to understand that photography does not exist in a vacuum and that issues that concern us also affect painters, sculptors, graphic designers and moviemakers. For this reason it is worthwhile checking out how they deal with composition: the more familiar you are with a broad range of visual arts the more flexible your approach to composition will become. We all share a common visual language and we can learn from one another.

We all have an inborn instinct for design, although of course our culture will also have a bearing. Most of us have a fair idea of our photographs that work and those that don't. Generally, it is when we try to over-compose that we ruin a composition, while on those many occasions when we work

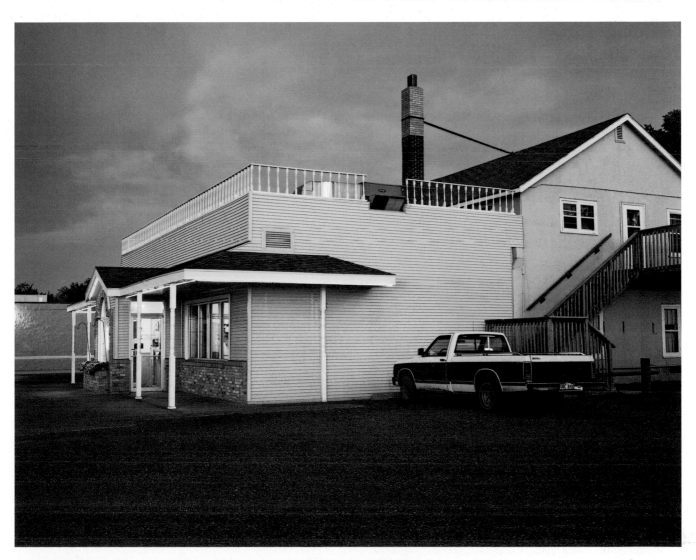

Balance and counterbalance are critical to successful composition. While the eye is naturally drawn to the illuminated doorway, imagine this image without the pick-up truck – somehow it just would not work.

instinctively, things just seem to click. Writing about art, the American abstract expressionist Robert Motherwell argues that 'The need is for felt experience, intense, immediate, direct, subtle, unified, warm, vivid, rhythmic.' While he was concerned with painting, this can apply equally to photography.

It is not a bad idea to sometimes revisit your failures and establish what went wrong. It is rare that an image is unsalvageable and sometimes just a simple crop can make all the difference. The process of editing your photographs is a particularly valuable exercise, because only by establishing why certain images worked, are you able to develop as a photographer.

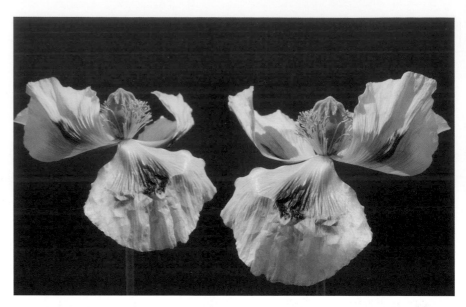

The interplay between the positive and negative shapes should always be an important consideration when composing an image. Designing this image so that the petals touch the edge makes this relationship clear and apparent.

This interesting trompe l'oeil raises various compositional issues, not least scale, but also considers what is real and what is not. The more familiar you are with the numerous compositional guidelines, the more likely you are to respond to unorthodox subject matter.

Acknowledgments.

Of the many books I have written this is possibly the one I have most enjoyed, due in no small measure to the help and support I have received from a variety of friends and colleagues. I must start by thanking Judith Harvey who was brave enough to commission this book, but also Hannah Kelly who supervised this with her usual calm and professional assurance. I am particularly indebted to Freya Dangerfield for her excellent editing work, and to Jo Lystor whose design skills have once again produced a cohesive and visually stimulating publication.

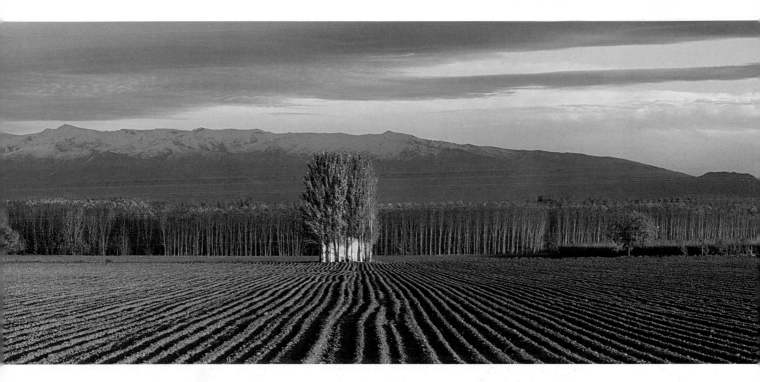

On a more personal level I must thank my close friend Ken Hawkins who seems always to provide me with models when I require them, and my wife Eva for contributing some truly inspirational photographs; I also owe a debt of gratitude to both Paul Foley and Dave Mason for allowing me access to the Roy King Archive. Finally, I would like to thank the numerous models who allowed me photograph them, in particular Geoff Barfoot, Hettie Bell, Laura Boyce, Hongbo Chen, Lily Hawkins, Zandie Hlomayi, Ellie Raven-Vause, Hayley Savage, Nicole Skipper and Faye Thompson.

Index

abstract photography 113–14
aerial perspective 88
Ancient Egyptians 10
Ancient Greeks 10, 76, 149
Andre, Carl 102
asymmetry 12, 18, 21, 48–50, 67–8, 78, 80, 126

background
 context 39
 minimalist 97–8, 105
 relationship with the foreground 38–9, 44
 using the foreground to mimic the 41
balance 17, 25, 143, 149–50, 155
 and the central meridian 76
 and composing from single corners 23, 79
 and counterbalance 18–21, 147
 and cropping text 100
 and empty space 97–8
 facial 79
 and the Golden Spiral 13–14
 and the Golden Triangle 15
 and matching numbers 52
 measurement 19
 and monochrome 91
 and odd and even subject numbers 49–50
 and pairs 47–8
 and positive and negative shapes 27
 and the rule of thirds 10–12
 and the visual fulcrum 18, 21, 22
 and the visual palindrome 125
beauty, notion of 79
borders 131
 see also frames

Cartier-Bresson, Henri 81, 83, 139
central meridian 76–9
children's art 151, 153
'circle within a square' 134–5
colour
 adding a splash of 64
 adjacent/analogous 58, 60
 advancing and receding 62–3
 complementary 58–9
 contrast 110
 cool 56, 61–2
 and depth 62–3

harmonious 60–1
 and minimalism 105
 monochromatic 65–6
 neutral 56–7, 59
 primary 56–9, 64
 psychology of 54–7
 and the rule of thirds 12
 value of 54
 warm 55–6, 61–2
colour wheel 58–60
constructed images 123
constructed kaleidoscope 124
content
 reduction 104
 relating to the image 44
context 39, 67
contrast 46, 65, 110
corners
 composing from opposite 24
 composing from single 23
 vignetting 130
counterbalance 18–22, 24, 48, 69, 149, 153, 155
 unweighted 147
counterchange 136–7
critical moments, planning for 139–40
cropping 85, 120–1
 text 100
 to suggest more 51
culture 54, 151, 153

Degas, Edgar 143, 148
depth, sense of 42–3
 and aerial perspective 88
 and colour 62–3
 and frames 67
 and lens choice 112
 and meandering lines 35
depth of field 105, 111
distorted images 87, 147
dividing images 148
dominant aspects 21
double-exposure 128
drama 23, 28, 41, 78, 96, 98, 110, 136, 140, 143

editing 141–2
empty space 97–9
enigmatic work 67

faded effects 95
Fechner proportions 81, 83
Fibonacci numbers 13, 14
flash, fill-in 110
flipping images 126
focal points
 and cropping 120–1
 and empty space 98
 and the Golden Spiral 13
 and the Golden Triangle 15
 illuminating 109–10
 and meandering lines 35–6
 and multifaceted designs 25
 and pairs 47–8
 placing at the edge of the frame 148
 and the rule of thirds 10, 18
 single 10, 18, 45–6
foreground
 mimicking the background with 41
 relationship with the background 38–9, 44
format
 choice of 81–5
 panoramic 78–9, 84–5, 120, 153
 rectangular 81, 82–3, 85, 120
 square 84, 120
fractals 71
frames 67–9
 see also borders

Gestalt Theory 27, 151, 153
Golden Ratio/Spiral 13–14
Golden Section see rule of thirds
Golden Triangle 15
grey 57, 89–90

Hamilton, Richard 127
high dynamic range (HDR) 122
high-key images 93–4, 104
horizons
 sloping 147
 and visual full stops 37
hues, grey 89–90
human form 10, 76, 149

image size 45–8
image structure, overall 76
imperfect composition 143–8
isolation, sense of 108

Kellogg, Rhonda 151, 153, 154

left to right flow 37, 146, 150, 153
lenses
 choice of 112
 focal length 30
 telephoto 88, 112
 wide-angle 43, 112
 zoom 112
Leonardo da Vinci 10
lighting
 artificial 110
 and colour contrast 110
 illuminating focal points 109–10
 natural 110
 and primary colours 64
line(s)
 in composition 28–9
 diagonal 33–4
 lead-in 30–2, 40
 meandering 35–6
 S-shaped 35–6
 zin-zag 36
low-key images 93–4, 104–5

McCullin, Don 81
Meyeroqitz, Joel 102
minimalism 101–5
mirrored images 86
Mondrian, Piet 10
monochrome 65–6, 89–92
mood 7, 60, 64–5, 89–94, 96, 111, 144–5, 149–50
Motherwell, Robert 156
multifaceted designs 25–6

Native Americans 135
negative shapes 27, 136–7, 156
negative space 24, 48, 97
negatives, presenting positive images as 127
number of elements
 even 47–50
 matching 52–3
 odd 45, 47, 49–50

order, amid chaos 138

pairs 47–8

panoramic format 78–9, 84–5, 120
patterns 70–2, 151
 broken 72
perception 27, 151, 153
personal style 74–117
 abstract photography 113–14
 aerial perspective 88
 central meridian 76–9
 choice of format 81
 cropping text 100
 depth of field reduction 111
 empty space 97–9
 high-key imagery 93–4
 illuminating focal points 109–10
 isolation 108
 lens choice 112
 low-key imagery 93–4
 minimalism 101–5
 monochrome 91–2
 reflections 85, 86–7
 restricted tonal range 93–6
 rhythm 115–17
 shades of grey 89–90
 silhouettes 106–7
 working off-centre 80
perspective
 aerial 88
 and diagonal lines 34
 and lead-in lines 30–2
 linear 30–1
 and sense of scale 42
photograms (rayographs) 127
Photomatrix 122
Photoshop 122–3, 125–6
Polanski, Roman 150
pop art 123, 127
positive images, presenting as negative 127
positive shapes 27, 136–7, 156
post camera techniques 119–31

Rauschenberg, Robert 128
Ray, Man 127
Read, Herbert 153
rectangular format 81, 82–3, 85, 120
reflections 85, 86–7
Reinhardt, Ad 102, 105
Renaissance 149, 150
rhythm 115–17

interruption 147
right to left flow 37, 146, 150
rule of thirds (Golden Section) 7, 10–12, 15, 18, 50, 148

scale, sense of 30, 42–3
schemas 151, 153–4
shape
 and abstract photography 113
 identification 16–17
 negative 27, 136–7, 156
 positive 27, 136–7, 156
silhouettes 106–7
size of image 45–8
space, empty 97–9
square format 84, 120
subordinate aspects 21
symmetry 76–7, 79, 125–6, 149

tension, sense of 24, 36, 48, 69, 82, 96, 108, 143, 145, 147
text, cropping 100
texture 73, 122
threat, sense of 96, 105, 108, 129, 150
three-dimensional objects 16
tonal values
 and low and high-key imagery 93–4
 manipulating using HDR 122
 and monochrome 65, 91–2
 restricted range of 93–6, 104–5
 and the rule of thirds 12
 and single focal points 46
translucent layers 128–9
triptych 50
two-dimensional objects 16

'ugly, the', celebration of 149–50

vignettes 130
visual fulcrum 18, 21, 22, 26
visual full stop 37, 153
visual palindrome 125–6

wide-angle distortion 147
working off-centre 80

A DAVID & CHARLES BOOK
© F&W Media International, Ltd 2013

David & Charles is an imprint of F&W Media International, Ltd
Brunel House, Forde Close, Newton Abbot, TQ12 4PU, UK

F&W Media International, Ltd is a subsidiary of F+W Media, Inc
10151 Carver Road, Suite #200, Blue Ash, OH 45242, USA

Text and Photography © Tony Worobiec 2013
Layout © F&W Media International, Ltd 2013

First published in the UK and USA in 2013

A catalogue record for this book is available from the British Library.

ISBN-13: 978-1-4463-0263-7 paperback
ISBN-10: 1-4463-0263-6 paperback

Printed in China by RR Donnelley for:
F&W Media International, Ltd
Brunel House, Forde Close, Newton Abbot, TQ12 4PU, UK

10 9 8 7 6 5 4 3 2 1

Acquisitions Editor: Judith Harvey
Desk Editor: Hannah Kelly
Project Editor: Freya Dangerfield
Proofreader: Beth Dymond
Art Editor: Jo Lystor
Production Manager: Beverley Richardson

F+W Media publishes high quality books on a wide range of subjects.
For more great book ideas visit: www.stitchcraftcreate.co.uk